WOMEN OF OUR TIME

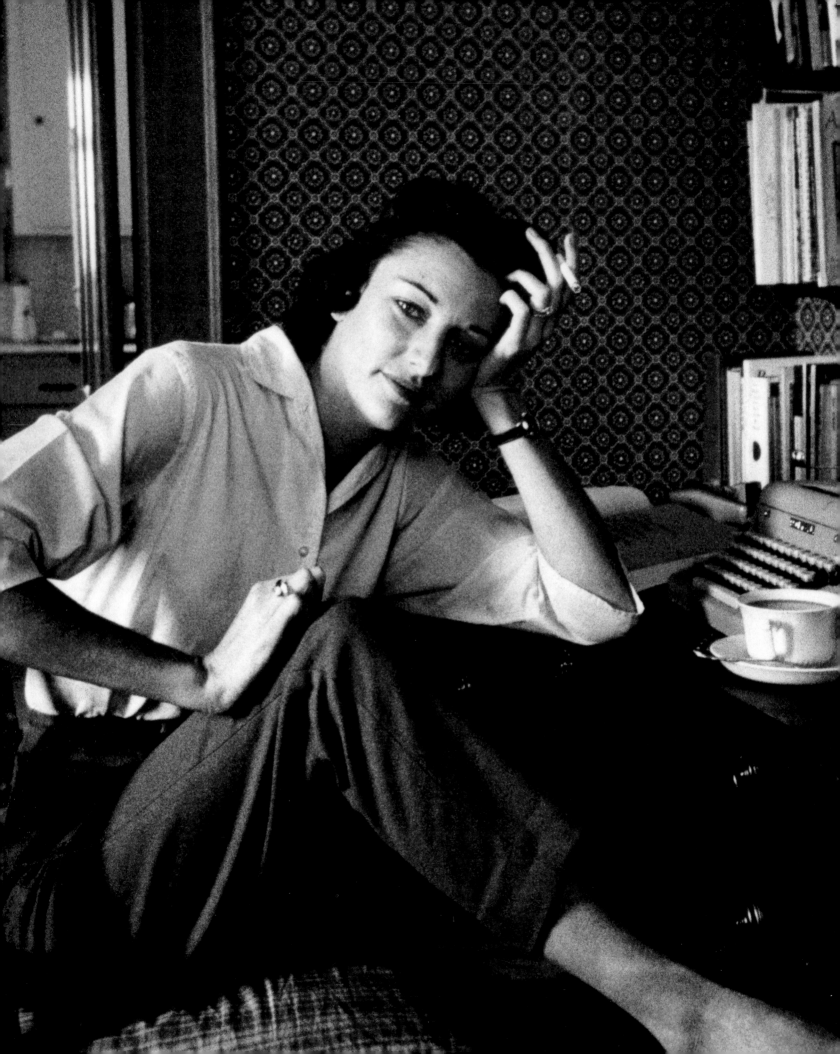

WOMEN OF OUR TIME

An Album of Twentieth-Century Photographs

Frederick S. Voss
Preface by Cokie Roberts

National Portrait Gallery
Smithsonian Institution
Washington, D.C.

MERRELL

First published 2002 by
Merrell Publishers Limited
42 Southwark Street
London SE1 1UN

in association with

National Portrait Gallery
Smithsonian Institution
750 Ninth Street, NW, #8300
Washington, D.C. 20560–0973

Published on the occasion of the exhibition:
*Women of Our Time: Photographs
from the National Portrait Gallery*
organized by the National Portrait Gallery,
Smithsonian Institution

Copyright © 2002 Smithsonian Institution

Distributed in the U.S. by Rizzoli
International Publications, Inc.,
through St. Martin's Press, 175 Fifth Avenue,
New York, New York 10010

Library of Congress Control Number
2002106995

British Library Cataloging-in-Publication
Data:
Voss, Frederick S.
Women of our time : an album of twentieth-
century photographs
1. Portrait photography – United States
2. Women – United States – Pictorial works
3. Celebrities – United States – Pictorial works
I. Title II. National Portrait Gallery (U.S.)
779.2′4

ISBN 1 85894 169 5

Project coordinator: Dru Dowdy
Produced by Merrell Publishers
Editor: Lisa Siegrist
Designer: Maggi Smith
Printed and bound in Italy

Front jacket: Helen Keller, photographer
Charles Whitman, 1904 (see p. 22).
Berenice Abbott, self-portrait, circa 1932
(see p. 54). Katharine Hepburn, photographer
Edward Steichen, 1933 (see p. 62).
Janis Joplin, photographer Linda McCartney,
1967 (see p. 148). Marian Anderson,
photographer Philippe Halsman, 1945
(see p. 94). Gertrude Simmons Bonnin
(Zitkala-Ša), photographer Joseph T. Keiley,
1901, from 1898 negative (see p. 20).
Lillian Gish, photographer Alfred Cheney
Johnston, 1922 (see p. 40). Martha Graham,
photographer Sonya Noskowiak, 1936
(see p. 72). Margaret Bourke-White,
photographer Philippe Halsman, 1943
(see p. 90). Sylvia Plath, photographer
Rollie McKenna, 1959 (see p. 136).
Margaret Sanger, photographer Ira Hill, 1917
(see p. 28). Billie Holiday, photographer
Sid Grossman, circa 1948 (see p. 108).

Back jacket: Mae West, photographer
C. Kenneth Lobben, 1935 (see p. 66).

Page 2: Anne Sexton, photographer
Rollie McKenna, 1961 (see p. 141).

CONTENTS

FOREWORD

This volume is, in part at least, a testament to how far the National Portrait Gallery has come in its photograph collecting in a remarkably short time. The original congressional statute of 1962 that created the Gallery expressly excluded photographic portraits from the museum's collecting mandate. Behind that prohibition was a fear that if the Gallery embarked on collecting photographs, it would place itself in an unseemly competition with yet another federal institution, the Library of Congress. By 1973, however, five years after the Gallery had opened its doors to the public, many individuals concerned with shaping the museum's future were realizing just how unfortunate that collecting restriction was, especially in light of photography's overwhelming importance in the modern portrait tradition. In that year, Gallery commissioner and distinguished art historian Jules Prown wrote to his fellow commissioner Nicholas Brown, "For a museum dedicated to the history of the United States as seen through the lives of its citizens, photographs are documentary material of primary importance through much of the nineteenth and all of the twentieth centuries." Out of that conviction eventually came action. Within another two years, a move was afoot to persuade Congress to permit the Gallery to acquire photographs, and in early 1976 Congress authorized the change. A year later, the museum's Department of Photographs came into existence and began assembling its photographic collection of eminent Americans.

Since then that collection, starting from almost literally nothing, has grown at a phenomenal rate. Today it numbers well over ten thousand images and contains works by many of the greatest American portrait photographers—from Mathew Brady and Alexander Gardner, to Alfred Stieglitz, Edward Steichen, and Berenice Abbott, to Arnold Newman, Irving Penn, and Hans Namuth. Thanks to this rapid but discriminating growth under the able direction of the Gallery's photography curators, the Portrait Gallery has been able to assemble this richly varied photographic cross section of noteworthy women of the twentieth century.

For a historian such as myself with a passionate interest in biography, perhaps the most riveting dimension of this selection of photographs is the texture of personalities they evoke and the biographical moments they often mark. It is fascinating, for example, to look at Ida Berman's picture of Rosa Parks, which is so suggestive of a mild, rather self-effacing character, and to note that not long after the likeness was made, its subject would spark one of the most salient events of the twentieth century's civil rights movement. Then there is Carl Van Vechten's scowling image of Emma Goldman, taken when she was in her mid-sixties, in which she looks every inch the militant and unrepentant anarchist that she was—still ready to take on the establishment at a moment's notice. Finally, some likenesses included here are intriguing not so much for what they reveal as for what they mask. In the case of Rollie

McKenna's picture of poet Anne Sexton, what we see is the self-possessed serenity of a successful writer, yet behind that quiet buoyance lay a deeply troubled and erratic individual who would ultimately resolve her difficulties in suicide.

In looking over the portraits of *Women of Our Time*, I also find it an interesting exercise to consider some of them in juxtaposition with one another. One learns, for example, that there are all manner of ways to record for posterity an actress's triumph—from Alfredo Valente's formally posed likeness of Helen Hayes in the title role of *Victoria Regina* to Ruth Orkin's snapshot-like picture of young Julie Harris awkwardly poised to take a sip of coffee following her much-lauded opening-night performance in *Member of the Wedding*. But as a measure of the great cultural shifts that occurred in the twentieth century, maybe the most telling of the juxtapositions here are the pictures of the nation's first congresswoman, Jeannette Rankin, dating from about 1917, and Texas congresswoman Barbara Jordan, taken in 1976. Rankin's likeness by L. Chase resonates with a gloved decorum that seems all too anxious to reassure the viewer of her traditional femininity. In an age none too comfortable with women venturing into the political arena, that was entirely understandable. By the mid-1970s, however, such reassurances were not necessary, and Jordan's likeness by Richard Avedon is strictly about forcefulness of personality irrespective of gender.

Many people have been involved in the realization of *Women of Our Time*. Two of the most crucial were Kimberlee Staking and Carla Freudenburg, who provided so much of the research material that served as the basis for the text. We are also enormously indebted to ABC news commentator Cokie Roberts for her wonderful introduction to the book. Finally, there is the Portrait Gallery's senior historian, Frederick Voss, the book's author. He tells me that he has rarely enjoyed working on a publication as much as he did this one, and this is one reader who thinks it shows.

Marc Pachter
Director
National Portrait Gallery
Smithsonian Institution

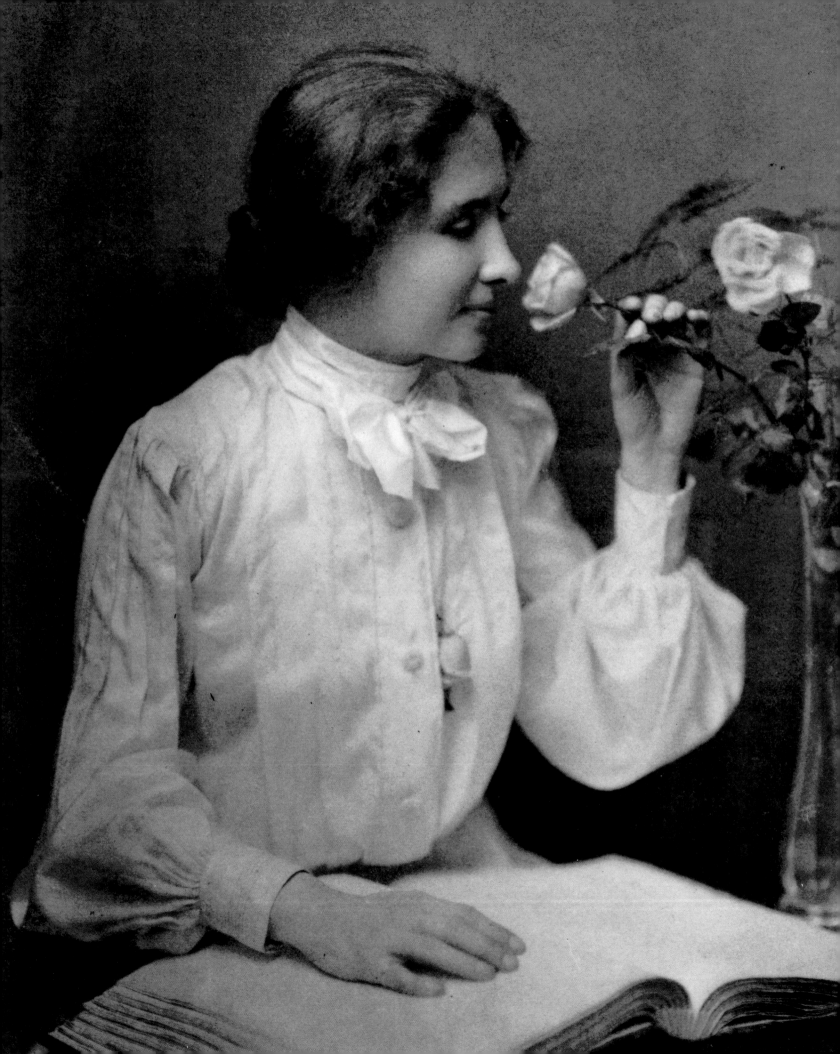

Women of Our Time: Firmly on Their Feet
Cokie Roberts

ook into the eyes of the subjects of these photographs and you see the triumphs, failures, hopes, and disappointments of some of the truly talented women of our time. Here you'll find athletes and actresses, scholars and singers, designers and dancers, politicians and playwrights, authors and artists, poets and photographers, evangelists and entrepreneurs, and aviators, architects, and activists of all kinds. All they have in common is their century and their sex, but that's quite a lot in a century when women found themselves in the midst of a revolution. Some fomented it, some floundered through it, and some foundered upon it, but none could ignore the seismic shift in women's lives that the twentieth century produced.

This book gives us the opportunity not only to see the faces of these women, many of them very familiar, but also to "hear" their words and the words of people who knew them or their work. We always knew that Amelia Earhart loved flying, for instance, but when we see a picture of her smiling out from the unfinished fuselage of a Lockheed Electra, she looks as though she's part of the airplane itself, as if she's the engine. And then we hear her mother's words about the first "flying machine" Earhart owned. It was the summer of 1921, her mother recalls, and young Amelia didn't want to leave the plane the first day she'd gotten it. It was almost as if the machine were "a favorite pony. We said goodnight to it and patted its nose and almost fed it apples." For sixteen years after that day, Earhart broke records and made history in her flying machines until she set off for a round-the-world adventure. When she called her husband from India and he asked if she was having a good time, she shot back, "You betja." It's comforting to know that the woman who disappeared over the South Pacific two weeks later was thoroughly enjoying herself.

Or take the picture of Fannie Lou Hamer, singing and sweating her way through the March Against Fear from Memphis to Jackson in 1966. The forcefulness of the photograph gives a sense of why the term "black power" came into the political vocabulary. Despite the power of the image, however, it's Hamer's words that continue to ring through the decades. For many involved in the civil rights movement at the time, her famous saying "I'm sick and tired of being sick and tired" became a rallying cry. This uneducated plantation worker risked her life and livelihood to exercise her right to vote. And then, in organizing other blacks to protest the all-white delegation at the Democratic National Convention of 1964, she helped provide the momentum that culminated in the Voting Rights Act of 1965. That revolutionary legislation so changed the face of American politics that Mississippi went from a state where blacks faced danger if they dared to register to vote to a state with the highest number of African American elected officials in the country.

One of those given the task of memorializing the civil rights movement was Maya Lin, who designed the Civil Rights Memorial in Montgomery, Alabama. She was in the

HELEN KELLER 1880–1968
By Charles Whitman (active 1890s–1900s)
Toned platinum print
22.6 × 16.9 cm (8 15/16 × 6 11/16 in.), 1904

process of conceptualizing that work when the photographer came to her studio and found Lin with her cat. By then she was already famous as the controversial architect behind the Vietnam Memorial in Washington, D.C. Though some in the artistic community and various Vietnam veterans organizations fought against her somber slabs of black stone, her plan was eventually executed, and the Vietnam Memorial is now the most visited site of any in the nation's capital. Millions of people every year run their fingers over the names of the war dead engraved in the stone, silently paying tribute. In defending their choice of Lin's concept, the judges called it "a memorial of our own times" that "could not have been achieved in another time or place." They could not have known how true that would turn out to be.

At a polar extreme from Lin's distracted gaze past her cat is the highly posed picture of one of the great celebrities of the century, Mae West. With her bleached blond ringlets carefully arranged on her head and her white fur draped around her gardenia-bedecked beaded dress, she holds a cigarette in her bejeweled hand as tuxedoed men with lighters at the ready swarm in around her. It was 1935, and she was one of the highest paid performers in Hollywood. But again, it's not West's carefully calibrated appearance that lives on; it's her words. "Come up and see me sometime," said in a sultry voice with a come-hither look, has become as familiar a phrase as "To be or not to be." Countless quotation collections throughout the years have offered up some of West's more delightful observations, among them "Too much of a good thing can be wonderful" and "Between two evils I always pick the one I never tried before."

Think of Mae West sharing an exhibit with Helen Keller and Dorothy Day! How different could the outrageous movie star be from the terrified child who was struck deaf and blind or the selfless social worker? Most of us know the remarkable story of Keller's emergence from a dark and soundless world through the efforts of her teacher, Anne Sullivan, and of how she became a spokeswoman for the American Foundation for the Blind. Keller is pictured here smelling a rose and touching braille, using two of her remaining senses. About her work, she wrote, "The field in which I may work is narrow, but it stretches before me limitless. I am like the philosopher whose garden was small but reached up to the stars."

Dorothy Day believed the world was a garden she could nurture to thrive despite inhospitable conditions. As the co-founder of the *Catholic Worker*, Day preached against poverty and war and practiced what she preached through the Catholic Worker Houses of Hospitality, which served as homeless shelters and soup kitchens across the country. Pictured here in her New York newspaper office, Day evinces a toughness that mirrored that of her newpaper. But she was wary of the accolades heaped on her. "When they say you are a saint," she said, "what they mean is that you are not to be taken seriously." How wonderfully wise!

That, in the end, is what binds these women together—their wisdom. Some of their actual words of wisdom have become famous. We've listened over the decades to Julia Child's common sense from the kitchen, even as she creates some impossibly difficult concoction. (It's somehow heartening to know that her husband considered himself a

"Cordon Bleu widower" and bemoaned his inability to pry his wife "loose from the kitchen day or night—not even with an oyster knife." Clearly, we are not dealing with your average cooking enthusiast here.) Equally compelling is the single-minded conviction of "Babe" Didrikson Zaharias, believed by some to have been the greatest female athlete of the century. A spectator marveling at her golf game remarked, "She must be Superman's sister." But Didrikson's explanation was somewhat earthier: "I just loosen my girdle and let the ball have it." Frances Perkins, Franklin Roosevelt's first secretary of labor, had a similar no-nonsense approach. When confronted by an opponent's assertion that her cabinet job was not appropriate for a female, she replied, "The accusation that I am a woman is incontrovertible." End of argument. Then there's Gypsy Rose Lee's insightful observation, "You don't have to be naked to look naked. You just have to think naked." Or Helena Rubinstein's pragmatic conviction, "It doesn't matter how shaky a woman's hand is. She can still apply makeup."

Some of these women show such strength and self-awareness that their pictures and prose make you stand up a little straighter. There's the first woman in Congress, Jeannette Rankin of Montana, elected before national suffrage. She cast one of the few votes against World War I and lost her seat. Decades of activism later, she returned to Congress in the election of 1940, just in time for the bombing of Pearl Harbor. This time hers was the only vote against World War II. "I want to stand by my country," she said, "but I cannot vote for war. I vote no." Now the words "I cannot vote for war" are etched in marble at the base of a statue of Rankin that is displayed in one of the most prominent corridors of the Capitol.

Gertrude Simmons Bonnin, as the founder of the National Council of American Indians, fought ferociously for the rights of Native Americans. "I fear no man," she declared. "Sometimes I think I do not even fear God." Margaret Sanger, the feminist fighter for birth control, assessed herself this way: "I am the protagonist of women who have nothing to laugh about." Designer Pauline Trigère had a sunnier but equally realistic description of herself: "I can't draw, I can't paint, but put a piece of fabric in my hands and magic happens." And you can almost hear the strong bass tones of politician Barbara Jordan's voice with her simple statement, "I never wanted to be run of the mill." That understatement is bound to bring a smile.

These fine photographs will coax both smiles and furrowed brows as they bring these remarkable women to life in all their variety. Combined with their subjects' stories, they come close to a shared biography of the women of our time. It's a story that's best summed up by Katharine Graham, the publisher of the *Washington Post*, who unexpectedly took over the newspaper after her husband committed suicide. "What I essentially did was to put one foot in front of the other, shut my eyes and step off the ledge. The surprise was that I landed on my feet." That's been the surprise in many women's lives over the last century as they took on new tasks that were thrust upon them or that they struggled to have the opportunity to tackle. This book presents some of the best of those women, firmly on their feet.

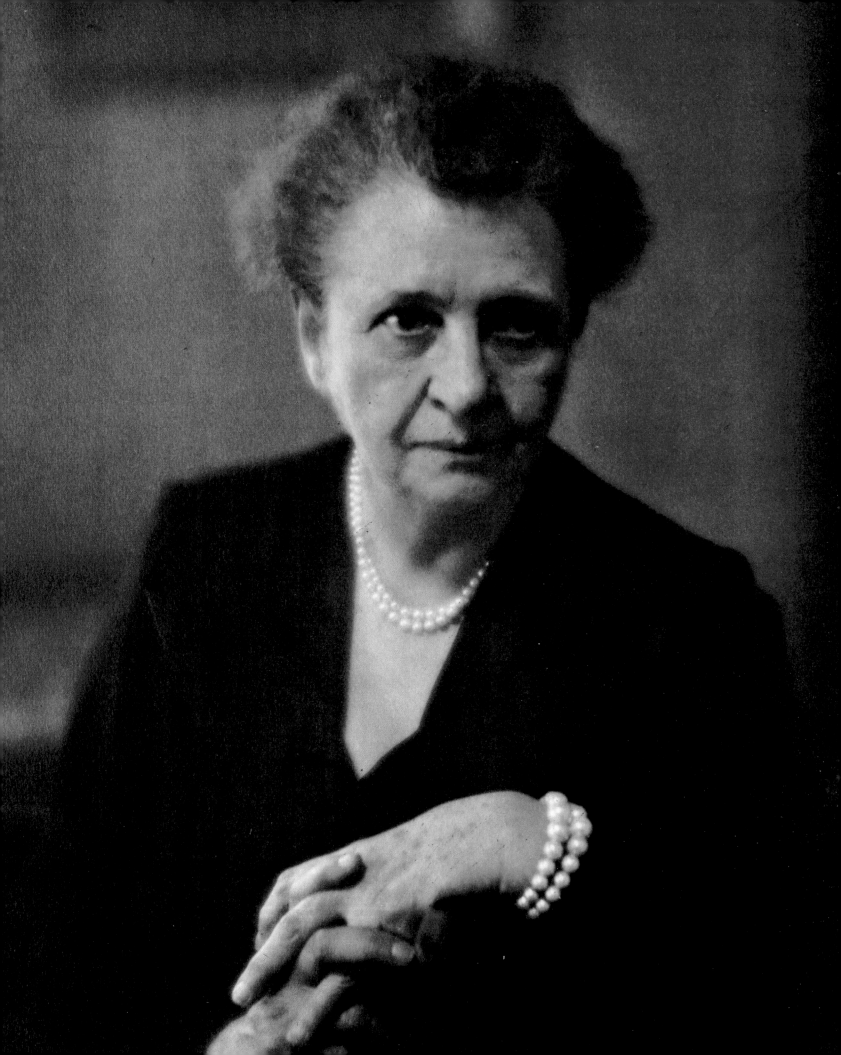

INTRODUCTION

The time frame for this book is the twentieth century, a hundred-year span that was remarkable for a host of landmark changes in the way we conduct our lives and what we expect from the world at large—from the advent of the airplane and the car to incredible leaps in medicine's ability to save lives, the miracle of space travel, and the emergence of a workplace-transforming computer technology. Many of the figures featured in *Women of Our Time* both reflected and enacted one of America's most important twentieth-century stories—the shifting role of women and their ever-enlarging significance in all branches of endeavor.

When the twentieth century began, most American women did not have the right to vote, much less hold public office, and the chances of winning the franchise any time soon seemed quite remote. In 1901 the expectations for most women were limited in a host of other ways as well. To marry a good provider and look after his household and children was just about all most conventional middle-class women dared hope for. Though a college education had been an option for American women for some time now, precious few of them went beyond high school. And if a woman had to work outside the home or simply chose to do so, the options, generally speaking, were on the sparse and none-too-lucrative side. Maids were always in demand, of course, and it was possible to get various types of factory work deemed suitable for a woman. For the better-educated woman, a career in teaching was an option. But heaven help the woman who might aspire to becoming a doctor, a lawyer, an engineer, a journalist, or a business executive. Though not altogether impossible to achieve such career goals, any woman setting her sights on them in 1900 would have to understand that the profession she had chosen was difficult to attain at best and if she was not endowed with an uncommon supply of fortitude, probably impossible.

By the close of the twentieth century, however, so much of that had changed. Not only could women vote, but no one was batting an eye when one of them won election to an alderman's seat, a state governorship, or the United States Senate. With two women sitting on the Supreme Court, a woman occupant in the Oval Office seemed only a matter of time. As for education and career options, while American women perhaps still had grounds for complaint of being held back in some areas, the choices were, by and large, as expansive as they were for males. From the armed forces and space exploration to corporate management, stock brokering, and law enforcement, the presence of a woman had largely ceased to be a novelty worthy of notice.

It is fair to say that virtually all the individuals included in this book were in one degree or another affected by this transformation as it played itself out around them. Doubtless the opportunities for their distinctions were shaped in part by the twentieth century's increasingly open-ended environment for feminine achievement. But maybe a

FRANCES PERKINS 1880–1965
By Clara E. Sipprell (1885–1975)
Gelatin silver print
25.2 × 20.3 cm (9 15/16 × 8 in.), 1952

more significant point to be made is that so many of these women were themselves significant instruments in creating and fostering that environment. On the political front, there are, for example, Jeannette Rankin, whose election to the House of Representatives in 1916 marked the beginning of a female presence in Congress, and Secretary of Labor Frances Perkins, whose long tenure in Franklin Roosevelt's cabinet accustomed the nation to seeing a woman as a high-level presidential adviser. In the realm of ideas and activism that had direct impact in enlarging the definition of women's potential, there are birth control advocate Margaret Sanger, who helped to transform childbearing from being a woman's inevitable lot to a matter of personal choice; journalist-editor Gloria Steinem, who ranked among the leading figures in the feminist movement of the late 1960s and 1970s; and anthropologist Margaret Mead, some of whose research yielded evidence that the roles of males and females—once widely believed to be biologically preordained—might in large part be the result of environmental conditioning [fig. 1]. And in the world of corporate enterprise, there are cosmetics entrepreneur Helena Rubinstein, whose skill in driving a bargain clearly gave lie to the notion that women had no head for business, and Katharine Graham, who surprised even herself with her stellar success as the first female chief executive officer of a Fortune 500 company.

This book, however, is as much about the art of photographic portraiture as it is about female achievements. Among the images featured in it are works by such distinguished photographers of the twentieth century as Adolph de Meyer, Edward Steichen, Louise Dahl-Wolfe, Philippe Halsman, Irving Penn, Lotte Jacobi, Arnold Newman, and Lisette Model [figs. 2 and 3]. But perhaps more noteworthy is the diversity in approach to

1 Lotte Jacobi's self-portrait has a staged quality that stands in sharp contrast to the understated naturalism of her likeness of anthropologist Margaret Mead.

Lotte Jacobi (1896–1990), self-portrait, gelatin silver print, 1936 (circa 1950 print). National Portrait Gallery, Smithsonian Institution

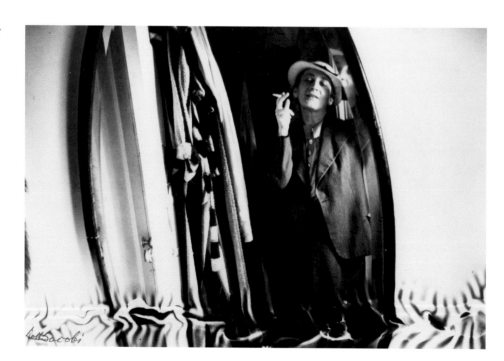

3 Photographer Lisette Model's interest in jazz and modern dance led her to make likenesses of singer Ella Fitzgerald and dancer Pearl Primus.

Todd Webb (1905–2000), gelatin silver print, 1948. National Portrait Gallery, Smithsonian Institution

2 The maker of Katharine Cornell's likeness, fashion photographer Louise Dahl-Wolfe, contemplates one of her pictures in a *Harper's Bazaar* cover layout.

Hans L. Jorgensen (born 1915), gelatin silver print, 1941.
National Portrait Gallery, Smithsonian Institution

portraiture that is to be found in this selection of likenesses. Thus, while the images of Indian reformer Gertrude Bonnin by Joseph Keiley and dancer Isadora Duncan by Arnold Genthe epitomize the soft-focus pictorialism that held wide sway early in the century, a number of likenesses—including Ruth Orkin's shot of actress Julie Harris negotiating an awkward sip of coffee at an opening night party—belong to a journalistic brand of portraiture that places a high premium on in-situ candor. Yet other pictures owe their inspiration to an unapologetically theatrical style of photography—Steichen's Katharine Hepburn [fig. 4] and Nickolas Muray's Anna May Wong, for example—that reached its most obvious flowering in the Hollywood publicity glamour still. In sharp contrast to that artificiality is the unadorned, almost naive simplicity of Ida Berman's photograph of civil rights activist Rosa Parks and the indifferent casualness of Fred Stein's likeness of political thinker and historian Hannah Arendt.

In one degree or another, photographic portraits are biographical documents.

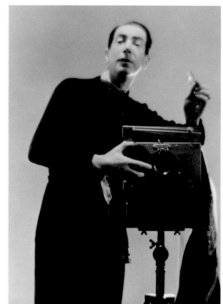

4 Edward Steichen's likeness of himself bespeaks his abiding interest in creating pattern in his portrait photography, which is also evident in his picture of Olympic swimmers Eleanor Holm and Helene Madison.

Edward Steichen (1879–1973), self-portrait, gelatin silver print, 1929. National Portrait Gallery, Smithsonian Institution; acquired in memory of Agnes and Eugene Meyer through the generosity of Katharine Graham and the New York Community Trust, The Island Fund

5 Adolph de Meyer created the soft-focus image of silent-screen star Mary Pickford.

Adolph de Meyer (1868–1946), self-portrait, gelatin silver print, circa 1920. National Portrait Gallery, Smithsonian Institution

As such, they perform their most basic function by telling us what a person looks like. But often they go beyond mere physical inventory to enlarge or reinforce our more qualitative understandings about the individual we are confronting. A prime case in point to be found in these pages is Adolph de Meyer's photograph of silent-screen actress Mary Pickford, which so fully captures the sense of innocent vulnerability that was for so much of her career the main source of her box office appeal [fig. 5]. Yet two other good examples are Arnold Newman's likeness of cosmetics entrepreneur Helena Rubinstein [fig. 6], which evokes so persuasively her hard-driving and at times tempestuous nature, and Vivian Cherry's picture of Dorothy Day, which speaks volumes about the stoic dedication of this intensely religious Catholic reformer. Finally, there is Linda McCartney's picture of singer Janis Joplin in performance, taken just as she was emerging as a major pop music star. Looking at Joplin's intensely contorted image, one can almost feel firsthand the impact of her shrill, high-voltage rasping style on audiences.

Among the most biographically compelling of the likenesses in *Women of Our Time*, for this writer at least, are those that belong to an especially significant moment in the subject's career. The image of Amelia Earhart by an unidentified photographer, for example, amply records the clean-scrubbed, tomboyish allure that so enhanced her celebrity as America's most celebrated female aviator. More significant, however, it records Earhart serenely looking out from the nose of the yet-to-be-completed plane that was being made for her flight around the world, a venture that was destined to end tragically with her death somewhere in the Pacific. Then there is Harry Warnecke's smiling photograph of the Hollywood child star Shirley Temple. Temple was ten in the picture and enjoying an incredible popularity. But the image does not stop at depicting the dimpled charm undergirding that

popularity; it also hints at an incipient maturity that would increasingly erode Temple's effectiveness in the precocious little-girl roles that had made her famous.

Yet another image imbued with more than the usual biographical salience is the picture snapped by Navy medic David Geary in Korea in the winter of 1954. The subject is Marilyn Monroe as she entertained American soldiers in Korea, and perhaps it should be titled *Marilyn's Epiphany*. Filled with fears and insecurities she would never entirely overcome, Monroe was amazed at the overwhelming enthusiasm her performances generated, and it was that enthusiasm she later said which convinced her at last of what had been clear to others for some time—that she was truly a star of the first magnitude. And finally, there is Bob Willoughby's picture of Judy Garland on the set of *A Star Is Born*. The picture is a memento of one of Garland's finest film performances in the making, but there is a dark, brooding edge to it that bespeaks the personal turmoil that plagued this gifted woman's career to the end and made even many of her triumphs a source of unhappiness.

In closing, something should perhaps be said about the selection of the individuals picked for this book. Readers might wonder why some women of obvious importance are not included here. In large degree the answer lies in the fact that the National Portrait Gallery's photography collection was only established in 1976. Since then, the collection has had impressive growth and now contains many substantial treasures in American portrait photography, including a good many of the images reproduced here. But in terms of building a comprehensive collection, a quarter century is not a long time. We can only hope that in the coming years the museum's photographic holdings will become richer yet and that future acquisitions will encompass a plenitude of likenesses that will further enrich the Gallery's capacity to tell the story of women in the twentieth century—and, for that matter, the twenty-first as well.

6 Arnold Newman typically shoots his likenesses of such personalities as strip artist Gypsy Rose Lee and cosmetics entrepreneur Helena Rubinstein against backgrounds evocative of their character and occupations.

Arnold Newman (born 1918), self-portrait, gelatin silver print, 1987. National Portrait Gallery, Smithsonian Institution; gift of Arnold Newman

WOMEN OF OUR TIME

GERTRUDE SIMMONS BONNIN (ZITKALA-ŠA)

1876–1938

NATIVE AMERICAN REFORMER, WRITER

JOSEPH T. KEILEY (1869–1914)

Photogravure

15.9 × 9.5 cm (6 1/4 × 3 3/4 in.)

1901, from 1898 negative

The daughter of a Sioux mother and a white father, Gertrude Simmons Bonnin spent her early childhood on the Yankton Reservation in what is now South Dakota. At age eight, she left the reservation to embark on an education that included attending a Quaker-run school in Indiana and a normal training school for Indians in Nebraska. In 1895 she embarked on two years of study at Earlham College, where she studied music and distinguished herself as an orator. Throughout her student years, Bonnin demonstrated great potential and many talents. But it always nagged at her that these educational opportunities were uprooting her from her Native American culture and calling on her to assimilate into a white society where neither she nor other Native Americans were especially welcome. That thought festered even more when Bonnin became a teacher at the Carlisle Indian School in Pennsylvania, where assimilation of the students was a primary goal. In an article about her Carlisle experience for the *Atlantic* in 1900, she likened her situation to a young uprooted tree. "I made no friends among the race I loathed," she wrote. "I was shorn of my branches, which had waved in sympathy and love for home and friends. The natural coat of bark which had protected my oversensitive nature was scraped off to the very quick."

Among her first efforts to deal with this sense of rootlessness was the compilation of some of the Native American lore that she had heard as child, entitled *Old Indian Legends* and published in 1901 under her Indian name Zitkala-Ša. She also created *The Sun Dance*, an opera about Indians that was first performed in 1913. Bonnin, however, found the ultimate resolution of her identity crisis in a reforming activism dedicated to advancing American Indian rights and interests. An early supporter of the Society of American Indians, founded in 1911, she became its secretary in 1916 and soon emerged as one of the most effective spokespersons in its drive to promote Indian welfare. Among her greatest accomplishments was her coauthorship, in the 1920s, of *Oklahoma's Poor Rich Indians*, which exposed the multiple strategies used to swindle Indians out of revenues from oil discovered on their land. In 1926 she founded the National Council of American Indians, which became a leading force in the effort to correct many of the injustices promulgated by the government's Indian policies. Of her readiness to challenge the federal establishment, she once said, "I fear no man—sometimes I think I do not even fear God."

This image was made in 1898 while Bonnin was teaching at the Carlisle Indian School, and its solemn wistfulness may reflect the unhappiness engendered by an environment that forced her to straddle two cultures. The photographer was Joseph T. Keiley, a practicing lawyer whose real passion was the camera. A close associate of Alfred Stieglitz, he was part of Stieglitz's Photo Secession movement, formed in the early 1900s to promote recognition of photography as a legitimate art form. Keiley also worked with Stieglitz to devise a method for developing platinum prints using glycerin.

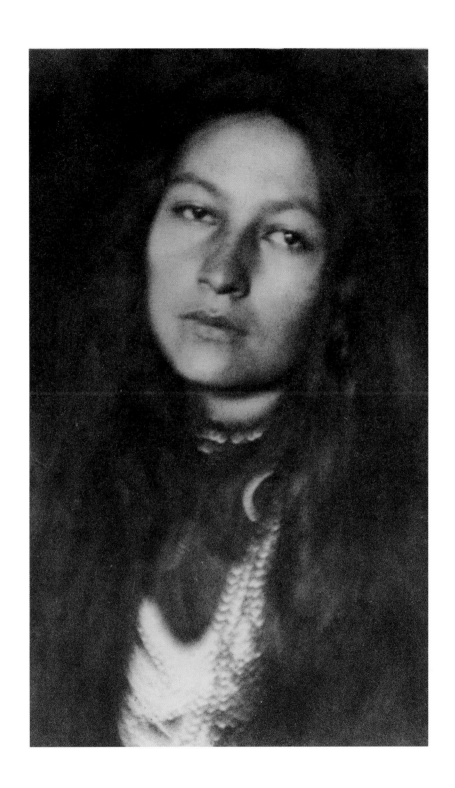

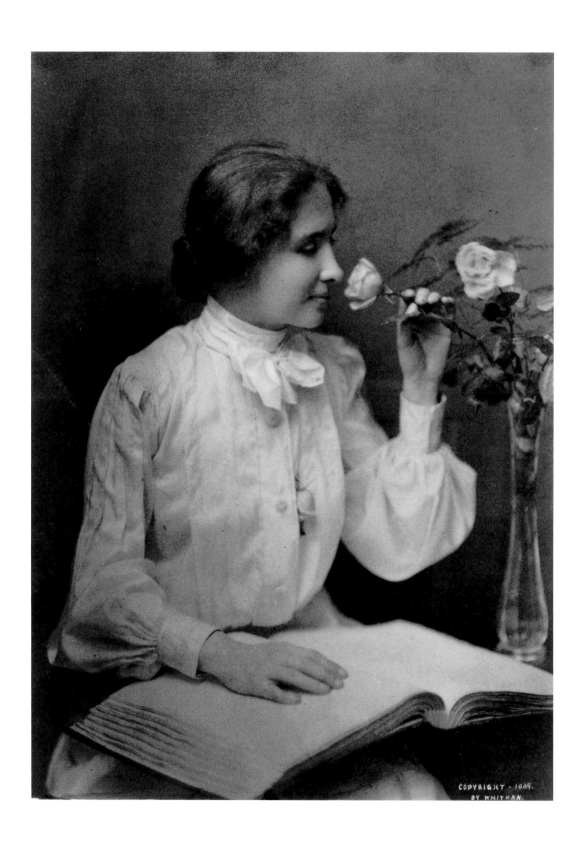

COPYRIGHT · 1904.
BY WHITMAN.

Helen Keller was born a normal, healthy child. But an illness that struck her at nineteen months left her deaf and blind, and her parents, having no idea of how to handle this dual disability, found themselves unable to cope with her needs. As a result, their strong-willed young daughter was left essentially undisciplined and reliant on her own devices, and over the next several years she grew into a wildly obstreperous child, largely unconnected to the world around her. That situation suddenly began to change in March 1887, when Anne Sullivan arrived at Keller's home in Tuscumbia, Alabama, to become her governess. Once blind herself, this recent graduate of the Perkins Institution for the Blind succeeded where all others had failed. She penetrated Keller's soundless, dark world, and within a few months, through the manual alphabet, Keller could finally connect to the world around her. By summer she was writing her first letter, to her mother.

Ultimately this dramatic transformation would become the inspiration for the Broadway play *The Miracle Worker*. Keller's remarkable progress, however, did not stop there. Under Sullivan's tutelage, she took on ever-greater learning challenges. In 1900 she entered Radcliffe College and graduated four years later cum laude. In the meantime, she had also written a best-selling autobiography and become for many a living embodiment of the human spirit's indomitability against adversity.

In the years following, Keller devoted much of her time to writing and lecturing, but she did not embark on the most significant phase of her career until 1924, when she became the official spokesperson for the newly formed American Foundation for the Blind. Her well-established celebrity opened many doors to her, and her efforts to promote the foundation's interests were of immense value. Among her most concrete triumphs was her successful lobbying in the 1930s for a congressional act to fund reading services for the blind and for the inclusion in the Social Security Act of a clause making the blind eligible for grant assistance.

Doubtless the quality that most inspired the admiration felt for Keller around the world was her relentless unwillingness to let her disabilities give rise to self-pity. "Our worst foes are not belligerent circumstances," she observed in *The Story of My Life*, "but wavering spirits…. The field in which I may work is narrow, but it stretches before me limitless. I am like the philosopher whose garden was small but reached up to the stars."

This image of Keller appeared as the frontispiece for her article in *Century* magazine in January 1905. Entitled "A Chat about the Hand," the piece focused on how Keller used her sense of touch to understand and communicate with her world. "Paradise," she declared in the first paragraph, "is attained by touch; for in touch is all love and intelligence." Underscoring that sentiment is the book written in braille on Keller's lap. Its comprehensibility, of course, depended entirely on touch.

HELEN KELLER
1880–1968
HUMANITARIAN

CHARLES WHITMAN
(active 1890s–1900s)
Toned platinum print
22.6 × 16.9 cm (8 15/16 × 6 11/16 in.), 1904

FRANCES BENJAMIN JOHNSTON

1864–1952
PHOTOGRAPHER

Attributed to GERTRUDE KÄSEBIER
(1852–1934)
Platinum print
22.2 × 15.7 cm (8 3/4 × 6 3/16 in.), 1905

Contrary to the prevailing social expectations for women in late-nineteenth-century America, Frances Benjamin Johnston did not particularly want the life of a wife and mother. Instead, she wanted to become an artist, and in 1884 she set out for Paris to study painting and drawing at the Académie Julian. After a year abroad, she returned to the United States to continue her training at the Art Students League in Washington, D.C., and it was there that her aspirations began to change slightly. Now she wanted to combine a longstanding interest in writing with her artistic bent to pursue a career as a journalist and illustrator of her own work. But her professional ambitions changed yet again when she discovered the reportorial potential of the camera. Following a brief apprenticeship with a commercial photographer and some training from Thomas Smillie, who headed the Smithsonian Institution's photography division, she determined to become America's first woman photojournalist.

Johnston published her first photographs—pictures of the United States Mint—in *Demorest's Family Magazine* in late 1889, and in the early 1890s she turned her camera on life and work in the Pennsylvania coal regions. While there, she found herself having to devise a safe way to use flash powder in photographing the highly combustible interiors of mines. The result was an impressive series of pictures that firmly established Johnston as a capable photojournalist. Other assignments included a series on shoe manufacturing in Lynn, Massachusetts, and another on student life and classroom activities at Hampton Institute, a Virginia school for black students. The latter—along with her photographs of public education in Washington, D.C.—earned her a gold medal at the Paris Exposition of 1900.

Based in Washington, Johnston enjoyed easy entrée into White House circles, so much so that she was dubbed "photographer of the American court." She also did considerable business as a portrait photographer and counted among her subjects such figures as Susan B. Anthony, Mark Twain, Andrew Carnegie, and Booker T. Washington. In later years, she turned to architectural photography. Among her most lasting achievements was the pictorial record that she made in the 1930s of the early American architecture of nine southern states.

Although Johnston conceded that photography was largely a mechanical process, she also numbered among those at the turn of the century who were beginning to espouse it as an expressive art form. "In portraiture, especially," she once observed, "there are so many possibilities for picturesque effects … that one should go for inspiration to … Rembrandt, Van Dyck, Sir Joshua Reynolds, Romney and Gainsborough, rather than to compilers of chemical formulae."

The evidence is persuasive that this likeness of Johnston was taken in Venice in the summer of 1905 and that it was probably the work of her traveling companion Gertrude Käsebier, who had built a substantial reputation as a portrait photographer. The two women enjoyed their stay in Venice immensely, largely owing to a third photographer, Baron Adolph de Meyer, who gave them free use of his darkroom in his palatial home on the Grand Canal. With encouragement such as that, the stay became a veritable busman's holiday for both of them.

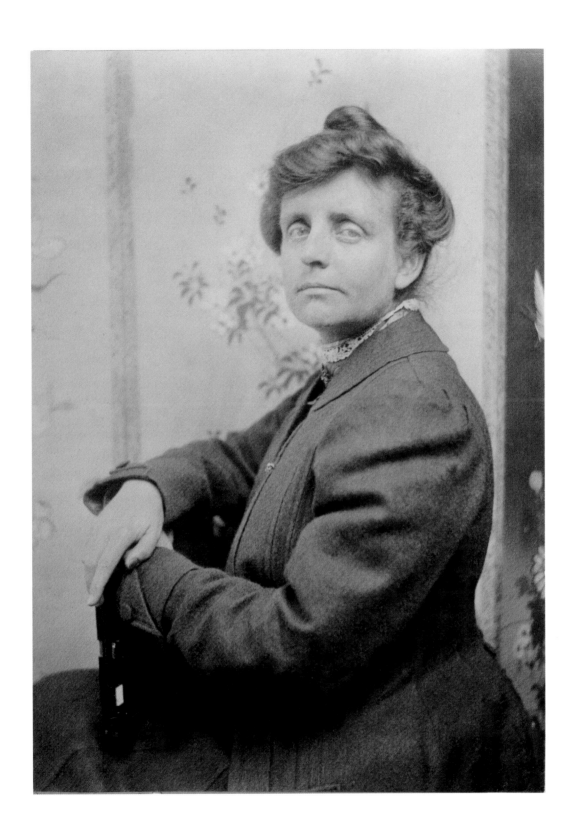

ISADORA DUNCAN

1878–1927

DANCER

ARNOLD GENTHE (1869–1942)
Gelatin silver print
28 × 35.3 cm (11 × 13 7/8 in.), circa 1916

Isadora Duncan grew up in a freewheeling bohemian atmosphere where she was left essentially to her own devices. In such a directionless environment, many youngsters would have felt lost, but she thrived in it. By age ten, Duncan not only knew that she wanted to be a dancer; she was already establishing herself as a dance teacher to other children. Moreover, she had begun to evolve her own definitions of dance, which rejected the rules and restrictions of classical ballet to embrace improvisation and self-expression of feeling and emotion.

In her late teens, Duncan began her performing career in earnest as a dancer-actress in a New York theatrical company. But she ultimately did not like the work, and after leaving the company, she started giving solo performances premised on her own expressionistic concept of dance. Appreciation for her innovations was scant in this country. Europe, however, was another story, and by the early 1900s she was building a substantial following there. No less than the famed French sculptor Auguste Rodin, in fact, said that he sometimes thought that Duncan must be the greatest woman that the world had ever known. Warmly received from Paris to Budapest, she may have created her greatest sensation in Berlin, where following her performances, wildly enthusiastic students drew her carriage through the streets to her hotel several nights in succession. On her return to the United States for a tour in 1908, audiences were still somewhat hesitant to accept her. Nevertheless, there were many admirers. "More like a spirit than a woman," a Philadelphia critic effused, "more like a vision than reality—faint, lovely appealing as a flower, Isadora Duncan, at the Academy of Music last night, stepped out of a fold of the heavy curtain and became immediately an embodiment of joy, the lightsome wraith of the veritable spirit of the melody." At one performance in New York, it was reported that "the applause became more and more hearty" as her program progressed, and the bravos did not stop until she had given three encores and a short speech.

Duncan made many attempts to establish schools of dance over the course of her career, the last one in the newly formed Soviet Union in 1921. The schools never lasted long, and her efforts at teaching had at best a negligible influence on the direction of dance. But the same cannot be said of her performances. Today Duncan is considered to be one of the primary founders of what has come to be known as modern dance.

Part of a series of pictures that Arnold Genthe took of Duncan in 1915–1918, this image shows Duncan in the loosely draped tunic costume—patterned on the garb seen on ancient Greek vases—that she often wore on stage. Genthe was a great friend of Duncan, and in his memoirs he described her talent as "the flame of genius driving its way through the narrow conventions of the classical ballet." "Her body was not beautiful," he added. "But when she danced the nobility of her gestures could make it into something of superb perfection and divine loveliness."

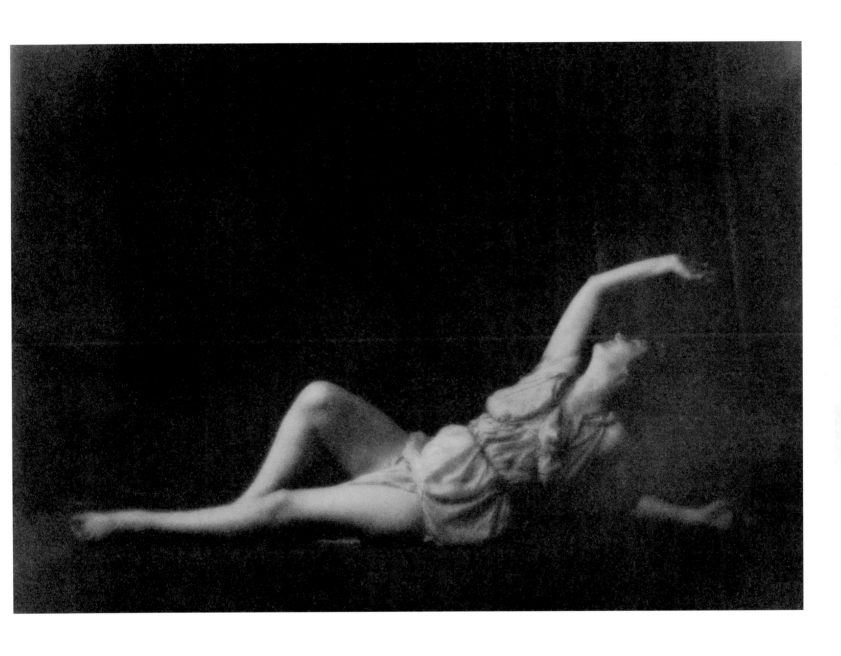

MARGARET SANGER

1879–1966
REFORMER

IRA HILL (active 1900s–1920s)
Gelatin silver print
24 × 18.8 cm (9 7/16 × 7 3/8 in.), 1917
Gift of Margaret Sanger Lampe and
Nancy Sanger Pallesen, granddaughters
of Margaret Sanger

Margaret Sanger's first experience as a reforming activist came in 1912, when she encountered the radical labor organizer "Big Bill" Haywood in the bohemian reform circles of New York and began participating in worker strikes precipitated by his union, the Industrial Workers of the World. As a maternity nurse working on New York City's Lower East Side, however, she was at the same time discovering a social ill that she ultimately found far more compelling than working conditions and hourly wages. In her rounds, she kept encountering women whose health had been devastated by excessive childbearing or desperate attempts at self-induced abortions. Beginning with that experience, she gradually defined over the next several years what her mission in life would be. By early 1914, she was publishing a feminist magazine called the *Woman Rebel*, a chief focus of which was the advocacy of birth control and the accessibility of information on ways to prevent pregnancy.

In an age that deemed the open discussion of such matters indecent, the journal did not last long. By year's end, Sanger was leaving for Europe rather than stand trial on charges of using the postal service to disseminate obscenities. A forced exile, however, could not deter her from her course now. In 1916 she returned to the United States to found a birth control clinic in Brooklyn. But once again the law frowned on her enterprise. Within ten days, the clinic was shut down, and Sanger again faced charges of illegal activity. This time, she stood trial and eventually served thirty days in prison.

The prospects for her cause were, nevertheless, not as bleak as they seemed. By the early 1920s, Sanger's preachments were winning respectability. In 1921 she organized the first national conference on birth control. Two years later, she was opening the Clinical Research Bureau in New York City, which became the first such facility in the United States to offer contraceptive advice, unhampered by fears of being closed down. Clearly, Sanger and her growing legions of followers were making progress. Over the next fifteen years, some three hundred birth control clinics were established across the country.

Doubtless Sanger's most important trait in charting the path to these successes was her single-minded dedication. When someone urged her to take a break from her cause to indulge in a little amusement, she replied, "I am the protagonist of women who have nothing to laugh about."

Yet another personal trait that advanced her cause is evidenced in this picture. Taken shortly after her thirty-day imprisonment early in 1917, the image suggests a woman who is benignly genteel and feminine. That unmenacing exterior often won her a sympathetic hearing in many quarters where a more militant demeanor might not have. Still, she could be fiercely combative. A case in point was her response to the police attempt to take her fingerprints just hours before she was to leave prison. Adamantly unwilling to submit to the process, she emerged from the hour-and-more struggle "bruised and exhausted" but nevertheless triumphant.

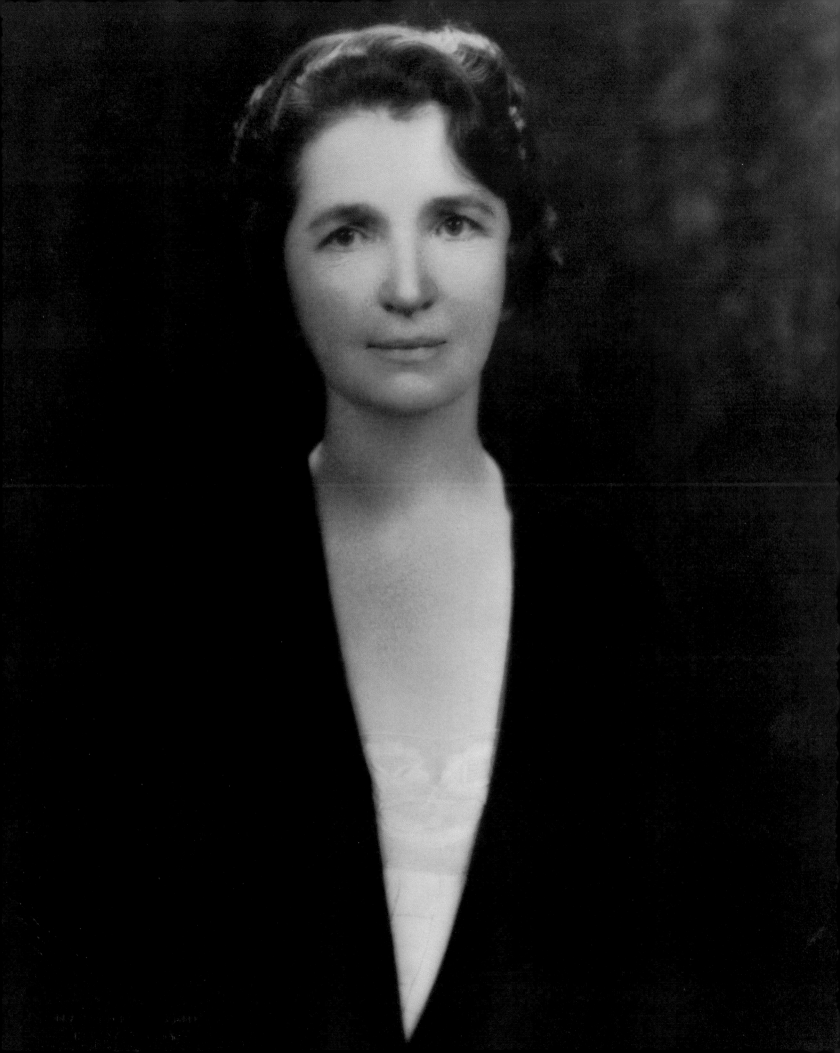

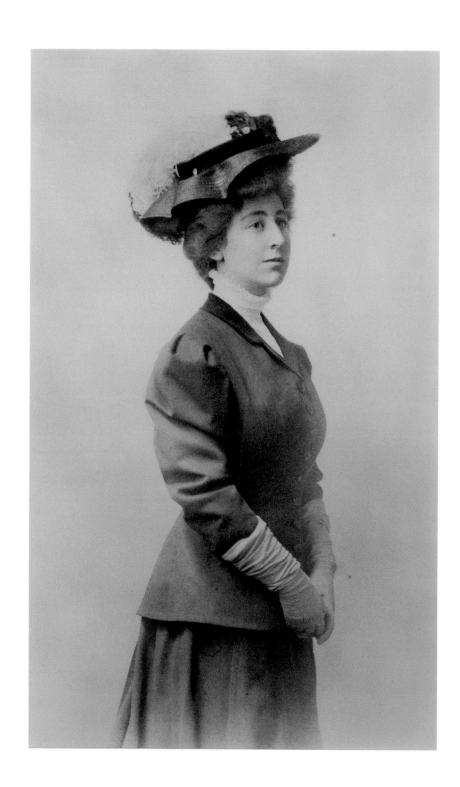

Coming from a family where achievement for daughters as well as sons was much encouraged, Jeannette Rankin rose rapidly in the woman suffrage movement after joining its ranks in 1910. Within a year she was lobbying the legislature of her native Montana to grant women the vote, and in 1913, after participating in a number of other state suffrage campaigns, she became a field secretary for the National American Woman Suffrage Association. Charged with promoting the suffrage cause in fifteen states, she had her most noteworthy success in Montana, where her campaign led to the enfranchisement of women in 1914.

That triumph only whetted Rankin's ambition to break through yet another barrier. By now a well-seasoned political strategist, she set her sights on becoming the first woman ever to serve in the United States Congress. But when she turned to her suffrage movement allies in Montana for encouragement, she got a disappointing reception. While some actually laughed at the notion, others gently suggested that she might be wiser to seek a lesser elective office. But Rankin was not listening. In July 1916, she announced her candidacy, and in the following month, she emerged from Montana's Republican primary as a GOP candidate for Congress. In the final November election, Rankin carried sixty-nine out of seventy-four counties to defeat her Democratic opponent by a generous margin.

Rankin's victory made her into an overnight celebrity. Requests for her photograph poured in; *Literary Digest* proclaimed her "The Girl of the Golden West"; and a car business sought to use her in its advertising. But most of all, she was the darling of the suffrage movement. When Rankin arrived in Washington to take her seat in Congress in early April 1917, the nation's suffrage leaders feted her at a breakfast where one of the speakers declared, "Now that we have a pull in Congress, there is no telling what we will accomplish."

Unfortunately, Rankin's rising star was about to plummet. On April 2, President Woodrow Wilson asked Congress to endorse America's entry into World War I. This would be the first congressional action on which Rankin would have to take a stand, and her political survival, most of her advisers believed, depended on her casting a vote in favor of war. To do otherwise, they said, risked being dismissed as a stereotypical female sentimentalist unable to face the world's harsh realities. Rankin knew they were right. Still, she could not reconcile herself to war, and when she rose to vote on April 6, she declared: "I want to stand by my country, but I cannot vote for war. I vote no."

In doing so, the first woman elected to Congress suddenly lost her allure in many quarters and ultimately foiled her chance for reelection. There remained, however, yet one more chapter in Rankin's congressional career. An unrelenting pacifist for the rest of her life, she won election to Congress again in 1940 and was present in the House in December 1941 to cast the single negative vote against America's entry into World War II following the Japanese attack on Pearl Harbor.

JEANNETTE RANKIN
1880–1973
SOCIAL ACTIVIST

L. CHASE (active 1910s)
Gelatin silver print
17.2 × 11 cm (6 3/4 × 4 3/8 in.), circa 1917
Gift of Margaret Sterling Brooke

LOUISE BRYANT

1885–1936

JOURNALIST

ALFRED COHN (1897–1972)
Gelatin silver print
16.8 × 10.2 cm (6 5/8 × 4 3/4 in.), 1918

Some historical personalities are remembered less for what they may have done than for the people with whom they associated. Louise Bryant was one of those individuals. Possessing an uncommon beauty and a taste for the unconventional life, she formed her most noteworthy association during the summer of 1914, when the socialist radical journalist John Reed came to Portland, Oregon, to visit his family. Bryant was married to a local dentist, and it seemed to be a happy union. She and Reed, however, were drawn to each other from the outset. Of his attraction to Bryant, Reed wrote, "I think she's the first person I ever loved without reservation." And Bryant was no less enamored of him. On December 31, 1915, she boarded an eastbound train to begin a new life with Reed in New York City's bohemian Greenwich Village.

Bryant fit easily into this community where so many social rules did not apply, and she readily accepted an open relationship with Reed that permitted both of them to pursue affairs with others. Thus, although her attachment to Reed remained steadfast and led to marriage in late 1916, Bryant nevertheless had affairs with other men, including playwright Eugene O'Neill.

Following her graduation from college, Bryant had worked as a journalist, and she worked at that profession sporadically after settling down with Reed in New York. In August 1917, she and Reed set out on what was to be the great journalistic adventure of both their careers—the coverage of the Russian Revolution. They arrived in time to observe the demise of the revolution's original provisional socialist government and the triumph of the Bolsheviks, led by the Marxian ideologues Vladimir Ilyich Lenin and Leon Trotsky.

As witnesses to the landmark shift in leadership, neither Reed nor Bryant were unbiased. An ardent believer in the socialist order, Reed characterized the ascendance of the Bolsheviks as the creation of "a kingdom more bright than any heaven had to offer." Bryant shared that perspective and, as a longtime feminist, was especially entranced with how Russia's Bolshevik order promised greater equality for women. Their obvious sympathies, however, did not prevent them from performing journalistic tasks, and of the early accounts of the Bolshevik takeover, none was more widely admired for its accuracy than Reed's *Ten Days That Shook the World*. But Bryant also made a significant contribution to the revolution's bibliography of firsthand accounts with her *Six Red Months in Russia*. Enriched by interviews with figures such as Lenin and Aleksandr Kerensky, her book was a good complement to Reed's. While his *Ten Days* offered a broad picture of the revolution's train of events, Bryant's *Six Red Months* revealed the human texture of those events. As one reviewer put it, she seemed to see the revolution "from the eyes of the people themselves."

It is thought that this photograph dates from late 1918, about the time that *Six Red Months* was published. Bryant was much in demand on the lecture circuit, despite America's mounting anxieties over Bolshevism and a distrust of anyone sympathetic to its ideals. In another two years, her life with Reed would end with Reed's death from typhus in the Soviet Union.

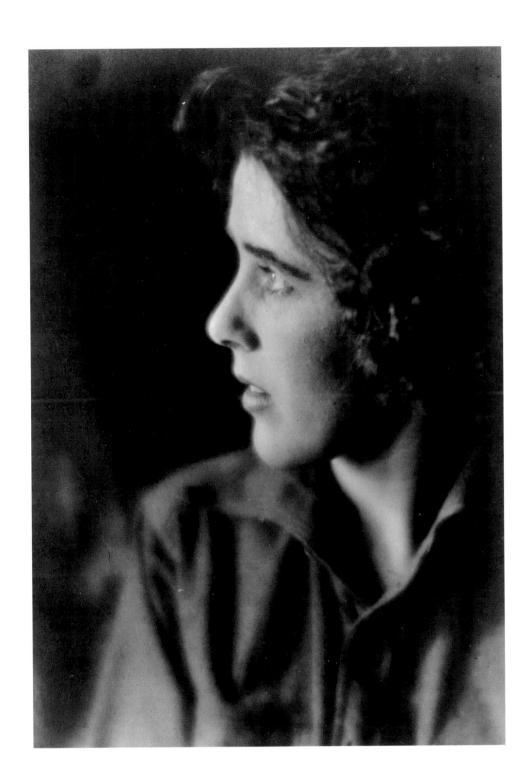

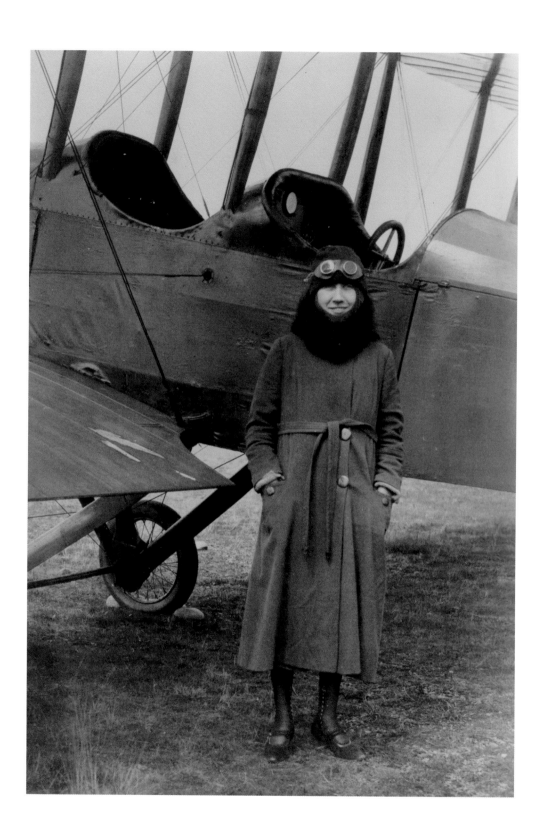

Katherine Stinson wanted to be a piano teacher in her youth, and when she learned that pilots could earn as much as a thousand dollars in a single day introducing people to the novelty of flying in an airplane, she decided that the best way to finance her music education was to become one of those pilots. To pay for the flying lessons, she sold her piano, but in the end that did not matter. By the time she flew her first solo and received her pilot's license from the Fédération Aéronautique Internationale in July 1912, the satisfactions of the piano had receded far into the background. Aviation was her passion now, and it apparently did not phase her a jot that of the three other American women who had so far been granted an FAI license, two had just recently died in an air crash. Known as the "Flying Schoolgirl," the petite Stinson was soon doing flying exhibitions, and in September 1913, while performing at the Montana State Fair, she operated a mail shuttle service between the fairgrounds and Helena under U.S. Post Office auspices, thus claiming the distinction of being the first female airmail pilot.

Some said that Stinson was also the first woman pilot to "loop the loop," but more noteworthy was the new twist she gave to that feat in 1915. She christened this maneuver the "dippy twist loop," which required rolling her plane wing over wing at the top of each loop. By late the following year, her fame took on an international flavor when she toured Asia with her plane. In Japan, where the women's realm was tightly constricted, her sex made her air exploits all the more fascinating. "The women were wild with excitement and the men were not far behind," she reported, and in some cities, her visits inspired the formation of Stinson clubs.

Following America's entry into World War I, Stinson volunteered her services to the Red Cross and ended up making a flying fundraising tour that generated some two million dollars. In late 1917 she flew 610 miles nonstop from San Diego to San Francisco in just over nine hours, setting new aviation benchmarks for both distance and time in the air. The previous distance record of 510 miles that she broke had been held by another woman, Ruth Law, and Stinson quipped afterward that Law was doubtless much relieved that it had been a woman who had bested her. Unfortunately, by 1920 her flying days had ended owing to tuberculosis, and among the pledges she made upon her marriage to World War I army aviator Miguel Otero in 1928 was a mutual promise never to pilot a plane again.

In her zest for flying, Stinson clearly departed from the feminine norms of her day, but some might say that, in one sense at least, namely the meticulous care she took in cleaning and maintaining her planes, she betrayed the stereotypical female instinct for tidiness. In truth, that concern had more to do with survival instincts. As she put it, "It's all right if your automobile goes wrong while you are driving it. You can get out … and tinker with it. But if your airplane breaks down, you can't sit on a convenient cloud and tinker with *that*!"

KATHERINE STINSON
1891–1977
AVIATOR

By an unidentified photographer
Gelatin silver print
24.7 × 17.1 cm (9 11/16 × 6 3/4 in.), circa 1919

MARY PICKFORD

1893–1979
ACTRESS

ADOLPH DE MEYER (1868–1946)
Gelatin silver print
23.2 × 18.2 cm (9 1/8 × 7 3/16 in.), 1920

In 1909 the young stage actress Mary Pickford needed a job to help support her family. She had just finished a run on Broadway in David Belasco's production of *The Warrens of Virginia*, but despite her considerable theatrical experience, her job prospects on the New York stage had stalled. So, at the urging of her mother, she did what few self-respecting stage actresses cared to do in those days. She paid a visit to Biograph Studios, a movie-making enterprise owned by D. W. Griffith, to inquire about openings. The never-too-tactful Griffith took a look at the diminutive seventeen-year-old and said, "You're too little and too fat." But, he added, "I may give you a chance." So began the ascent of the silent film industry's first major star.

Pickford possessed a magnetic screen presence from the outset. She also demonstrated an ability to play a variety of character types, including prostitutes. But it was her portrayal of the demurely frail but spunky young innocent in one melodrama after another that most endeared her to audiences and transformed her into "America's Sweetheart." And with that persona came considerable fortune. Beginning at Griffiths's studio at a salary of ten dollars a day, Pickford was commanding five hundred dollars a week by 1914. In another year that figure had doubled, and by 1916 she was earning ten thousand dollars a week. But as exorbitant as that salary might have seemed, it was perhaps not enough. "Any picture in which [Mary Pickford] appears," declared one observer, "the fact that she appears in it makes it a good picture."

Interestingly enough, behind the vulnerable feminine allure that made Pickford so good for the box office was a good mind for business, and along with being the early American film industry's greatest female star, she may also have been its most astute businesswoman. By 1918 she had established her own movie company, which increased her earnings on her films and gave her complete artistic control. A year later, with Charlie Chaplin, D. W. Griffith, and her soon-to-be husband Douglas Fairbanks, she became a cofounder of United Artists, a film distribution enterprise that would reap substantial profits.

This picture dates from Pickford's marriage to fellow screen star Douglas Fairbanks—a union that raised them both to a new level of celebrity as Hollywood's reigning royal couple. Taken by the noted fashion photographer Adolph de Meyer, the portrait shows Pickford in her wedding dress designed by the American couturier Herman Tappé. Originally made for an extremely petite model who wore it for a bridal spread in *Vogue*'s January 1920 issue, the elaborate gown was too small to have much chance of ever finding a real bride wealthy enough to afford it and small enough to fit into it. One of the few women who met both those criteria was Pickford, who, in addition to wearing the dress at her wedding, allowed de Meyer to photograph her in it for publication in *Vogue*'s February 1920 issue. Running with the picture was the magazine's observation that "though she looks almost helplessly feminine, she makes every year a tremendous fortune."

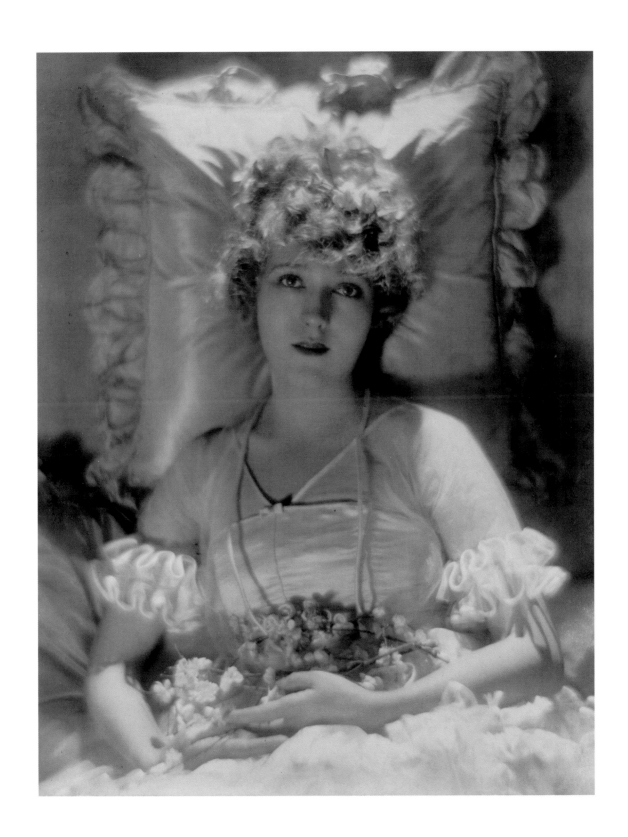

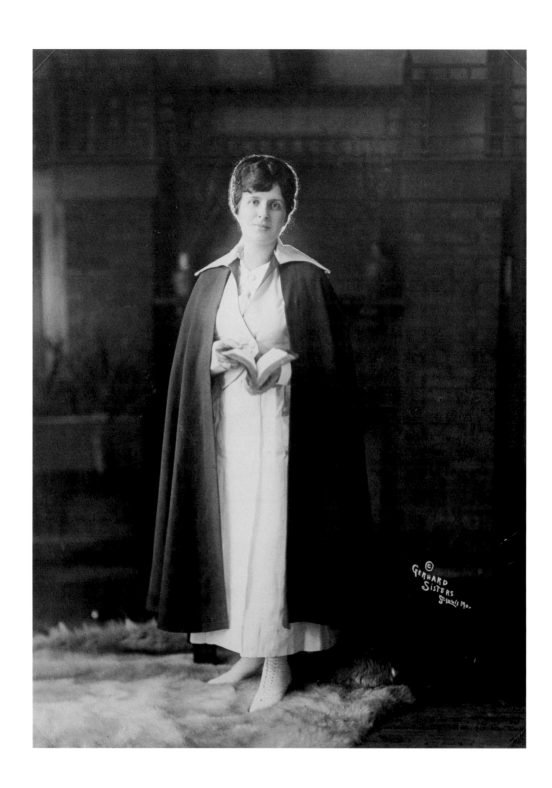

t Aimee Semple McPherson's birth in 1890, her mother was determined that her newborn daughter should dedicate herself to the work of God. But in committing young Aimee to that course, she certainly had no inkling of just what that would ultimately mean for both her daughter and American evangelical religion. McPherson had the flair and magnetism of a natural performer, and when she set out to become an evangelist, her uncommon talent for stirring religious fervor was profound. By 1916 she was traveling the eastern seaboard from Maine to Florida, and as her reputation grew and stories of her faith healings spread, her field of operations became more ambitious. In 1917 she established her own monthly magazine, the *Bridal Call*, and it was not long before her "Gospel Car" was carrying her and her message across the entire country. Feeding off a seemingly inexhaustible fund of energy, she crisscrossed the nation eight times between 1918 and 1923, often preaching several times a day, every day of the week. But more noteworthy than her unrelenting preaching schedule were her extraordinary crowd-drawing powers. During two stays in Denver, her programs of preaching, music, and healing attracted roughly twelve thousand people to the city's Coliseum every single night for a month, and in San Diego her preaching attracted a mass of people that virtually filled Balboa Park from one end to the other.

As McPherson's fame grew, critics sneered at her histrionics, which ultimately included riding down the aisle on a motorcycle. They dismissed her as the "[Sarah] Bernhardt of the sawdust trail," "the titian-haired whoopee evangelist," and the "[P. T.] Barnum of religion." But even the cynics had to acknowledge her power to persuade. "She shouts and chants and sings," admitted one such naysayer, "and … electrifies every person in the hall."

All evidence suggests that this photograph of McPherson—dressed in the blue cape and white dress that she wore at her revivals—was taken in the spring of 1921. Her career was fast approaching its height. With audience donations from her revivals steadily pouring in, construction had begun on the Angelus Temple in Los Angeles, the future seat of her Church of the Foursquare Gospel. In a few more years, she would also be presiding over a Bible college and a radio station dedicated to spreading her message. At the moment, however, she was preaching in St. Louis, where the initial response to her presence had been tepid. But as word of her evangelical pyrotechnics spread, the crowds began to swell. Then, a local newspaper carried a report on her doings, under the headline "MAN BARKS AS WOMEN AND GIRLS … SHRIEK AT REVIVAL." With that, the police had to be called in to prevent people from trampling each other in their attempt to see this woman who was inspiring such behavior, and at some of her sessions as many as five thousand now had to be turned away. By the end of McPherson's stay, the site for her revivals had been moved from its original three-thousand-seat facility to the St. Louis Coliseum, where she preached three times a day to overflow crowds of sixteen thousand.

AIMEE SEMPLE McPHERSON
1890–1944
EVANGELIST

GERHARD SISTERS STUDIO
(active 1903–1920s)
Gelatin silver print
19.5 × 14.2 cm (7 11/16 × 5 5/8 in.), circa 1921

LILLIAN GISH

1893–1993
ACTRESS

ALFRED CHENEY JOHNSTON
(1885–1971)
Gelatin silver print
33 × 25.5 cm (13 × 10 1/16 in.), 1922

In many ways the silent-screen career of actress Lillian Gish ran parallel to that of her friend Mary Pickford. Raised mainly by their mothers, they both began acting at an early age and traveled many of the same theater circuits. Both also got their starts in the silent-film industry working with director D. W. Griffith. In fact, it was Pickford who, having made her first film with Griffith in 1909, introduced Gish to the director. Finally, although both ultimately demonstrated abilities to play a variety of roles well, Pickford and Gish found themselves most frequently cast as the innocent, wide-eyed heroine, especially in the early phases of their filmmaking. Of that typecasting, Gish wryly observed years later that she "played so many frail, downtrodden little virgins" that she began to think that she invented them.

Despite the parallels, Gish was by no means an imitation of Pickford. In fact, her greatest distinctions in the early American film industry were ultimately quite different from Pickford's, for Gish never came close to rivaling Pickford as a box office draw, nor did she ever match Pickford's glamorous persona as a Hollywood celebrity. In terms of talent, however, Gish may well deserve pride of place as the most capable actress of the silent-screen era. Of her performance in 1919 as the endangered twelve-year-old child in *Broken Blossoms*, one critic wrote that her sustained expression of terror in a key scene was the "finest example of emotional hysteria in the history of the screen," and today that scene is still regarded as one of the finest acting moments in all of silent film. Equally superlative were the estimates of Gish's portrayal of Hester Prynne in *The Scarlet Letter* in 1926. "She is not Hawthorne's Hester Prynne," one critic declared, "but she is yours and mine."

No one in the early movie industry was more dedicated than Gish to perfecting her craft, and the accolades for her performances often were the well-deserved fruit of some considerable personal efforts. When playing the tragic Mimi in *La Bohème*, for example, she went without water for days to ensure that she would look like a woman who was dying in the movie's final scenes.

No treatment, however brief, of Gish's silent-screen career could fail to mention her performance in D. W. Griffith's *Birth of a Nation*, the movie industry's first feature-length film, released in 1915. Gish was not Griffith's first choice for the major role of Elsie Stoneman, but he came around to her thinking that she would at least be adequate in the part. Gish exceeded that expectation by a good deal, and there is little doubt that her performance was a significant ingredient in the film's success.

The maker of this picture was Alfred Cheney Johnston, who was an official photographer of the Ziegfeld Follies. In it, Gish is dressed for her role in *Orphans of the Storm*, her last film made under Griffith's direction. Not long after the movie's completion, Griffith urged her to approach other moviemakers for her parts because he could not pay her what she was worth.

40

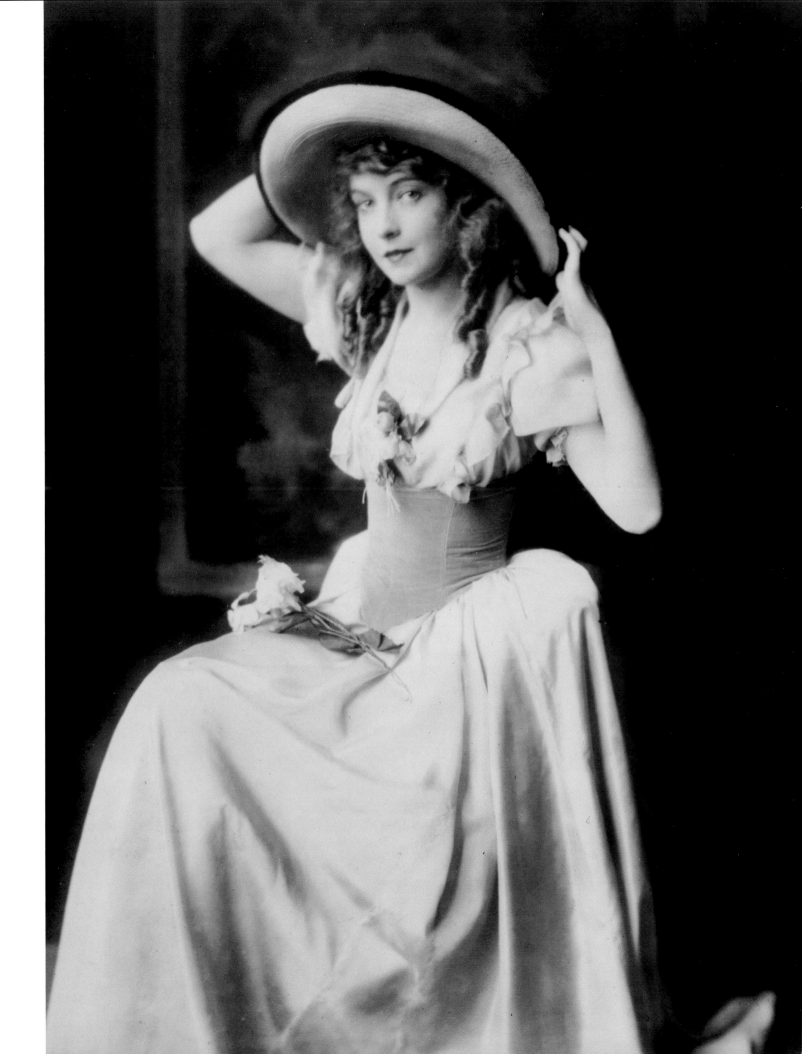

GERTRUDE STEIN

1874–1946

with JO DAVIDSON

WRITER, ART COLLECTOR

MAN RAY (1890–1976)
Gelatin silver print
16.9 × 11.8 cm (6 5/8 × 4 5/8 in.), circa 1922

Short and heavyset, Gertrude Stein possessed a solemn physical presence that made her seem cut out for the role of a gurulike arbiter, and in some degree, her place in the cultural history of the twentieth century does indeed live up to those expectations. Raised in Oakland, California, and educated at Radcliffe and Johns Hopkins, Stein had originally intended to pursue medicine. But by her fourth year of medical school, she had lost interest in that profession, and in late 1903, intending to live off the income from a family inheritance, she settled in Paris with her brother Leo. There, following Leo's adventurous lead, she became an avid collector of works by such modernists as Henri Matisse, Pablo Picasso, and Georges Braque. Her and brother Leo's picture purchases were soon crowding the walls of their shared house at 27, rue de Fleurus, where they served as the backdrop for salons hosted by Stein. Attended by some of the era's most significant avant-garde painters and, later, the American and English writers who flocked to Paris in the 1920s, these salons were a social hub of early-twentieth-century modernism. At the center of the hub, of course, sat the imposing Stein, expounding her thoughts on the new directions in art and letters.

But Stein was not just a patron and interpreter of modernism. A writer herself with serious aspirations, she also became one of its most arcane practitioners. Wanting to achieve a style that was the verbal counterpart of cubist painting, she created a prose characterized by unpunctuated dislocations, repetitions, and abstruse word play that were inaccessible to most readers. When one critic declared her *Prayers and Portraits* an equivalent to "the Chinese water torture" because "it never stops and it is always the same," he spoke for many.

Still, Stein had her admirers. Among them was Ernest Hemingway, who frequented her salons and whose own prose clearly evinced traces of her mentoring. Even many critics who dismissed her work as "soporific rigamaroles," noted one observer, nevertheless remained respectfully mindful "of her presence in the background of contemporary literature." Moreover, Stein eventually proved that she could not only write for a general audience, but also do it with considerable wit. The most enduring evidence of that was her engaging memoir, *The Autobiography of Alice B. Toklas* of 1933, told in the voice of her longtime companion.

In the photograph here, Stein poses for her terra-cotta portrait by Jo Davidson. Taken by Man Ray, the picture ran in *Vanity Fair* in February 1923 with an article that billed Stein as an "American Revolutionary of Prose." It also carried her verbal portrait of sculptor Davidson, which ran in part: "Wives of great man. / Wives of a great many men. / Wives a great introduction. / Wives are a great recognition. / There were more husbands than wives in their lives. / Two live too him. / This is the story of Jo Davidson." Davidson recalled that it made sense when Stein herself read it to him, but when he read it later, it was only gibberish.

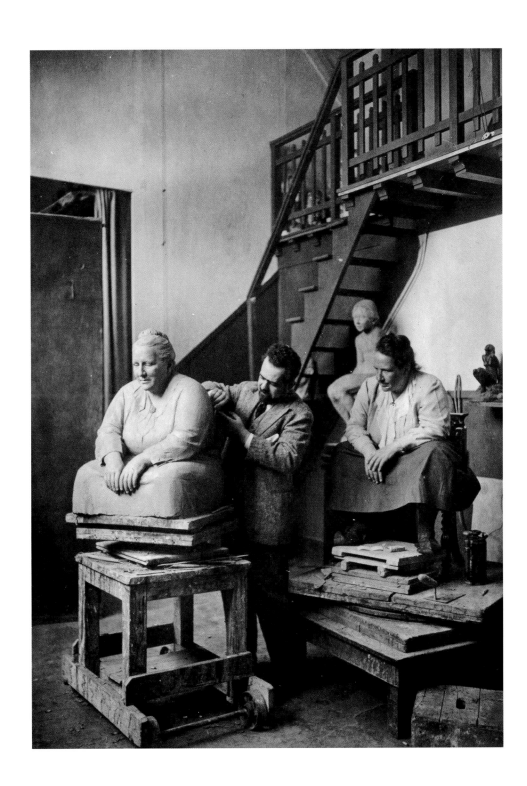

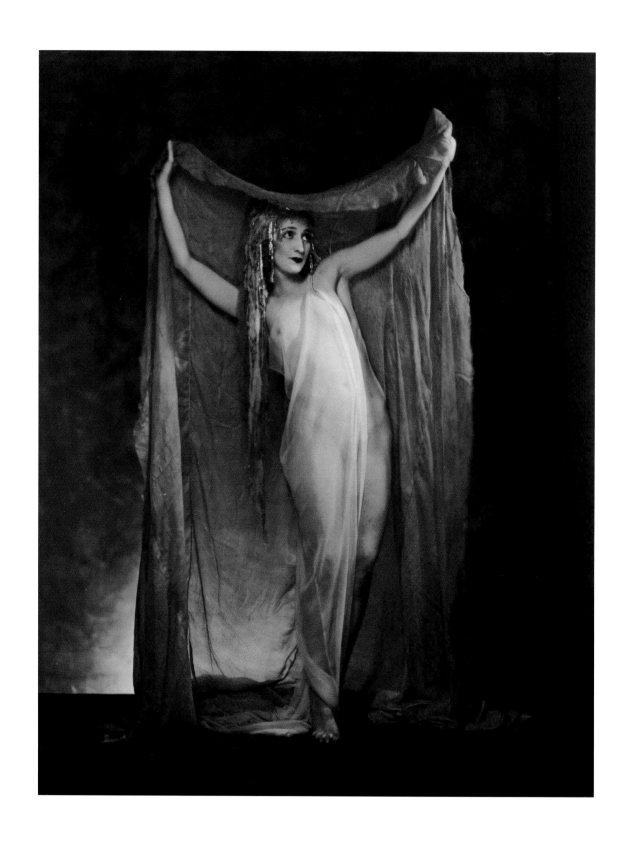

Doris Humphrey demonstrated a clear talent for dancing in her early childhood, and she had by her late teens set her sights on a performing career in that field. Unfortunately, her family's need for money forced her to delay pursuing her ambition, and following her graduation from high school in 1913, she found herself having to support her parents by teaching ballroom dancing. In 1917, however, she took a break from that endeavor to enroll in a summer session at the Denishawn School of dance in Los Angeles, whose coproprietors, Ruth St. Denis and Ted Shawn, were creating dance forms drawn largely from Middle Eastern and Asian traditions. St. Denis appreciated Humphrey's abilities immediately, and over the next ten years, Humphrey became the school's most able teacher and leading performer.

Ultimately, Humphrey outgrew the Denishawn company, feeling that it was too imitative. In 1928, wanting to explore the potential for new dance forms, she teamed up with another Denishawn dancer, Charles Weidman, to form their own dance company. Over the next several years, she began developing an approach to dance that rejected prescribed steps and forms in favor of a freer dance vocabulary premised on the conviction that dance was, above all, expression of emotion or, as she put it, "moving from the inside out."

The Humphrey-Weidman Company toured the country many times in the 1930s and, in the process, became a leading force in the evolution of American modern dance. As much a choreographer as a performer, Humphrey created many groundbreaking compositions for the company, among them *Life of the Bee*, which patterned itself on the movements of nature, and a trilogy of works, *New Dance*, *Theatre Piece*, and *With My Red Fires*, which, at their stagings in the mid-1930s, represented the most ambitious and demanding modern dance enterprise ever mounted.

Arthritis brought an end to Humphrey's performing career in the mid-1940s, but she continued to work as a choreographer, creating some of her finest work for the company founded by her former pupil José Limón. She also taught, and in 1951 she joined the faculty of the Juilliard School of Music, where she once told a class that a dancer was someone who "never ceases to be curious about the meaning of movement and never stops wondering at [its] infinite possibilities." Speaking of the enormous impact of her career, *New York Times* dance critic John Martin declared at her death that she was "an enduring part of the dance in America, as the granite under the soil is enduring."

This photograph was taken about 1923 when Humphrey was still performing with the Denishawn Dance Company. In it, she wears a wig of simulated seaweed that was part of her costume in Ruth St. Denis's ballet *The Spirit of the Sea*. The picture's maker, Nickolas Muray, was well known for his skill in photographing dancers. To determine how best to show off a dancer, he often invited his subject to perform in his studio. Then he would ask the dancer to adopt a pose that struck him as most evocative of the performance he had just witnessed.

DORIS HUMPHREY
1895–1958
DANCER

NICKOLAS MURAY (1892–1965)
Gelatin silver print
24.6 × 19.2 cm (9 11/16 × 7 9/16 in.), circa 1923

JOSEPHINE BAKER

1906–1975
DANCER, SINGER

STANISLAUS J. WALERY
(active 1880s–1920s)
Gelatin silver print
22.2 × 16.2 cm (8 3/4 × 6 3/8 in.), 1926

Recalling his first sight of the dancer Josephine Baker in the chorus of the musical comedy *Shuffle Along* in about 1923, poet Langston Hughes remarked that "there was something about her rhythm, her warmth, her smile, and her impudent grace that made her stand out." Indeed, whenever this lithe, teenaged showgirl set foot on stage, her comic verve and easy sensuality drew the audience's attention to her, no matter how many others might be on stage. Even so, when the St. Louis–born Baker went to Paris in 1925 as a featured performer in *La Revue Nègre*, no one could have anticipated the electric impact she would have there. When her nearly nude figure first appeared upon the stage, writer Janet Flanner noted, "a scream of salutation spread through the theater. Whatever happened next was unimportant. The two specific elements had been established and were unforgettable—her magnificent dark body … and the acute response of the white masculine public…. Within a half hour of the final curtain … the news of her arrival … had spread to the cafes on the Champs-Elysées."

Baker, in short, was an overnight sensation, and when *La Revue Nègre* went to Berlin, the response was much the same. She even had an offer to work with Germany's distinguished theatrical director Max Reinhardt, but she turned it down when *La Revue* agreed to raise her salary. On her return to Paris, she was soon ensconced as a star of the Folies-Bergère, where she introduced the French to the Charleston and danced in a G-string strung with bananas. By 1927 she had received some forty thousand love letters and marriage proposals numbering in the thousands, and postcards bearing her image were for sale in the city's bookstalls. Picasso proclaimed her the "Nefertiti of now," while the writer Colette declared her "a most beautiful panther." With her slim, light brown body—ideal for showing off the liberating flapper fashions of the day—she also captivated the world of haute couture, and some designers supplied her with their clothes for nothing, believing her the ideal advertisement for their wares.

In the 1930s, Baker added to her fame as she made singing a more important element in her performances, and throughout the decade she remained one of France's most popular entertainers. Becoming a French citizen in 1937, she went to work for the Free French army during World War II as an intelligence gatherer in the Resistance and was awarded the Legion of Honor at the war's end.

This photograph depicts Baker in her first revue at the Folies-Bergère in 1926. In the dance number pictured here, she reached the stage concealed in a flowered ball lowered from above. Once the ball hit the stage, it slowly opened, revealing a scantily clad Baker on a large mirror that became her dancing surface. Upon finishing her dance, she then left the stage as she had come. In rehearsing this entry and exit, Baker had some harrowing moments when the cables carrying her aloft failed to function properly, leaving her dangling precariously above the stage. But everything worked in the actual performance, and the audience loved it.

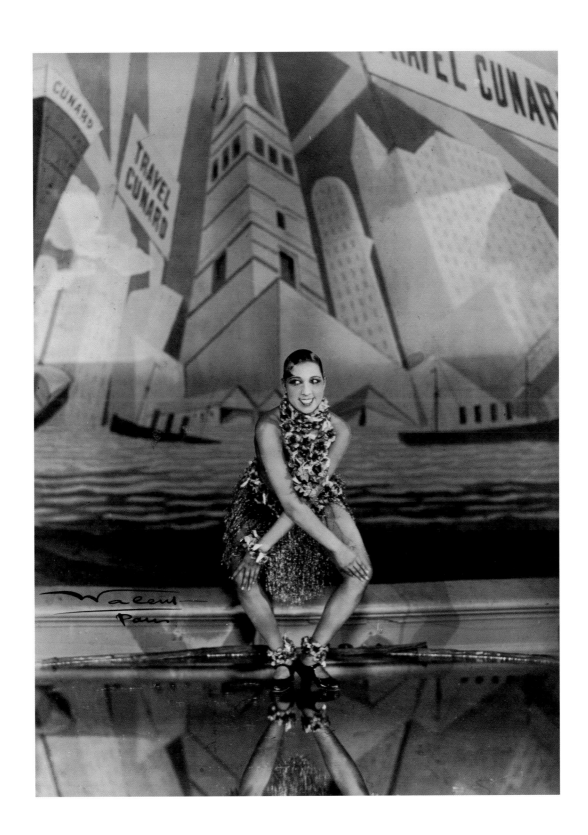

WILLA CATHER

1873–1947
WRITER

EDWARD STEICHEN (1879–1973)
Gelatin silver print
24 × 19.2 cm (9 7/16 × 7 9/16 in.), 1927
Acquired in memory of Agnes and Eugene
Meyer through the generosity of Katharine
Graham and the New York Community
Trust, the Island Fund

The decision by Willa Cather's father in 1883 to sell the family's spacious house and farmland in Virginia and move to the Nebraska frontier proved the most wrenching experience of Cather's life. By the age of nine, she was already deeply attached to the Virginia countryside where she could hunt, fish, and explore largely on her own. Upon encountering the vast, treeless expanses of the Nebraska plains, so different from the verdant and rolling terrain of Virginia, she felt as if she were undergoing "an erasure of personality." In some degree it was a trauma she never got over. When she returned to Nebraska as an adult to visit her parents, she often could not wait to leave "for fear of dying in a cornfield."

Yet Cather was by no means irrevocably alienated from the Great Plains. Quite the contrary, it was the pioneer experience of that region that became the primary source for her most memorable fiction, and while she sometimes painted the West as narrowly provincial, she ultimately saw it as the repository of cherished values and moral strength.

Having quit journalism in 1911 to devote herself to writing fiction, Cather produced her first novel with a western setting two years later. The book was entitled *O Pioneers!*, and when writing it, she harbored no great hopes for popular interest in this story "concerned entirely with heavy farming people" and "set in Nebraska of all places!" But a story set in Nebraska did hold interest for readers after all—at least, if it was by Cather. One critic declared *O Pioneers!* a work "touched with genius"; another claimed it was the "most vital, subtle and artistic piece of the year's fiction."

In 1918 Cather published *My Ántonia*, the story of a woman who ultimately finds fulfillment on the western prairie. Also warmly received, it is today probably her most frequently read work. But the period of greatest acclaim within Cather's own lifetime began with the appearance in 1922 of her best-selling novel *One of Ours*, which earned a Pulitzer Prize. Hard on the heels of that success came the much-praised *A Lost Lady* in 1923. But Cather experienced perhaps her greatest triumph four years later with the publication of her tale of two mid-nineteenth-century French missionary priests in the Southwest, *Death Comes to the Archbishop*. The book inspired an avalanche of rave reviews, including one declaring it to be the ultimate fruition of Cather's "literary artistry" and "an American classic."

Just before that triumph, *Vanity Fair* ran this portrait of Cather by Edward Steichen with a caption hailing her as "a stylist of precision and beauty." Several months later, following the appearance of *Death Comes to the Archbishop*, the magazine published yet another Steichen likeness of her derived from the same sittings. This time the caption was even more laudatory. Cather was, *Vanity Fair* informed its readers, "the heir apparent to Edith Wharton's lonely eminence among America's women novelists," and "her position in American letters" was "an absolute one by right of sheer artistic stature."

48

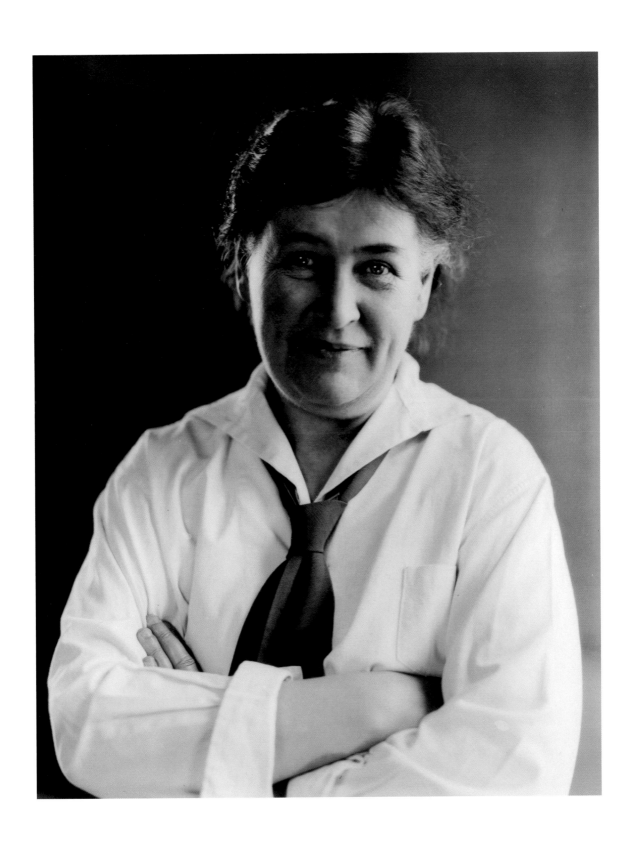

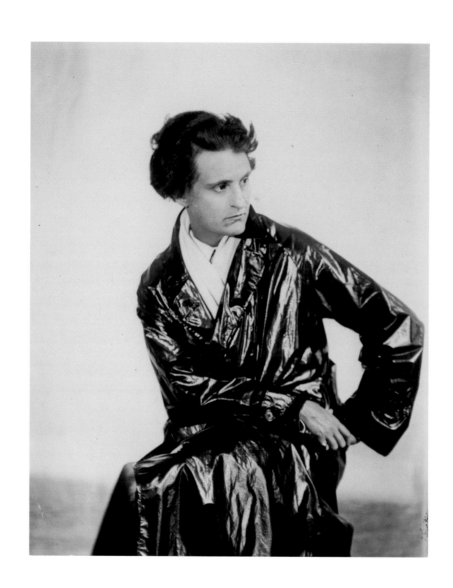

In late December 1921, a young writer named Ernest Hemingway, who had just arrived in Paris, walked into a bookshop and lending library on the rue de l'Odéon on the city's Left Bank. It was love at first sight. Specializing in English-language books and periodicals, the shop was called Shakespeare and Company and carried a rich and varied trove of literature, from classics to the avant-garde—just the sort of wide-ranging fare for an untested writer in search of his own literary voice. Before long, Hemingway was one of the shop's most frequent patrons.

The proprietor of this Hemingway find was Sylvia Beach, daughter of an American Presbyterian minister, who had a passion for books and, having spent much of her youth in France, had developed a special love for French literature. To satisfy that pair of interests, she toyed with establishing a French bookshop in New York City following World War I. Her longtime French friend, Adrienne Monnier, however, convinced her instead to open an English bookshop in Paris. Initially, Beach's clientele was mostly French, many of them literati such as André Gide and Paul Valéry. But before long the English and Americans were discovering her shop, and by the time of Hemingway's visit late in 1921, it was fast becoming a center for the Anglo-American community of modernist writers that began flocking to Paris at the close of World War I. At one time or another, Shakespeare and Company's customers included such figures as John Dos Passos, Gertrude Stein, Ezra Pound, Ford Madox Ford, T. S. Eliot, and Wyndham Lewis. Today, the surviving records from Beach's lending library are an invaluable means for gauging what literary works may have been influencing her various famous patrons at a given point in their careers.

Beach's place in Anglo-American letters, however, goes well beyond her role as a bookshop proprietor. In 1921, when it became clear that the sexual frankness of James Joyce's *Ulysses* precluded its publication in the United States or the British Isles, Beach took the novel into her care. Serving as Joyce's all-purpose agent and nursemaid, she managed publication of *Ulysses*, and on Joyce's birthday, February 2, 1922, the first two bound copies of the work arrived at her shop. For the next eleven years, Beach continued to oversee new editions of this watershed novel and to cater to the wants of its often-demanding and not-always-grateful author.

Among the most noticeable features of Beach's shop was its photographic gallery of writers, which, over time, came to constitute a who's who of the Anglo-American literary avant-garde that congregated at Shakespeare and Company. In the shop's early years, these images most often came from the studio of Man Ray. Later, however, many of them were the work of Berenice Abbott, who learned photography under Man Ray's tutelage. In 1928 Abbott took this likeness showing Beach clad in a shiny slickerlike coat. The image's cool, hard-edged quality is suggestive of a personality that was all practicality and no sentiment. In fact, it was quite the opposite with Beach. At heart she was a romantic, and if it was a choice between looking out for her own interest and doing a kindness for a patron, the latter inevitably won out.

SYLVIA BEACH
1887–1962
PUBLISHER, BOOKSELLER

BERENICE ABBOTT (1898–1991)
Gelatin silver print
9.5 × 8 cm (3 3/4 × 3 1/8 in.), 1928

MALVINA HOFFMAN

1885–1966
SCULPTOR

CLARA E. SIPPRELL (1885–1975)
Gelatin silver print
23.2 × 19 cm (9 1/8 × 7 1/2 in.), circa 1928

Malvina Hoffman studied painting for six years with the American artist John White Alexander. But when it came to doing a likeness of her father in 1909, she did not think she could do full justice without depicting him in three dimensions. Putting aside her oil and canvas, she set about modeling her parent's features in clay. The venture proved so successful that sculptor Gutzon Borglum urged her to translate the bust into marble. When that attempt proved equally successful, Hoffman went from being an aspiring painter to being an aspiring sculptor, and in 1910 she was on her way to Paris, intent on learning her newfound vocation from no less than Auguste Rodin.

Initially Rodin wanted nothing to do with this young American, and it took five visits before Hoffman could convince the maid to admit her into his presence. Once shown in, however, she clearly made a good impression. For the next sixteen months Hoffman had the privilege of studying her craft under the great Rodin. While in Paris, she also was exposed to the Ballets Russes, which instilled a career-long concern for infusing her work with a sense of animated immediacy. Nowhere was that more evident than in her first real artistic triumph, *Bacchanale Russe*, a high-spirited two-figure composition portraying ballerina Anna Pavlova dancing in partnership with Mikhail Mordkin.

Hoffman was aware in Paris of the avant-garde trends in art, and after an encounter with the abstract sculptor Constantin Brancusi, she "wondered if it might not be a defect" in herself "not to have experimented more" in her own work. But that self-doubt was short-lived, and her art always remained firmly rooted in the representational tradition. Among her finest pieces were her naturalistic portraits, which included portrayals of musician-statesman Ignacy Paderewski, actress Katharine Cornell, and philosopher Pierre Teilhard de Chardin, and which often seemed to go beyond mere likeness to the delineation of character and personality.

The Yugoslavian sculptor Ivan Meštrović, her friend and mentor, once warned Hoffman that she would not have an easy time commanding respect within her overwhelmingly male profession unless she went beyond the norm in acquiring expertise in parts of her craft generally left to others, such as casting. She did that, but it sometimes seemed that she tried to exceed the norm more than was necessary. Her friend, poet Marianne Moore, for example, remembered a time in London in the mid-1920s when Hoffman was overseeing the installation of a pair of huge stone figures symbolizing Britain and America. Once they were installed in their lofty setting, Hoffman noted that the light struck them in a way that suggested a need for some modification, and she was soon atop scaffolding, some ninety feet in the air, making refinements with her mallet and chisel. It was, Moore said, "as if she had wings and carried a torch."

In this photograph, Hoffman stands before her larger-than-life, full-length likeness of her friend Meštrović, who had recently offered her instruction in modeling animals. Shot in the soft-focus style that its maker Clara Sipprell favored throughout her long photography career, the picture appeared in *Town and Country* in late 1928.

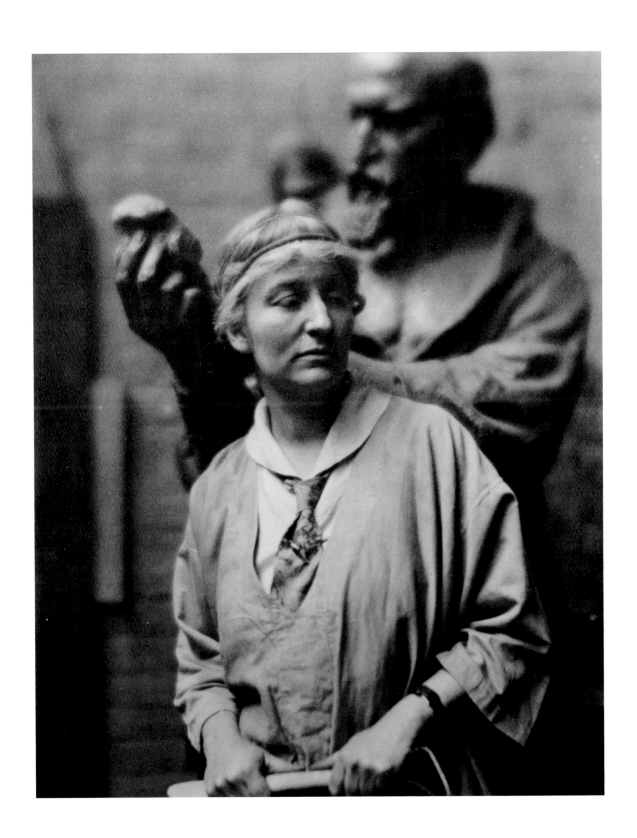

Berenice Abbott went to Paris in 1921 intent on pursuing training in sculpture. By late 1923, however, following several months of study in Berlin, she had concluded that sculpture held no future for her, and she was back in Paris, faced with the need to earn a living and not at all sure what her next career move should be. In the midst of this uncertainty, she ran into the photographer Man Ray, who complained about a know-it-all darkroom assistant and told her that he hoped to replace the tiresome young man with someone who knew nothing about photography. "How about me?" offered Abbott. Although she did not realize it at the time, Abbott had sealed her fate. Man Ray took her on immediately.

For a while, Abbott confined her activities to printing and developing. But in her second year, she began taking pictures of her own. Remembering some of those first moments with a camera, she claimed, "I had no idea of becoming a photographer, but the pictures kept coming out." Better yet, "most of them were good" and "some were very good," and it was not long before Abbott found herself building her own photography business while still working for Man Ray. By 1926 she was establishing her own studio, and over the next several years she built a thriving business specializing in portraiture. Among her sitters were French literati such as Jean Cocteau and André Maurois, the American composer George Antheil, and the Irish writer James Joyce. In the case of Joyce, her likenesses would in time become some of the best-known images of him.

But as the intelligentsia paraded past her camera, the seeds were being sown for a new phase in Abbott's photographic career. While still working for Man Ray, she had become aware of the aging photographer Eugène Atget, who spent his life recording Paris. Much impressed with his pictures, Abbott befriended Atget, and after he died in 1927, she acquired the personal archive of his work. Long recognized as an extraordinary collection of urban photography, this trove whetted Abbott's appetite for going beyond portraiture. In late 1929, she moved to New York City, where she hoped to create a similar pictorial chronicle of urban life. Frequently hard-pressed for money, she did not have an easy time at first. But finally, with backing from the New Deal's Federal Arts Project, her ambition to document New York came to fruition between 1935 and 1939. And a memorable fruition it was. Like Atget before her, she documented a time and place with an immediacy that continues to entrance current-day viewers. As art critic Hilton Kramer put it, the most remarkable aspect of Abbott's New York images is "the degree to which they retain ... [a] sense of discovery—of something freshly seen and intensely valued."

Abbott's self-portrait, taken in New York in the early 1930s, has an unforced objectivity about it that critics often singled out as her greatest strength in portraiture. In the 1950s, Abbott used a distorted version of this likeness in an advertisement for her Distortion Easel, a darkroom tool of her own devising for distorting photographs in amusing ways.

BERENICE ABBOTT
1898–1991
PHOTOGRAPHER

Self-portrait
Gelatin silver print
14.1 × 10.9 cm. (5 9/16 × 4 1/4 in.), circa 1932

PEARL S. BUCK

1892–1973
WRITER

EDWARD STEICHEN (1879–1973)
Gelatin silver print
24.8 × 19.6 cm (9 3/4 × 7 11/16 in.), 1932

It is not always entirely clear how early experiences shape an individual's future accomplishments. In the case of writer Pearl Buck, however, the causative links cannot be more obvious. The daughter of missionary parents, Buck spent most of her childhood in China, and by her late teens, her familiarity with the country's language and culture certainly ran as deep, if not deeper, than her knowledge of her native United States. As a young woman married to an agricultural missionary, she continued to live mostly in China, and so as Buck embarked on her writing career in the early 1920s, her focus on that country was not only natural; it was inevitable.

Buck's first ventures into writing about China were nonfictional magazine articles. But by the late 1920s, she was trying her hand at fiction, and in 1930, after many publisher rejections, her pairing of two extended stories entitled *East Wind: West Wind* reached print. Taking the clash of the old and the new in China for its theme, the book ran through three editions in a single year. That success paled, however, compared to the reception accorded Buck's first full-length novel, *The Good Earth*, a year later. Written in a tone evocative of traditional Chinese storytelling, this tale of an impoverished Chinese couple's rise to wealth leapt to the best-seller list almost instantly and eventually sold an unprecedented two million copies. Ultimately translated into thirty languages, it became a movie in 1932 and earned Buck a Pulitzer Prize. As if that were not enough, in the presentation to Buck of its coveted Howells Medal in 1935, the American Academy of Arts and Letters declared *The Good Earth* "the most distinguished work of American fiction" published in the past five years.

An unusually prolific writer who would produce more than eighty-five more books, Buck published two sequels to *The Good Earth* in the early 1930s that, with it, formed a trilogy called *House of Earth*. Meanwhile, she was also testing her mettle as a biographer, and in 1936 she brought out *The Exile* and *Fighting Angel*, which recounted the missionary lives of her mother and father, respectively. A modern-day critic has described these two volumes as "so searching and frankly realistic that every facet of the parents' lives rivets the reader's attention." But perhaps the ultimate accolade for these biographies came in 1938, when they were among the works specially singled out for praise in the citation that named Buck a winner of the Nobel Prize in literature.

Although Buck would write steadily for the rest of her life, it is widely thought that the Nobel Prize represented the high-water mark of her career. Nevertheless, her books generally sold well, and whatever their shortcomings, they continued to bear witness to their author's remarkable talent for engaging narrative.

The magazine *Vanity Fair* featured this portrait of Buck in its November 1932 issue in a picture spread titled "Nominated for the Hall of Fame: 1932." The image's maker, Edward Steichen, was one of America's most highly regarded photographers, and his celebrity and fashion photography for *Vanity Fair* and *Vogue* in the 1920s and 1930s represents a high point in magazine illustration.

When it came to "looks, grace, and carriage," *Vanity Fair* reported in September 1932, the U.S. women's swim team that had just finished competing at the Los Angeles summer Olympics boasted "five angels who would fit into a Ziegfeld chorus." Offered up as visual testament to the truth of that assertion was this full-page photograph by Edward Steichen. The names of the two aquatic angels pictured were Eleanor Holm (standing) and Helene Madison (seated). Physical attractiveness, however, was the least of these two young women's stories. Holm, who had indeed already turned down an invitation to join the lineup of Ziegfeld Follies girls, claimed between 1927 and 1936 no less than thirty-five U.S. swimming championships, including twelve in the backstroke and eleven in the individual medley. At the Los Angeles games, having already set the world's record in the hundred-meter backstroke just a month or so earlier, she easily claimed the gold medal in that event.

More impressive yet, however, was the evidence of Helene Madison's athletic prowess. Beginning in 1928 to the end of her competitive swimming career, she never lost a freestyle race of any distance. By the end of 1930, she held twenty-six American records in freestyle events ranging up to one mile. When the Associated Press named her female athlete of the year in late 1931, she laid claim to ten world freestyle records as well. Things only got better the following year. At the Olympics, she became the second female swimmer ever to win three gold medals, and when this nineteen-year-old wonder retired from competition not long thereafter, she held three Olympic records, forty-five American records, and seventeen world records.

Vanity Fair noted that Madison was too much of the unrelenting competitor to be well liked among her fellow swimmers, but once in the water she invited only admiration. There, she became "a human torpedo boat gliding forward, smoothly, steadily and relentlessly with such a sense of power and rhythm" that it made one "exult to watch her." There was, the magazine added, "no checking in her forward movement"; instead it was "one sweet, continuous motion that pull[ed] her steadily away from her field."

Edward Steichen's picture of Holm and Madison offers a clear demonstration of the brilliant sense of design that underlay so much of his work. On the surface, his pictures may have seemed simply to be exceptionally effective renderings of reality, but his compositional flair often took them well beyond that and instead made them testaments to what one critic has called Steichen's "uncanny ability to manipulate reality" for his own aesthetic ends.

ELEANOR HOLM
born 1913 and
HELENE MADISON
1914–1970
ATHLETES

EDWARD STEICHEN (1879–1973)
Gelatin silver print
24.1 × 19.3 cm (9 1/2 × 7 5/8 in.), 1932
Acquired in memory of Agnes and Eugene Meyer through the generosity of Katharine Graham and the New York Community Trust, the Island Fund

HELEN WILLS MOODY

1905–1998
ATHLETE

By an unidentified photographer
for Acme Newspictures, Inc.
Gelatin silver print
16.9 × 21.4 cm. (6 11/16 × 8 7/16 in.), 1933

The 1920s yielded a succession of stellar athletes that earned the decade its reputation as a golden era in American sports. In baseball, it was the "Sultan of Swat," Babe Ruth; in golf, the "Mechanical Man," Bobby Jones; in football, the "Galloping Ghost," Red Grange. And in women's tennis it was "Little Miss Poker Face," Helen Wills Moody. So nicknamed because of her cool, deadpan demeanor on the court, Moody was not as exciting to watch as some of the decade's other sports celebrities. As one sportswriter put it, "She plays her game with a silent, deadly earnestness…. That, of course, is the way to win games, but it does not please the galleries." But if Moody's style did not unleash roars of warm affection, it led to one of the most impressive records in tennis history.

Beginning in 1923, when she won her first American singles title, Moody dominated women's tennis for more than a decade. The number-one ranked women's player over eight successive years, she eventually claimed thirty-one grand-slam titles. From 1927 to 1933 she won 180 straight matches, and by the time she retired in 1938, her triumphs included eight singles championships at Wimbledon, four at the French Open, and seven at the American.

An impressive string of victories was not, however, Moody's only noteworthy legacy to tennis. She also helped free women's tennis from the fetters of Victorian convention with her short-skirted, sleeveless playing outfits and her daring appearance at Wimbledon in 1927 without stockings. Commenting on the shift to less constraining clothing that she fostered, Moody once speculated that it "more than anything else" was responsible for raising the playing level in women's tennis. Moody, however, contributed to the rising standard in a much more important way, for it was the toughness of her playing that truly sparked the sport's transformation from decorative sideshow into a rigorously competitive enterprise.

This photograph depicts Moody on the eve of the most controversial incident of her career. It was the late summer of 1933, and Moody is pictured playing out a match on her way to a final singles match in the United States Open against Helen Jacobs. The outcome of the Moody-Jacobs face-off seemed a foregone conclusion. Moody had not lost a set in nearly six years, and the best that Jacobs had ever managed against her was winning three games in one set. But Jacobs surprised everyone in the U.S. final by taking the first set, 8–6. In the next set, Moody seemed back in her championship form, winning 6–3. Then, as they settled into the third and final set, Jacobs took the lead quickly. But before Jacobs could bring home her all-but-certain triumph, Moody suddenly exited the court, pleading severe pain and leaving Jacobs the winner by default. The event set off a heated debate, with many arguing that Moody should have played the match out, thereby allowing Jacobs to claim her championship without feeling that it had not been properly earned. Ever true to her reputation, "Little Miss Poker Face" never said much about the incident, and it remains unclear to this day exactly what prompted her withdrawal.

KATHARINE HEPBURN

born 1907
ACTRESS

EDWARD STEICHEN (1879–1973)
Gelatin silver print
23.2 × 19.4 cm (9 1/8 × 7 5/8 in.), 1933

When Katharine Hepburn struck her unabashedly theatrical pose for this likeness by Edward Steichen in late 1933, she seemed to be riding an ever-rising crest. The previous year, her performance in the Broadway show *The Warrior's Husband* had earned her an unusually generous contract with Hollywood's RKO studios, and in her first movie, *Bill of Divorcement,* she had amply demonstrated her worth, as critic after critic singled out her "startlingly clear and vibrant performance" as one of the film's main virtues. Hard on the heels of that beginning came her portrayal of an aspiring actress in *Morning Glory,* a characterization that one reviewer termed "strangely distinguished" and that won Hepburn a best actress Academy Award. As if that were not enough, within three months of *Morning Glory*'s release came the unveiling of RKO's interpretation of Louisa May Alcott's *Little Women,* in which Hepburn played Jo March. In that role, *Time* declared, she provided the movies with "one of the most memorable heroines of the year."

As Steichen refined the dramatic lighting for her likeness, Hepburn's future prospects seemed every bit as roseate as her recent past. Most imminent among those prospects was her return to the New York theater in *The Lake*. Expectations were running high that yet another Hepburn triumph was in the offing, and it was in anticipation of that triumph that Steichen made this image for *Vanity Fair*. Unfortunately, *The Lake* proved an unqualified disaster, prompting, among other things, Dorothy Parker's famous quip that Hepburn's acting "ran the whole gamut of emotions from A to B." Other reviewers were not quite so harsh, but neither were they complimentary. Writing in *Vanity Fair* a month after Steichen's photo of Hepburn had appeared there, critic George Nathan opined: "Miss Hepburn has many of the qualities that may one day make her an actress of position.... But that day ... is still far from being at hand."

After the play's close, Hepburn returned to Hollywood, where over the next several years her career lost its upward momentum. By the late 1930s, she had, to be sure, added a number of well-received films to her credits. But the mediocrity of many of her other movies, along with her difficult ways both on the set and with the press, had earned her a reputation as box office poison. By the spring of 1939, however, she was about to find herself riding yet another crest as she prepared to open as Tracy Lord in the Broadway production of Philip Barry's *The Philadelphia Story*. Written specifically with her in mind, this drawing room comedy won the plaudits that had been denied her performance in *The Lake*. Leading the way in praise was Brooks Atkinson of the *New York Times,* who said that she played the strong-willed Lord "like a woman who has at last found the joy she has always been seeking in the theater." In effect, she had become "an actress of position." It was an eminence that would only grow with the years. By 1981, when she claimed her fourth best actress Oscar, she had provided American film with more memorable moments than perhaps any other actress.

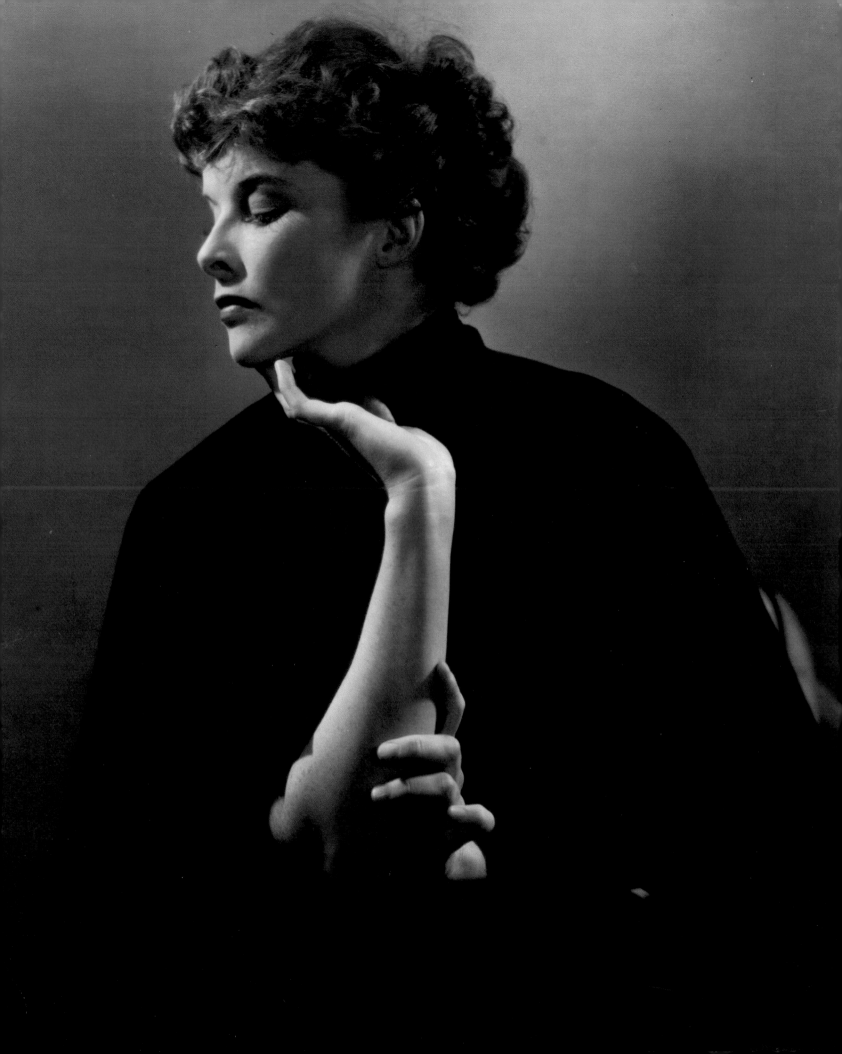

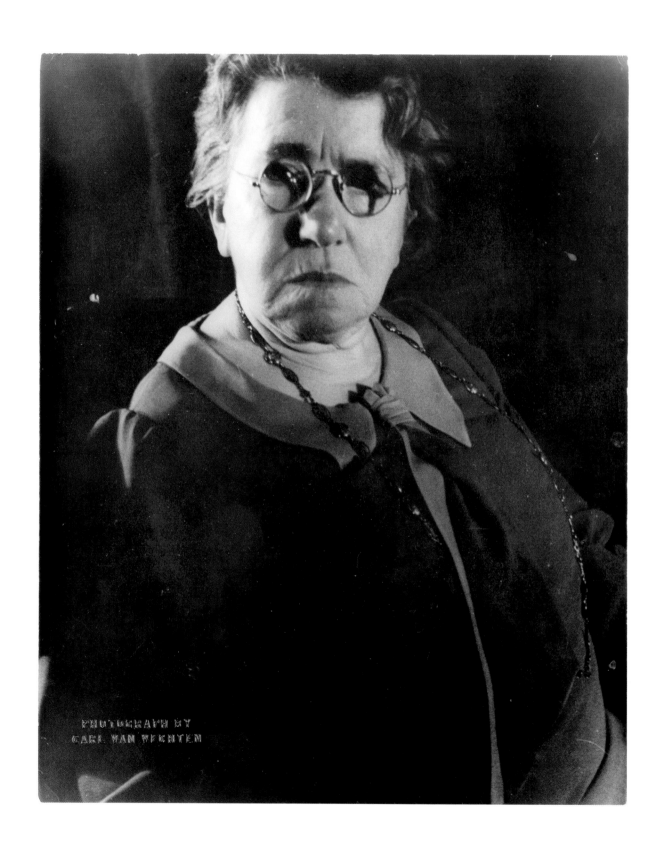

PHOTOGRAPH BY
CARL VAN VECHTEN

The scowling stolidness of the woman in this photograph bespeaks a temperament of the more feisty sort, and it would surprise no one to learn that this is one individual who did not shy away from controversy. But to say that Emma Goldman relished a bit of controversy hardly does justice to her. Known as "Red Emma," she was the quintessential political radical—extreme, unrelenting, and indifferent to the negative impact that her zeal sometimes had on her immediate well-being.

Born in Russia, Goldman immigrated to the United States in 1885 and settled in Rochester, New York, where she worked in a factory. Low wages and poor working conditions quickly soured her on American capitalism, and by 1890, having moved to New York City, she had become an adherent to anarchism, which envisioned replacing the centralized state with small communal entities founded on principles of absolute equality. In advancing that end, she accepted resorting to illegal tactics, and among her first major acts on behalf of anarchism was collaboration in a nearly successful attempt to assassinate Carnegie Steel executive Henry Clay Frick during the Homestead Strike of 1892. Her part in that plot went unpunished, but the following year she was sentenced to prison for telling unemployed workers in New York City that it was their right to steal food.

Goldman's vision of an anarchistic paradise was far too extreme to draw much of a following. But many of the more specific causes that she championed as a lecturer, writer, and magazine publisher were also espoused by more mainstream reformers, and in retrospect her advocacy of such things as more humane working conditions, birth control, and women's rights seems moderate indeed. And when it came to one expression of her impulse to change the prevailing order—her frequent lectures urging Americans to embrace modern European playwrights such as Henrik Ibsen—she seems downright tame. But tame though she sometimes appeared, she remained ever the radical at heart, and for years she was regarded as one of the most dangerous extremists in America. When she was due to speak in Toledo, Ohio, in 1906, the city "worked itself into a nervous lather" over the prospects of her arrival, and ultimately the mayor, fearing that her presence would derail the imminent settlement of a local strike, ordered the police to prevent her from speaking.

In 1917 Goldman was sentenced to two years in jail for opposing the military conscription that was instituted following America's entry into World War I. On her release in 1919, with the country's fear of radicalism running at high tide as a result of the Russian Revolution, she was deported to her native Russia. Russia's new Bolshevik regime, however, eventually alienated her, and after 1921 she resided for extended periods in a number of other countries, including France and England.

In early 1934 Goldman was allowed to return to the United States for ninety days. Soon after she arrived, a journalist asked her if she had changed any of her ideas. "No," she answered, "I was always considered bad; I'm worse now." To another reporter who asked if she thought she was reasonable, she again said no, adding, "Who the hell wants to be reasonable?"

EMMA GOLDMAN
1869–1940
REFORMER

CARL VAN VECHTEN (1880–1964)
Gelatin silver print
25.2 × 20.1 cm (9 15/16 × 7 15/16 in.), 1934
Gift of Virginia M. Zabriskie

MAE WEST

1893–1980
ACTRESS

C. KENNETH LOBBEN (circa 1905–1961)
Gelatin silver print
31.7 × 24.3 cm (12 1/2 × 9 9/16 in.), 1935
Gift of Keith de Lellis

No one would ever have ranked Mae West among Hollywood's more significant acting talents. Nor would anyone have singled her out as one of the great screen beauties of her era. Still, there was something compelling in her hand-on-hip earthiness. Today her tongue-in-cheek portrayals of the worldly wise sex siren remain some of the most memorable moments in American moviemaking of the 1930s.

West began her career performing in New York revues and on the vaudeville circuit, where she developed the essential ingredients of her performing persona—not least of which was her "sin-promising strut." On occasion her style got her into trouble, and in New Haven, Connecticut, the suggestiveness of her act inspired objections that led to her firing. As one New Haven paper announced, "her wriggles" had cost West her job. Such incidents, however, did little to rein her in. By 1918 she was giving New Yorkers their first taste of the shimmy in the hit musical comedy *Sometime*.

In the mid-1920s, West began applying her penchant for the risqué to writing plays for herself. Her first effort, entitled *Sex*, proved a box office hit. Nevertheless, its raciness offended many, and ultimately West was sentenced to ten days in prison for corrupting the morals of the community. Other plays by her incurred similar difficulties, and her only great success in a play of her creation came in 1928 with the opening of *Diamond Lil*, in which she played the loose woman with a heart of gold.

Three years later West was in Hollywood adapting her vamp's persona to the silver screen. The transition went well. By 1933, she was co-starring with Cary Grant in Hollywood's two biggest box office draws of the year, *She Done Him Wrong*, the screen version of *Diamond Lil*, and *I'm No Angel*. Before long, she ranked among the most highly paid performers in Hollywood.

Perhaps the most enduring aspect of West's career is the host of suggestive one-liners that have become since their original utterance oft-repeated aphorisms and catchphrases of American popular culture. Of those one-liners, easily the most familiar is the slyly delivered, "Come up and see me some time" from *Diamond Lil*, which became as much a West trademark as her come-hither strut. Almost as famous is her confession that "between two evils I always pick the one I never tried before." Finally, there is the bit of repartee in her first movie, *Night After Night*, between a heavily jeweled West and a hatcheck girl. "Goodness, what beautiful diamonds!" exclaimed the girl, to which West rejoined, "Goodness had nothing to do with it, dearie."

This photograph was among the publicity images made to promote *Goin' to Town*, released in 1935. Hollywood censors had raised many objections to the suggestiveness of West's previous films, and in this new vehicle, every effort was made to ensure that those objections would not arise again. Unfortunately the film lacked the freshness that had drawn moviegoers to West's movies in the first place. "What once looked like hearty bawdiness," declared one critic, "has palled to the point where it's just the handwriting on the back fence."

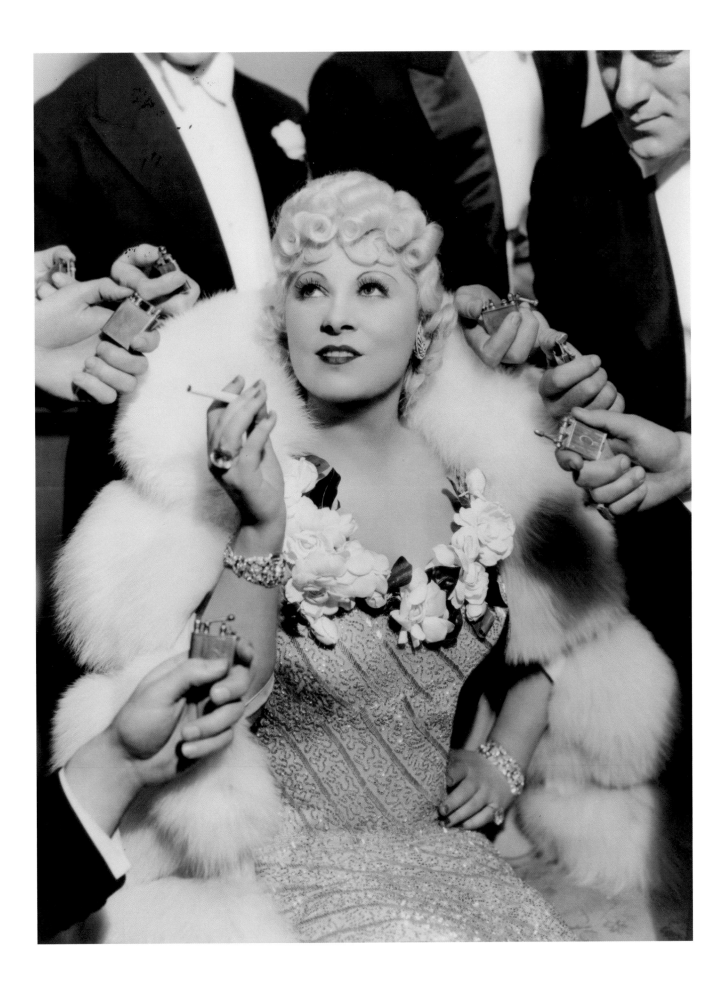

AMELIA EARHART

1897–1937
AVIATOR

When Amelia Earhart took her first plane ride in 1920, it was love at first sight. Whatever the hazards of this new mode of travel, she was determined to learn how to pilot a plane herself, and on January 3, 1921, she took her first flying lesson. The experience lived up to her expectations and then some. That summer, Earhart bought her own plane, and after her first day with it, her mother noted, she took leave of her new flying machine as if bidding farewell to a "favorite pony. We said goodnight to it and patted its nose and almost fed it apples." Over the next several years, she became a familiar figure at air shows and, early in 1922, set a new women's altitude record of fourteen thousand feet. By then, she was, in fact, so well known in aviation that an advertisement for the plane she flew featured her with the headline "A Lady's Plane as Well as a Man's."

Aviation, however, could not provide Earhart with the living that she needed, and by 1927, the year Charles Lindbergh became the first pilot to fly the Atlantic nonstop, she was working at a Boston settlement house. Then, in the spring of 1928, flying again became a primary preoccupation when she was invited to become the first woman to cross the North Atlantic on a nonstop flight. Although she would not be the pilot in this enterprise, she could hardly say no, and shortly before the plane's departure from Newfoundland she wrote her father, "Hooray for the last grand adventure!"

The "last grand adventure," however, it was not. On June 17, when her plane landed in Burry Port, Wales, it was nearly out of gas, but its goal had been reached, and Earhart was suddenly one of the most celebrated aviators in the world. Drawn to her cleanly boyish face and unassuming presence, the public embraced her as "Lady Lindy," the feminine counterpart of Lindbergh. But more to the point, the flight made her a leading advocate of the air industry and opened the way for more flying distinctions. In 1931 she started off across the country in an Autogiro, the forerunner of the helicopter, and set an altitude record for that class of aircraft. In the following year, she became the first woman to pilot a solo nonstop flight across the Atlantic.

In the picture here, taken in May 1936, Earhart is perched in the unfinished fuselage of a Lockheed Electra, purchased with funds from Purdue University, where she was an aeronautics adviser. The plane was to be her "flying laboratory," and on June 1, 1937, Earhart and her navigator, Fred Noonan, boarded it in Miami, Florida, for a flight around the world to study the effects of high altitudes and extreme temperatures on aviation equipment and human stamina. By mid-month, she had reached Karachi, India, where she spoke by phone with her husband back in the States. When he asked if she was enjoying herself, she answered, "You betja! ... We'll do it again, together, sometime." That, unfortunately, would never be. Some two weeks later, her plane disappeared over the South Pacific. To this day the exact circumstances of that disappearance remain one of the great mysteries in aviation history.

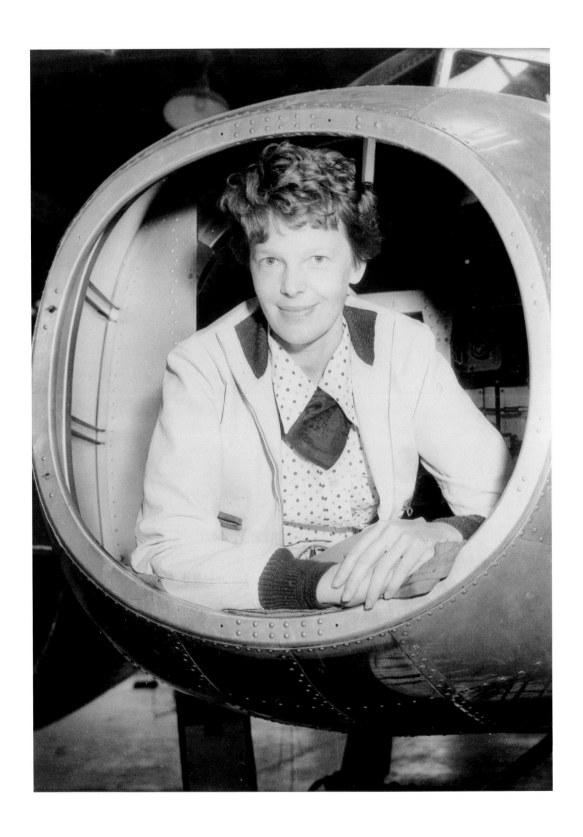

HELEN HAYES

1900–1993
ACTRESS

ALFREDO VALENTE (1899–1973)
Gelatin silver print
32.6 × 22.7 cm (12 13/16 × 8 15/16 in.), 1936

Dressed as the young Queen Victoria for the play *Victoria Regina*, actress Helen Hayes stands in this picture at height of her long career. In this play spanning Victoria's entire reign, the then thirty-five-year-old Hayes faced the task of depicting a woman from her late teens to her enfeebled old age, and she might have been forgiven if aspects of her multiaged portrayal proved less convincing than others. But forgiveness was never even an issue. From beginning to end, Hayes invested her performance with a credibility that has long been considered one of the finest moments in Broadway history and that, more than anything, ordained that one day she would be known as the "First Lady of American Theater." "It would be idle to say," wrote a critic in January 1936, "in which she is best, as the girlish queen, as the loving but spirited wife … or as the sovereign at her apotheosis.… She re-creates not only a monarch but an age."

Hayes, however, had not always seemed destined for such admiration. Having begun her theatrical career before she was ten, she was a seasoned actress by 1920, when she received her first star's billing in *Bab*. But she was by no means a great one. On opening night, reviewers found her shrill and artificial, and when she tried to overcome the criticisms in subsequent performances, she only seemed more forced. Stung by yet other criticisms over the next few years, Hayes was soon pursuing all manner of instruction—from voice lessons to interpretative dancing to fencing. Of the results of this self-improving regimen, Hayes later said, "My posture became military," and "I became the tallest five-foot woman in the world."

Height was the least of it, however. As she practiced her breathing, scrutinized her facial expressions, and gained control of her voice, Hayes vastly increased her range and credibility. By 1927, when she opened in *Coquette*, it was clear that she had matured into a first-rank talent. Recalling opening night, the play's producer, Jed Harris, claimed that he had never "seen anything like the ovation Miss Hayes received." Among the reviewers heaping praise on her was a critic who resorted to word play to remind theatergoers of just how far Hayes had traveled since playing the sub-deb title role in *Bab*. "She acts," he wrote, "with passion and authority; all her tricks and mannerisms have been … subdued to the part."

The maker of this image, Alfredo Valente, was a specialist in theatrical photography and for many years the staff photographer for *Stage* magazine. He had first photographed Hayes in 1933 when she was playing yet another monarch, Mary, Queen of Scots, in *Mary of Scotland*. Here, in her second queenly role, Hayes strikes a pose from the first scene in *Victoria Regina*, when the nineteen-year-old Victoria is called out of bed to be told that her uncle, King William IV, is dead and that she is now Britain's queen. This was the first magic moment of the play in which, according to *Time*, Hayes "by some alchemy of gesture and expression" managed to "convey in full" her character's simultaneous sense of bewilderment and delight.

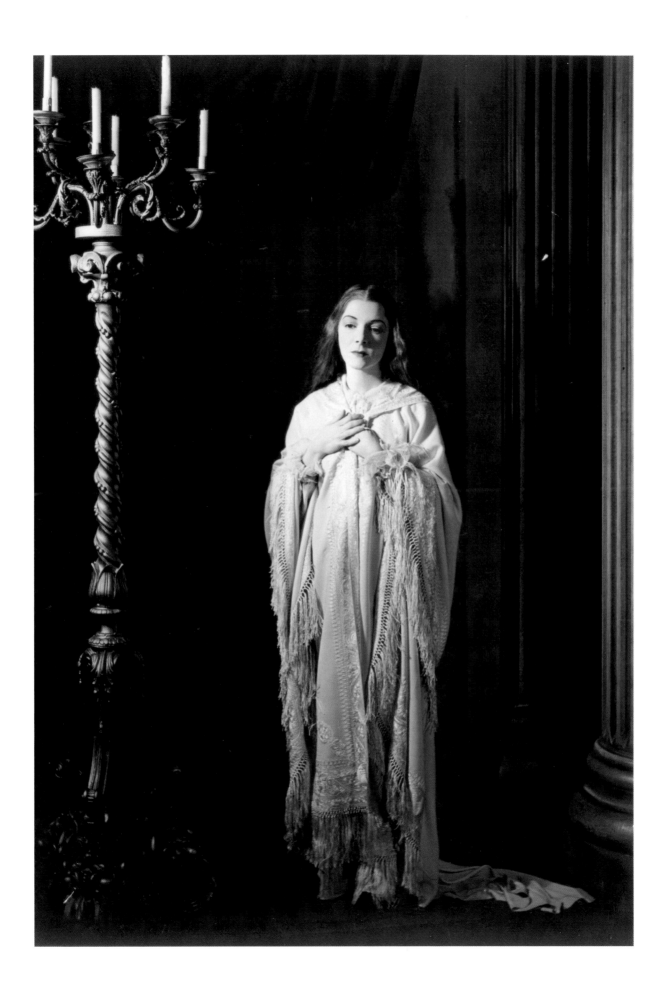

A widely accepted truism in the performing arts holds that professional dancers must begin learning their craft at an early age and that anyone starting out in dance past the age of twenty should not expect to go very far at all. On the whole, that may be true. But the twentieth century bore witness to one notable exception. Enrolling in her first dance class at the age of twenty-two, Martha Graham not only formed her own dance company, but continued to perform with it until she was seventy-five. Along the way, she choreographed more than 180 original works and became a leading figure in creating modern dance and winning its acceptance as a serious art form. Although others such as Doris Humphrey and Charles Weidman made significant contributions to that idiom, there is no disputing that the late-starting Graham can claim pride of place as the personality most universally identified with modern dance's coming of age.

Premising her approach to dance on the idea that formal movement must grow out of emotion, Graham always sought a visceral, rather than an intellectual, response from her audiences. When she started working out that principle in dance compositions for herself and her company in the 1920s, she met with a good deal of hostility that would continue for years. Summing up one of her performances, one reviewer wrote, "Ugly girl makes ugly movements onstage, while ugly mother tells ugly brother to make ugly sounds on drum." Another critic dismissed her work as "macabre" and "unhealthy," and a third called it frankly perplexing in its tendency to shift "from downright ugliness to an occasional cold beauty." But that last critic also recognized that there was a substantial body of opinion building up quite different from his own, and he knew from experience that in expressing distaste for her performances he was undertaking "perilous work" that could invite "letters comparing him, unfavorably, with Ivan the Terrible."

Graham had her first great public success in 1938 with *American Document*, a presentation in dance of key moments and themes in America's past. In a cross-country tour the work routinely drew capacity audiences. Two years later, she created *Letter to the World*, a work inspired by the poetry of Emily Dickinson. When *New York Times* dance critic John Martin first saw it, his response had a provisional tone. But after Graham revised the work, he hailed her visualization of Dickinson as "a miracle of intuition," and it is considered to be one of her masterpieces. The work that is most closely identified with her, however, is *Appalachian Spring*, which she staged in 1944 to music commissioned from Aaron Copland. In the performing arts, the work ranks among the most compelling celebrations of America's rustic heritage.

Photographer Sonya Noskowiak took this likeness in late March of 1936, when Graham and her company came to San Francisco to perform at its Opera House. The stop was part of Graham's first transcontinental tour with her company, and for the audiences who were seeing her work for the first time and finding it a bit too avant-garde, she had a ready rejoinder. "No artist is ahead of his time," she said. "He *is* his time; it is just that the others are behind the time."

MARTHA GRAHAM
1893–1991
DANCER, CHOREOGRAPHER

SONYA NOSKOWIAK (1900–1975)
Gelatin silver print
21.8 × 16.7 cm (8 9/16 × 6 9/16 in.), 1936

Anna May Wong made her film debut in 1919 as one of several hundred lantern-bearing extras in *The Red Lantern*. Blessed with a luminous complexion once likened to a "rose blushing through ivory," she was soon moving up to more substantial parts, and in 1922 she landed the female lead in Hollywood's first Technicolor movie, *The Toll of the Sea*. In 1924, her performance as a Mongol slave in Douglas Fairbanks's box office smash *The Thief of Bagdad* established her as the movie industry's leading Chinese-American actress. But being Hollywood's best known Chinese-American actress was quite different from being a leading actress of Caucasian descent. Unwilling to run counter to prevailing American prejudices, the movie industry was reluctant to accord full star status to anyone from a racial minority. As a result, the best parts were generally not offered to Wong, even when the script seemed to demand giving the plum role to an Asian actress. In 1928, for example, Wong was relegated to playing a minor character in *The Crimson City* while the Caucasian actress Myrna Loy took the film's female Chinese lead. Worse yet, she found herself all too often playing characters patterned on popularly held racial stereotypes, such as the treacherous oriental villainess.

Wanting to be free from the typecasting constraints of Hollywood, Wong left for Europe in 1928 and over the next several years made a succession of films there. In Europe, she found greater racial tolerance and was able to play starring roles that would have been denied her in the States. Still, the tolerance was far from absolute. In late 1929, when her film *The Road to Dishonor* opened in England, censors viewed the kisses between her and her Caucasian leading man as unseemly endorsements of miscegenation and ordered them cut from the film.

Returning to the United States in 1931, Wong first stopped in New York, where she had a lead role in the successful Broadway production of *On the Spot*. After the play's closing she returned to Hollywood and appeared in a succession of suspense melodramas. Among the best was *Shanghai*, starring Marlene Dietrich, and according to some observers, Wong routinely upstaged Dietrich in the scenes they shared. Though largely reconciled to playing lesser roles, Wong had her heart set in 1935 on playing the Chinese female lead of O-Lan in the film version of Pearl Buck's best-selling novel *The Good Earth*. Instead, the part went to the Caucasian actress Luise Rainer, while Wong was offered the role of a mean-spirited concubine, which she ultimately turned down. Doubtless compounding that disappointment was the fact that Rainer won an Oscar in the O-Lan role.

When Wong posed for this picture, the most active part of her screen career was nearing its close. Most likely it was taken in New York in the spring of 1937, when she was performing Chinese songs and sketches at a theater there. In an interview with the *New York Times*, she did not hesitate to express the hope that Hollywood would begin casting her in better roles. She had her eye, she said, on a part in the upcoming *Adventures of Marco Polo*, but it, unfortunately, went to someone else.

ANNA MAY WONG
1907–1961
ACTRESS

NICKOLAS MURAY (1892–1965)
Color carbro print
38.7 × 31.1 cm (15 1/4 × 12 1/4 in.), 1937

SHIRLEY TEMPLE

born 1928
ACTRESS

HARRY WARNECKE (1900–1984)
and Lee Elkins (lifedates unknown)
Color carbro print
42.5 × 32.8 cm (16 3/4 × 12 15/16 in.), 1938
Gift of Elsie M. Warnecke

"Boom in Child Stars" ran a headline in *Time*'s entertainment section of July 25, 1938, and to substantiate that assertion, the magazine went on to list the bumper crop of youngsters who were currently in great demand in Hollywood. Prominent on the roster were Freddie Bartholomew, Jane Withers, Judy Garland, and Mickey Rooney. But talented as they might be, there was one whose stardom eclipsed them all. Her name was Shirley Temple, and her curly-haired effervescence had long since made her "the most celebrated child alive." In the previous three years, she had been the movie industry's top box office draw, and she was about to claim that distinction yet again. Her fan mail often exceeded three thousand letters a week, and her annual income was thought to be in excess of five hundred thousand dollars.

One of the more interesting aspects of Temple's rise to stardom was Hollywood's slowness in sensing the magnitude of her talents. Beginning her screen career in 1932, she spent her first year appearing mostly in one- and two-reel shorts made by Educational Pictures. Then, early in 1934, in the mostly forgettable *Stand Up and Cheer*, she wowed audiences with her song-and-dance rendition of "Baby Take a Bow." Fox Studios, however, with which she had a contract, was not quick to grasp the impact of that performance. Instead of finding its own showcase for her talents, it lent her out to Paramount. But by year's end, the message had been absorbed. With her performances in Paramount's *Little Miss Marker* and Fox's *Bright Eyes* about to earn her a special Oscar for outstanding contribution to movie entertainment of 1934, it was clear that Temple was one of Hollywood's hottest properties.

She was also one of its easiest stars to work with. Even on the set in the early stages of rehearsal, Temple made it all seem effortless. She often knew the script so well that she could supply the forgotten lines of other cast members. At one rehearsal, tap dancer Bill "Bojangles" Robinson took her aside to teach her five dance numbers, and she quickly mastered them all simply by listening to Robinson's feet. On another occasion, the studio was shooting a scene where the camera followed Temple dancing down some lighthouse steps and where her lines were to coincide with her reaching certain points on the stairs and specific dance moves. This was a complicated meshing of dialogue and movement to say the least, but Temple carried it off with unruffled ease.

In the spring of 1938, Temple set out with her parents on a much-publicized cross-country tour. In mid-June, in anticipation of her arrival in New York City, the *New York Daily News* featured on the cover of its photogravure section this image by its photographer Harry Warnecke. Some easterners, unmoved by Temple's dimpled smile and sunny temperament, expressed disgust with all the attention that the press gave her visit. To these naysayers, the *New York Times* replied: "Shame on them! Shirley belongs in the very spot into which she has hurled herself—right in the great big, soft-shelled heart of America."

ELIZABETH HAWES

1903–1971
FASHION DESIGNER

RALPH STEINER (1899–1986)
Gelatin silver print
18.9 × 24.1 cm (7 7/16 × 9 9/16 in.), circa 1938

One does not have to know much about the career of fashion designer Elizabeth Hawes to understand the meaning of this strangely posed photograph of her by Ralph Steiner. In it, Hawes's left index finger is poised to depress a key on the typewriter and about to set off a chain reaction that will cause Hawes's right hand to plunge a pin into the miniature dress form. In other words, she seems on the verge of subjecting her own profession to a bit of discomfiting, voodoolike torture. No image better sums up a central strand of Hawes's fashion odyssey, and its message applies as easily to Hawes in her early days as it does to the later stages of her career.

Having gone to Paris in the mid-1920s to learn the fashion business, Hawes started out working for a concern that specialized in pirating dress designs from the city's haute couture salons. By the time she turned to reporting on French high fashion for the *New Yorker* in early 1927, her cynicism about the business that she wanted to break into had already taken firm root, and she was not afraid to show it. Signing her pieces for the magazine "Parasite," she wasted no time in registering her objections to high fashion's many vehicles for tyrannizing women into accepting its dictates. In one instance, she opened her column with a tongue-in-cheek cable that read in part, "ALL REDDISH BROWN OR BLACK PRINTS ARE SMART CHANEL SAYS SO IT MUST BE SO."

In 1928 Hawes returned to the United States and for a while eased up on her fashion-world needlings. Instead, she focused on making a go of her own couturier establishment in New York City. And make a go of it she did. By the early 1930s, working on the premise that women's clothes must be both attractive and easy to wear, she was making a considerable reputation as a designer of elegant, simple, and meticulously crafted clothes that were at once comfortable and flattering. Success, however, did not kill her impulse to cast a critical eye on her industry. In 1938 she published *Fashion Is Spinach*, in which she took deadly aim at the edicts of French couturiers that could make women feel "absolutely out of fashion" if they failed, for example, to have two silver foxes hanging around their necks. Declaring fashion "a complete anachronism in modern life," the book was a best-seller and was soon followed by *Men Can Take It*, which sought to convince men to adopt lighter and more relaxed clothing.

By now, Hawes was finding writing more engaging than making clothes, and in 1940 she closed her New York salon to write a column for the newspaper *PM*. Two years later, she gave up the column to advance the concerns of women in the labor force and for a number of years worked on the staff of the United Auto Workers. But ultimately she returned to fashion, reopening her New York salon for a short time in the late 1940s. In 1954 she came out with *It's Still Spinach*, where once again she waxed eloquent on the tyranny of fashion-world dictates and called for more self-expression in clothing.

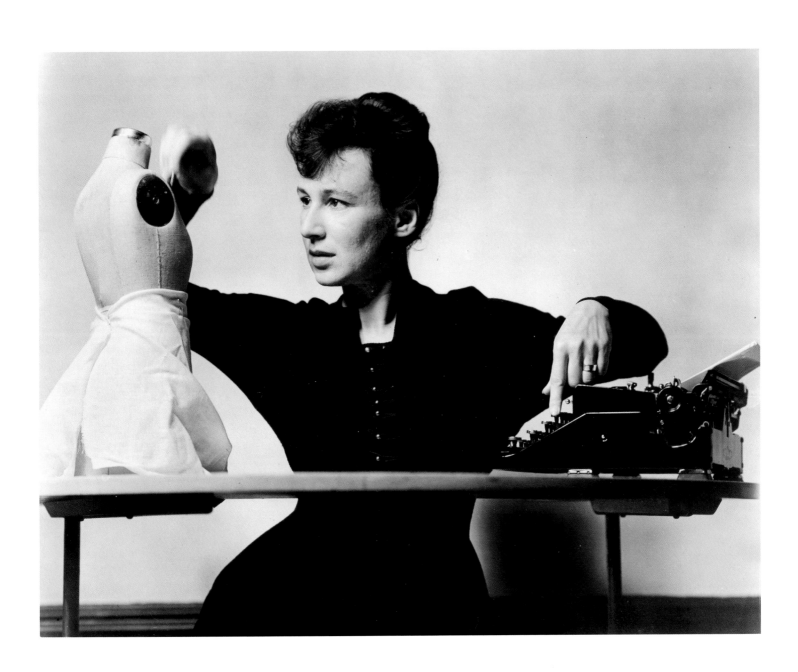

CARMEL SNOW

1887–1961
EDITOR, FASHION ARBITER

GEORGE HOYNINGEN-HUENE
(1900–1968)
Gelatin silver print
27.6 × 21.8 cm (10 7/8 × 8 9/16 in.), 1939

Described at her death as the "voice of American fashion," Carmel Snow began advancing toward that distinction working as an assistant in her mother's custom dressmaking salon in New York City. In 1921 she became assistant fashion editor of *Vogue*, where she moved up quickly. By 1929 she was serving as editor of the magazine's American edition, and it seemed likely that one day she would be its editor-in-chief. Before that could happen, however, Snow decided on a career shift, the prospects of which did not seem quite as solid as the ones she was giving up. In 1932 she left *Vogue* to become the fashion editor of *Harper's Bazaar*, a flagging competitor that had defied recent efforts to revitalize its tired pages.

But *Harper's Bazaar* was not as hopeless as it looked, at least in the hands of Snow. Raised to editor-in-chief in 1935, she made one of her most noteworthy contributions to the magazine's revival in November 1933 when she tracked down the Hungarian news-sports photographer Martin Munkacsi and took him out to Long Island to photograph models in bathing suits running down a beach. The result was a spread in *Harper's Bazaar* of action shots that offered a new twist in fashion photography and would become one of the magazine's most engaging trademarks. Equally momentous was Snow's hiring of Alexey Brodovitch as the magazine's art director in 1934. The two meshed well together, and their partnership of many years yielded a new look to *Harper's Bazaar* that was the admiration of the entire magazine business.

At the same time Snow created a more stimulating mixture in the magazine's content. Under her guidance, *Harper's Bazaar* fell into the habit of reproducing the art of modernists such as Matisse, Picasso, and Chagall. It also became more adventuresome in its literary offerings, which came to include the work of W. H. Auden, Gertrude Stein, Evelyn Waugh, Virginia Woolf, and Eudora Welty.

But above all, *Harper's Bazaar* was about the way women wanted to look, and as the magazine thrived, Snow's stature as an arbiter of fashion became formidable. The mere fact of her appearance at a dress-collection showing was enough to send a designer's spirits soaring, and she was commonly perceived as the main instrument in generating American interest in French designers Dior and Balenciaga. "You can't keep an exciting fashion down," she once said. That may have been true. Still, there was no doubt that it did not hurt to have *Harper's Bazaar*'s editor-in-chief promoting it.

The maker of Snow's portrait, George Hoyningen-Huene, was one of her earliest recruiting coups for *Harper's Bazaar*. A gifted and innovative fashion photographer, Hoyningen-Huene had worked for *Vogue* for many years. Then, one afternoon in 1935, he was lunching with other magazine staffers to discuss a renewal of his contract. Taking exception to someone's remark, he was soon strutting out of the restaurant in a rage and telephoning Snow to offer his services. Snow did not know quite what to make of this unexpected call, and she knew moreover that Hoyningen-Huene could be difficult. But she made him an offer anyway, thus snagging one of her competition's greatest assets.

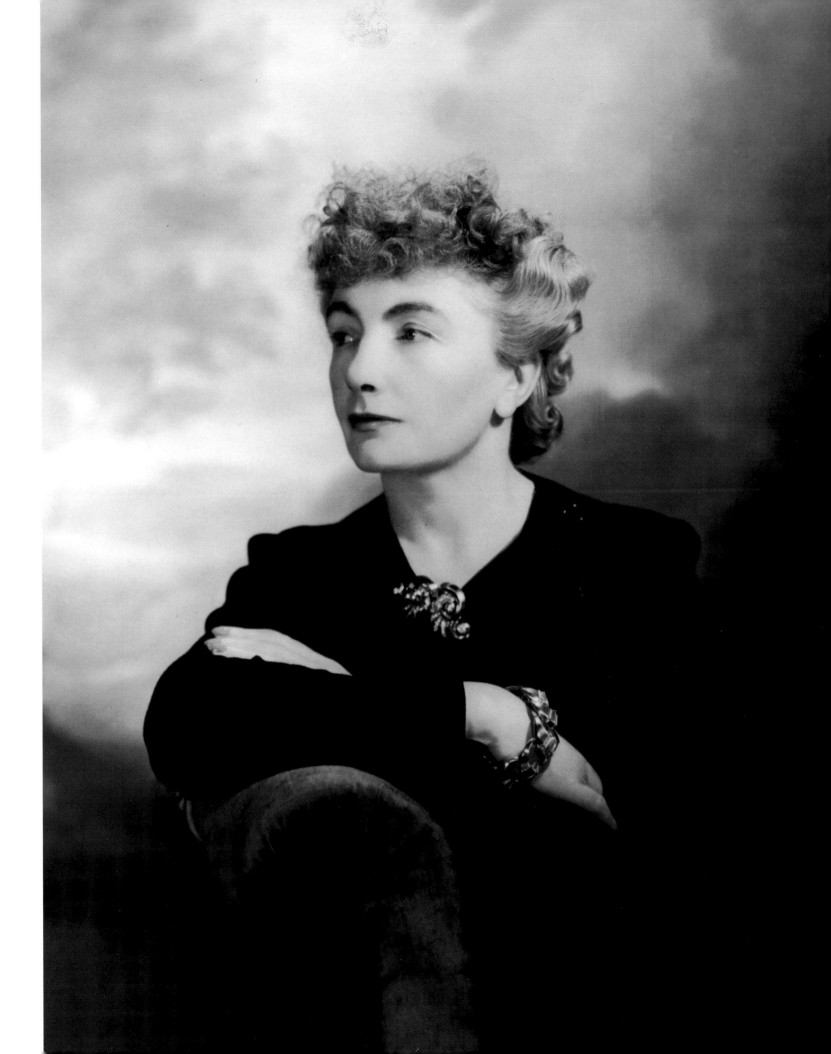

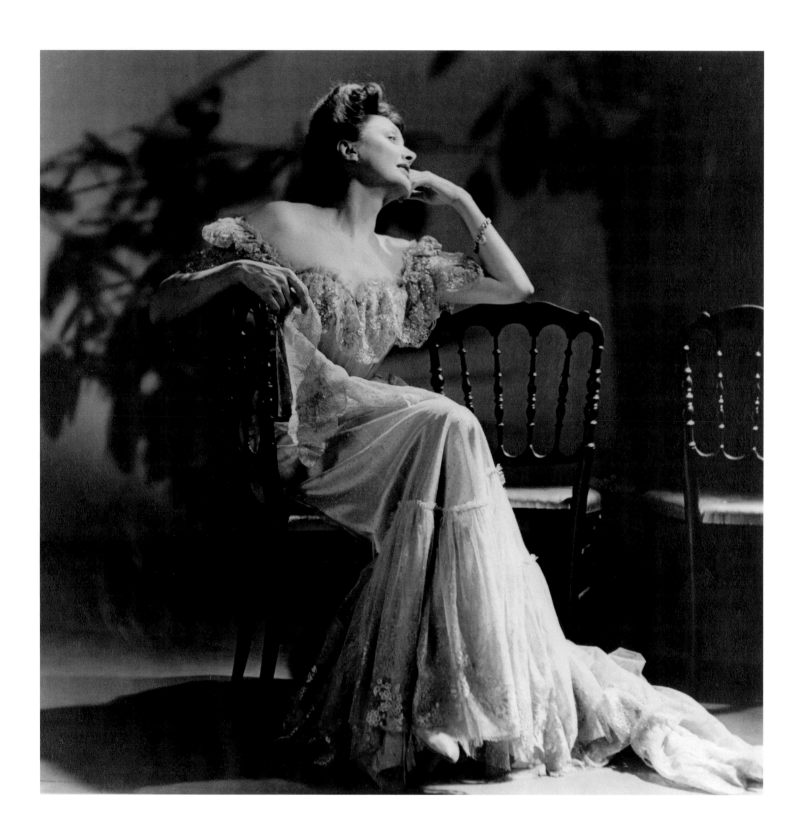

Looking back on her stage career, Katharine Cornell once confessed that her stage fright "got worse as the years went on." On days when she had an evening performance, she added, "I don't think … that I was ever happy—beginning at 4 o'clock any afternoon." Those may seem to be strange recollections, coming from someone who had chosen to become an actress entirely of her own volition. Nevertheless, they were quite genuine, and if one had to make the case for the constructive potential of stage fright, perhaps the most compelling evidence that could be cited is Cornell's illustrious career. At her death, *New York Times* theater critic Brooks Atkinson claimed that "she was born to be an actress" and that whenever she stepped out onto the stage "something electric happened."

Cornell made her first significant splash in London in 1919 when she appeared as Jo March in a stage version of *Little Women*, and over the next several years, she drew increasingly favorable reviews in a series of mostly undistinguished plays. In late 1924, however, she claimed the title role in a New York production of a play that was worthy of her talents, George Bernard Shaw's *Candida*. Her performance, which one critic said "had something in it of the light of another world," marked the first step toward becoming one of the legends of the American stage.

The final consolidation of that legend began six years later, when Cornell bought the production rights for *The Barretts of Wimpole Street*. Initially she regarded this purchase more as a gift for her director husband, Guthrie McClintic, than as an acting opportunity for herself, and she, in fact, did not think she was appropriate for the female lead of Elizabeth Barrett Browning. Her husband, however, persuaded her otherwise. In early 1931, the play opened in New York to rave reviews that reserved a good deal of their praise for Cornell, hailing her, among other things, as "an actress of the first order." The next several years brought yet more triumphs, including her lead performances in *Romeo and Juliet* and Shaw's *St. Joan*.

Cornell greatly lamented the toll that the advent of talking movies had taken on the touring theater business, and in partnership with her husband, she spent much of her talent and resources revitalizing the touring company tradition. Her efforts did not go unappreciated. On one occasion, when train delays caused her company to arrive in Seattle after 11:00 p.m. the evening of its scheduled opening, it was assumed that the first performance would be delayed to the next day. The expectant ticket holders, who had waited patiently for the cast's arrival, were having none of that, however, and the curtain went up on a much-gratified cast at 1:05 a.m.

Cornell is pictured here as the female lead in a 1941 production of Shaw's *Doctor's Dilemma*. The likeness's maker, Louise Dahl-Wolfe, worked for many years at *Harper's Bazaar*, where she did both fashion and celebrity photography. She was long regarded as the one of the world's leading fashion photographers, and her pictures of elegantly clothed models were widely admired for their innovative composition.

LOUISE DAHL-WOLFE (1895–1989)
Gelatin silver print
28 × 27.1 cm (11 × 10 11/16 in.), 1941

MARY LOU WILLIAMS

1910–1981

JAZZ PIANIST, COMPOSER,
ARRANGER

GJON MILI (1904–1984)
Gelatin silver print
33.9 × 26.7 cm (13 3/8 × 10 1/2 in.), 1943

When *Life* magazine ran a photo essay in late 1943 featuring moments at a late-night jam session of New York jazz musicians, the caption beneath this image of pianist Mary Lou Williams described her as "one of the very few capable female jazz musicians." There might have been some other women in the jazz world who regarded that characterization as unfairly exclusionary. At the same time, however, it hardly did justice to Williams. She was not merely "capable." As both a performer and composer-arranger, she was superb. "If you shut your eyes," noted one who had recently seen her play, "you would bet she was man." In an age that still harbored strong doubts about women's fitness for so many professional endeavors, this was high praise indeed, especially in an art form that prized musicianship of the more vigorous sort.

Endowed with an astonishing musical memory, Williams began learning to play the piano as a toddler. By the age of two and a half, she could play tunes. At twelve, she began touring with a revue, and within another year, she was playing with a small band in vaudeville. By 1930, she was in Kansas City performing with the Clouds of Joy Orchestra and being billed in its advertising as "The Lady Who Swings the Band." In addition to playing the piano, she was soon serving as the group's chief musical arranger. Her scores, such as "Walkin' and Swingin'" and "Froggy Bottom," made Clouds of Joy one of the most popular swing bands of the 1930s. They also led to requests for her arrangements from other top musicians, including Louis Armstrong and Earl Hines.

In 1942 Williams moved to New York, where she eventually became a featured performer in nightclubs. There she got to know Thelonious Monk, Dizzy Gillespie, and Charlie Parker, who were fomenting the bebop revolution in jazz, and after mastering the new style, she joined them as one of its proponents. In 1945 she expanded her range in yet another direction by writing *Zodiac Suite*—twelve symphonic jazz pieces, each evoking a certain musician from Claude Debussy to Ellington. The following year, the New York Philharmonic Orchestra premiered three of the work's movements at Carnegie Hall.

In 1954, fed up with the commercial demands on jazz, Williams retired to devote herself to charitable endeavors which led, in turn, to a religious reawakening and conversion to Catholicism. By 1957, however, she was ready to return to her music, and she continued to perform into the 1970s. In her composing, she turned to religious themes. Among her most notable later works were three jazz masses, including one called "Mary Lou's Mass" that served as the score for a ballet choreographed by Alvin Ailey in 1971.

The jam session where this picture was made took place in the photographic studio of Gjon Mili and had been convened by *Life*'s entertainment editor. "Every great in jazzdom who happened to be in town," Mili later recalled, was there—from Duke Ellington to Billie Holiday. For the photographer, the event was "a revelation, not for the music itself … but as a spectacle *non pareil*."

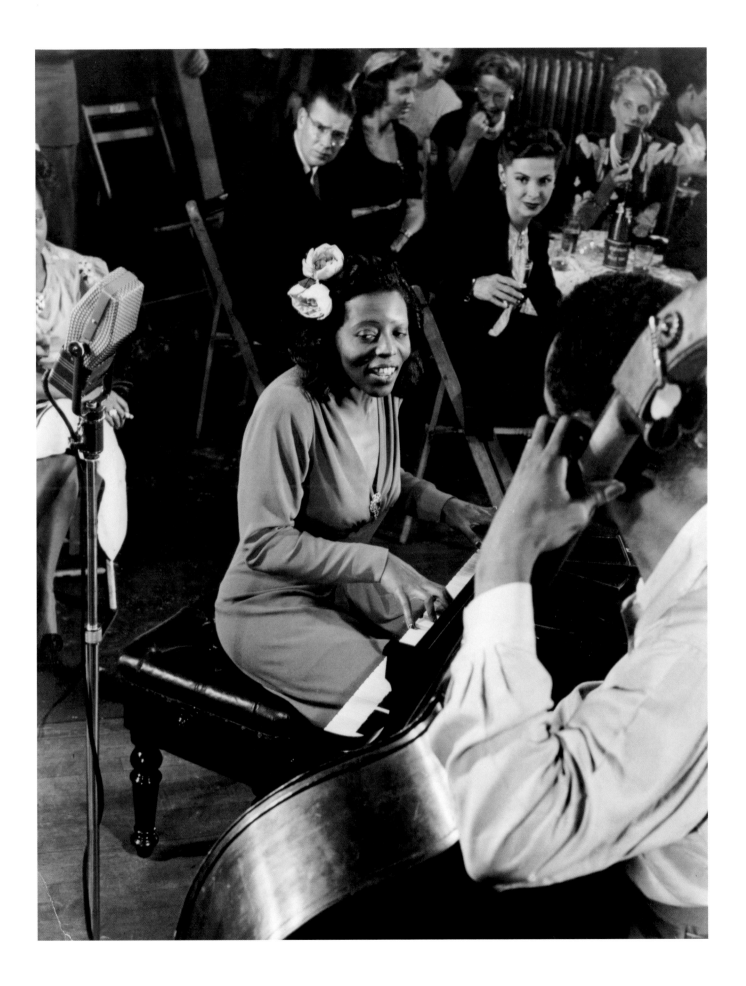

There is a vulnerable, waiflike quality to this somber image of Dorothy Parker. As she clutches herself, it almost seems as if she is seeking protection against some unseen threat. Her friend and fellow writer Alexander Woollcott once described Parker as an "odd … blend of Little Nell and Lady Macbeth," and it would appear that as she posed at age fifty before photographer George Platt Lynes, it was the Little Nell part of that peculiar blend that his camera captured.

But the public perceptions of this critic, poet, and short story writer tilted more in the direction of Lady Macbeth. That is not to say that Parker had a taste for regicide. She did, however, have a sharp wit that, figuratively speaking at least, could be quite as lethal as any Scottish regicide's dagger. As an early contributor to the *New Yorker* and member of New York's legendary Algonquin Round Table of literati and journalists in the 1920s, she came to enjoy a celebrity built largely on her gift for coining devastating barbs and bon mots. In reply to the young man who said that he could not abide fools, for example, she mused, "That's queer. Your mother could." And when challenged to come up with a homonymic usage of horticulture, she coined the adage: "You can lead a whore to culture but you can't make her think." As for her own epitaph, she said that it should read "Excuse my dust."

Parker's writing career began in about 1915, when *Vogue* hired her to compose captions. Two years later *Vanity Fair* made her a drama critic, a position she held until the scathing tone of her reviews proved more than some of the magazine's theatrical advertisers could abide. By the late 1920s she had become a staff book reviewer for the *New Yorker*. She also produced a great deal of poetry—best remembered for its blend of tragic perceptions and jaded wisecracks—and in the 1930s she went to Hollywood to work as a screenwriter. The most enduring aspect of Parker's output, however, were her short stories. Armed with a splendid ear for dialogue, she set her tales in the cosmopolitan upper-class world of New York City and focused largely on the darker side of male-female relationships. Her "Big Blonde" claimed the prestigious O. Henry Prize in 1929, and at their best, her stories have often been compared favorably to the work of Ring Lardner and Ernest Hemingway.

The sense of vulnerability apparent in Parker's likeness of 1943 was probably no accident. Beneath the wisecracking confidence of her exterior, she had always been a fundamentally insecure and emotionally unstable person. With the most productive part of her career in the past and her marriage to Alan Campbell going through one of its many rocky periods, it may have been inevitable that any picture of Parker at this moment in her life would be less than ebullient. But despite her unhappiness, Parker could still turn a witty phrase. Musing on being over fifty, she observed that it was not worth lying about age anymore. After all, she said, "What's a couple of sandspits to an archipelago?"

DOROTHY PARKER
1893–1967
WRITER

GEORGE PLATT LYNES (1907–1955)
Gelatin silver print
22.8 × 19 cm (9 × 7 1/2 in.), 1943

PEARL PRIMUS

1919–1994
DANCER, CHOREOGRAPHER

LISETTE MODEL (1906–1983)
Gelatin silver print
27.6 × 34.7 cm (10 7/8 × 13 11/16 in.), 1943

After graduating from Hunter College in 1940, Pearl Primus intended to become a physician. However, when she sought to finance her medical schooling as a laboratory technician, she found that opportunities in the area were not open to blacks, and to make ends meet she turned to the National Youth Administration, the New Deal organization established to provide employment for young people during the Depression. The NYA initially assigned her to work in wardrobe for a dance group. But not long afterward, she became an understudy, and with that, her notion of what she ought to do with her life began a radical transformation. Suddenly Primus found that she had an extraordinary gift for dancing. In the summer of 1941, she won a scholarship at New York City's New Dance Group, which in turn led to instructional opportunities with Martha Graham and Doris Humphrey. Within another year, she was committed to dancing as a full-time vocation. By then she had also begun to formulate an agenda for her dancing that was focused on dramatizing the black American experience.

In early 1943, she gave her first professional concert at New York's 92nd Street Young Man's Hebrew Association (YMHA). The concert featured *African Ceremonial*, a piece inspired by Primus's museum and library studies of African culture, and *Strange Fruit*, a composition focused on the most brutal expression of white racism in America, the mob lynchings of blacks. The thematic content and quality of Primus's performance made for a compelling meld. "If ever a young dancer," effused *New York Times* dance critic John Martin, "was entitled to a company of her own … she is it."

Primus is seen in this photograph performing yet another of her triumphs at the YMHA, *Hard Times Blues*, a piece that evoked the brutal realities of the southern share-cropping system that had entrapped so many black farmers since the Civil War. Primus's stiff-necked, contorted stance in the picture offers strong hints of what would soon become a trademark of her style—her vigorous athleticism. Commenting on that athleticism, *Time* declared several years later, "Pearl Primus is no filmy ballerina. Her forte is force."

Soon after her YMHA debut, Primus began a ten-month engagement at Manhattan's Cafe Society Downtown. In 1944 she formed the dance troupe that critic Martin had said she deserved, and in the fall the group opened at a Broadway theater to much critical praise.

A trip in 1948, financed by a grant from the Rosenwald Foundation, took Primus to Africa, where she studied tribal dance tradition. Several years later, she traveled to the West Indies to study the black dancing heritage there, and ultimately these sojourns provided the inspiration for many new dance compositions and vastly enlarged her ability to impart the cultural meanings of dance within the black heritage. Eventually earning a doctorate in anthropology, she had a profound influence on several generations of African American dancers. As for what her career had most meant to her, Primus once said, "Dance is my medicine.… [It] is the fist with which I fight the sickening ignorance of prejudice."

In the story of the journalistic coverage of World War II, some of the correspondents charged with reporting the war's events seemed to emerge as news items in themselves. Perhaps the best case in point was *Life* photographer Margaret Bourke-White, seen here in a studio photograph by Philippe Halsman. Taken in 1943, the neatly composed image seems to belie the reputation that Bourke-White was earning of late as an aggressive frontline wartime photographer. The only American photographer in Moscow when Hitler invaded the Soviet Union in June 1941, she had scooped her entire profession with her dramatic pictures of the first German night air raids over Moscow, and her success in finagling a photo session with the reclusive Joseph Stalin was sufficiently newsworthy to make it a *Life* feature story. Then, in late 1942, she again became part of her own photo story when, on her way to the Allied front in Africa, the boat she was on was sunk by a German torpedo. Suddenly, she was recording for *Life* the scramble for survival that she was sharing with her fellow passengers. Not long afterward, she also became the first woman allowed to go on a combat flying mission. When *Life* ran the resulting pictures in March 1943, the headline read "Life's Margaret Bourke-White Goes Bombing." In short, when it came to newsworthiness, Bourke-White sometimes ranked right up there with the generals and admirals.

Bourke-White's reputation, however, did not just rest on her wartime exclusives. Practically from the moment she embarked on photography in the late 1920s, her work was impressive. By the early 1930s she was widely respected as an architectural and industrial photographer. In 1936 she supplied the cover image for the maiden issue of *Life*, and over the next several years, her contributions helped to establish its preeminence in the evolution of the photographic news essay. Listed in 1935 as one of the ten most successful women in New York City, she gradually shifted her focus from mechanistic and structural subjects to people, and to remarkably good effect. Her collaboration with novelist Erskine Caldwell in documenting the human texture of southern sharecropper poverty yielded a classic in photographic reportage, *You Have Seen Their Faces*. In one review, the critic said that Bourke-White's photographs were "almost beyond praise." By the advent of World War II, Bourke-White thus ranked at the top of her profession, and in 1940 *U.S. Camera* declared her "the most famous on-the-spot reporter the world over."

Bourke-White's fame, however, by no means guaranteed that all her photographic ventures would be unalloyed triumphs. Not long after posing for this photograph in New York, she went back to covering the war, this time in Italy. Included in her work there were scores of pictures of an army field hospital trying desperately to tend to the wounded while under fire from the enemy. It was, in Bourke-White's estimation, some of her finest work. Unfortunately, while going through wartime censorship, the best pictures were lost. When she learned of this carelessness, she recalled years later, "I was wild." "It does no good," she added, "when wisecrackers remark, 'Anything can happen in the Pentagon.' The wound remains unhealed."

MARGARET BOURKE-WHITE

1906–1971
PHOTOGRAPHER

PHILIPPE HALSMAN (1906–1974)
Gelatin silver print
35.8 × 26.8 cm (14 1/8 × 10 1/2 in.), 1943
Gift of Irène Halsman

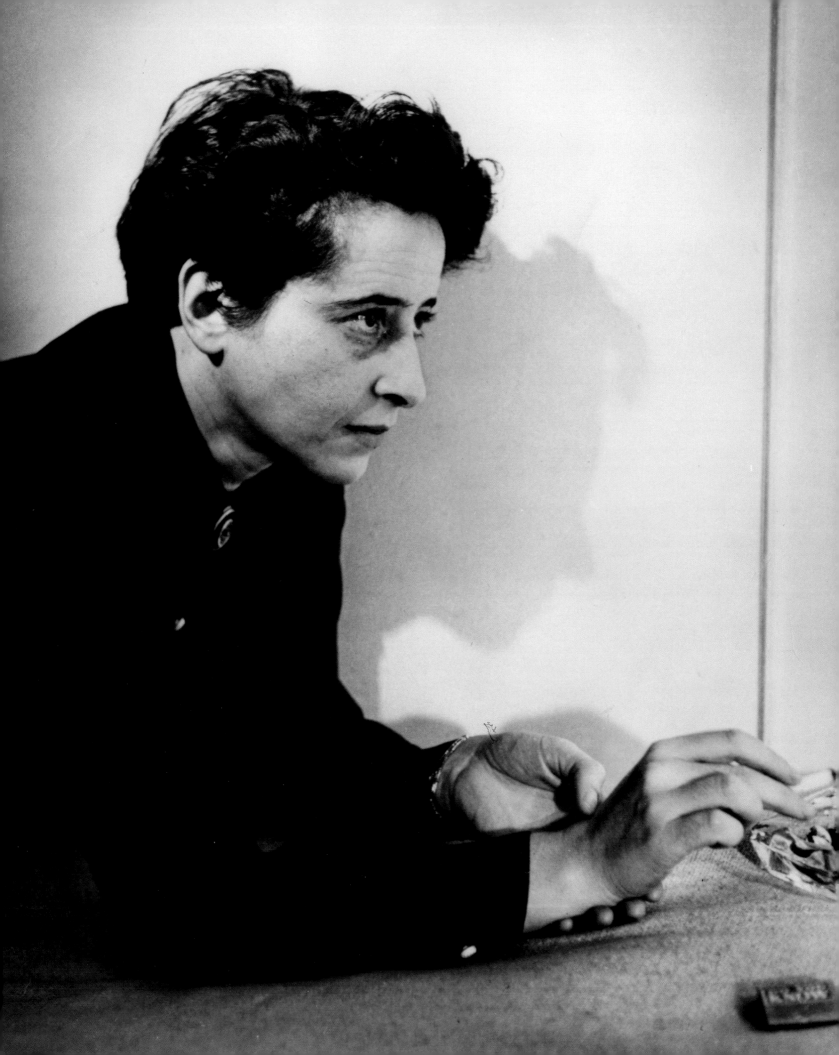

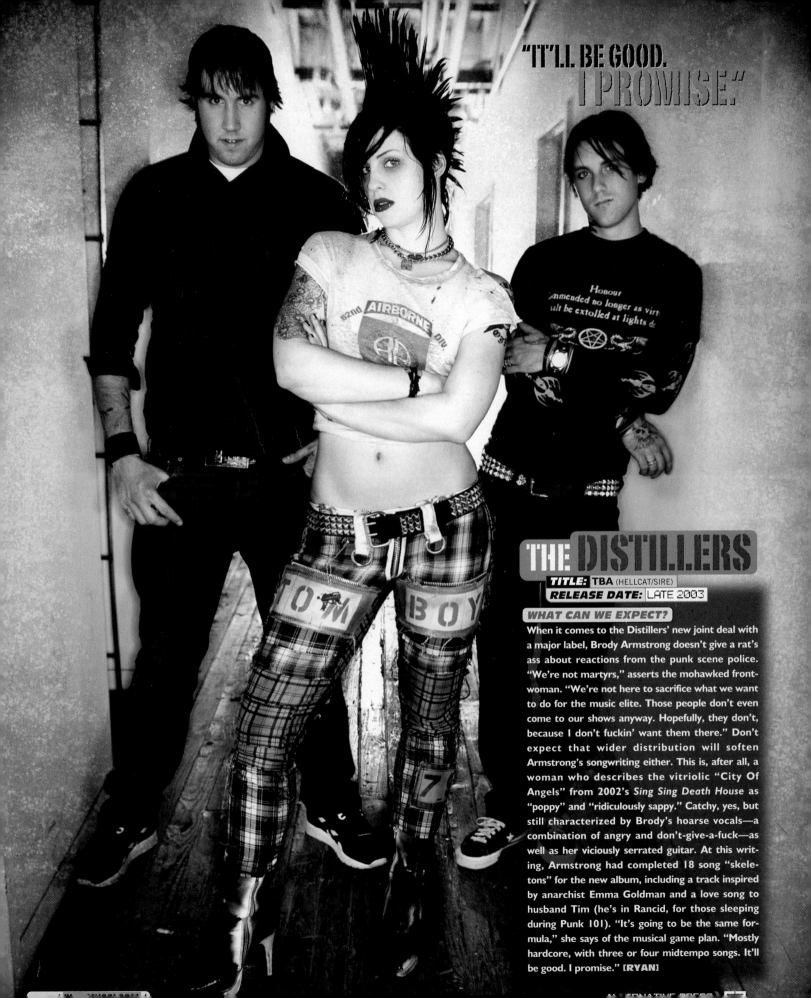

"IT'LL BE GOOD.
I PROMISE."

THE DISTILLERS

TITLE: **TBA** (HELLCAT/SIRE)
RELEASE DATE: LATE 2003

WHAT CAN WE EXPECT?

When it comes to the Distillers' new joint deal with a major label, Brody Armstrong doesn't give a rat's ass about reactions from the punk scene police. "We're not martyrs," asserts the mohawked front-woman. "We're not here to sacrifice what we want to do for the music elite. Those people don't even come to our shows anyway. Hopefully, they don't, because I don't fuckin' want them there." Don't expect that wider distribution will soften Armstrong's songwriting either. This is, after all, a woman who describes the vitriolic "City Of Angels" from 2002's *Sing Sing Death House* as "poppy" and "ridiculously sappy." Catchy, yes, but still characterized by Brody's hoarse vocals—a combination of angry and don't-give-a-fuck—as well as her viciously serrated guitar. At this writing, Armstrong had completed 18 song "skeletons" for the new album, including a track inspired by anarchist Emma Goldman and a love song to husband Tim (he's in Rancid, for those sleeping during Punk 101). "It's going to be the same formula," she says of the musical game plan. "Mostly hardcore, with three or four midtempo songs. It'll be good. I promise." [RYAN]

TITLE: **TBA** (INTERSCOPE)

RELEASE DATE: LATE SUMMER 2003

WHAT CAN WE EXPECT?

Guitarist Wes Borland walked out of Limp Bizkit over a year ago and hasn't regretted a thing. Borland says his first post-Bizkit project, Big Dumb Face, "will rise again," but now he's concentrating on Eat The Day, a new ensemble best described as an asylum for the musically insane. While creativity is at an all-time high at Day-care, the only thing holding up Wes, brother Scott and drummer Greg Isabelle is the lack of a vocalist.

Scott: We've been saying 350 for the last four days, so it's way more than that. We're looking for someone unique, and about 0.2 percent of the demos we've received are unique.

Greg: It was pretty comforting that we didn't receive a whole lot of demos from rappers.

Wes: I know that the Dillinger Escape Plan found their singer by posting some songs online and having people sing over them. The problem with the right guy showing up is that people only know me from my last band, so we might have to show that the music is not like that.

band sound?

Wes: To explain it to you is like telling you an inside joke without the punchline. Hard, grooving metal; really progressive with lots of synthesizers; seven-minute-long songs... It's not a tailor-made-for-radio kinda thing.

Greg: We don't write hits.

Wes: And if we do, it's an accident. **[JP]**

"IT'S NOT A TAILOR-MADE-FOR-RADIO KINDA THING."

Hannah Arendt and her portrait photographer, Fred Stein, had a great deal in common. Both of German-Jewish origin, they had fled Germany shortly after the rise of Hitler and the onset of his anti-Semitic policies in 1933. Well educated—he as a lawyer and she with a doctorate in philosophy—they had both originally sought refuge in Paris, and then, when the Germans invaded France in 1940, they had both fled to America and settled in New York City. And in the midst of these upheavals in their lives, neither had been able to pursue career paths for which their educations had prepared them. Thus, when Stein turned his camera on Arendt to make this informal likeness in 1944, the trained jurist had long since decided to make his way as a professional photographer. Similarly, Arendt, who in more settled times might have occupied a professor's chair at a European university, was making her living as a freelance journalist and research director for the Conference on Jewish Relations.

Arendt, however, had not divorced herself entirely from her academic past. By the late 1940s, she was at work on a volume probing into the cultural and political conditions that had led to Hitler's dictatorship and the absolutism of the Soviet Union's Stalin. Titled *The Origins of Totalitarianism*, the book created a sensation at its publication in 1951 and earned Arendt a reputation as a political theorist and historian to be reckoned with.

After *Origins* came many invitations to teach and lecture. In the coming years Arendt held academic positions at a number of schools, including Princeton, the University of Chicago, Cornell, and the University of California at Berkeley. Meanwhile, she continued to write, and in 1958 she published *The Human Condition,* in which she examined society's preoccupation with survival and the modern-day lack of zest for the life of the mind. Some faulted the book for its lack of clarity. Others could not praise it enough. One critic characterized her analysis as "the combination of tremendous intellectual power with great common sense." At the publication of a collection of her essays, *Between Past and Future*, three years later, another admirer declared Arendt "one of the most brilliant … of living political philosophers."

In 1962 Arendt went to Jerusalem to report for the *New Yorker* on the trial of German war criminal Adolf Eichmann, who had had a significant role in the Nazi effort to exterminate Europe's Jews during World War II. Her reportage ultimately reached book form under the title *Eichmann in Jerusalem: A Report on the Banality of Evil*. Among the most intriguing insights in that work was how ordinary the perpetrator of such brutality seemed to be. That characterization incensed many, who saw it as an exoneration of Eichmann, while Arendt saw it as a warning of all the pedestrian forms that evil can take.

One of Arendt's most endearing traits for her friends and students was her abiding delight in the free interchange of ideas. Her publisher once confessed to her that he had borrowed some of her thoughts for a paper he was writing, apparently without acknowledging the source. "Isn't that marvelous! That's what it's for," she replied.

HANNAH ARENDT
1906–1975
POLITICAL PHILOSOPHER

FRED STEIN (1909–1967)
Gelatin silver print
35 × 27.7 cm (13 3/4 × 10 7/8 in.), 1944
(printed 1987)
Gift of Peter Stein

MARIAN ANDERSON

1897–1993
SINGER

PHILIPPE HALSMAN (1906–1979)
Gelatin silver print
34.7 × 27.3 cm (13 11/16 × 10 3/4 in.), 1945
Gift of George R. Rinhart

Photographer Philippe Halsman depicted Marian Anderson in the manner that she most wanted to be known—as a concert singer in the act of performing. But by the time Halsman made this picture in 1945, Anderson was more than a widely acclaimed singer whose contralto voice numbered among twentieth-century music's greatest miracles. Since 1939, when she was barred on racial grounds from singing at Constitution Hall in Washington, D.C., she had been a potent symbol of the drive for racial equality. And Anderson's Easter Sunday concert at the Lincoln Memorial, which had been offered as an alternative to the denied Constitution Hall, was an event that would be cited forever after as a defining moment in America's black civil rights movement. Recalling being there that day to hear Anderson, African American singer Todd Duncan said, "I have never been so proud to be an American.... I have never been so proud to be an American Negro."

Anderson's singing career began in the children's choir of the Union Baptist Church in her native Philadelphia, and by her mid-teens, the church was sufficiently appreciative of her gifts to raise funds for voice lessons from a locally prominent singing teacher, Giuseppe Boghetti. At her audition, Boghetti was so overwhelmed with her performance he could not move, and in 1925 he entered her in a New York Philharmonic Orchestra voice contest, in which she claimed first place. Owing to the current racial climate, however, Anderson's attempts to establish herself as a concert singer in the United States met with little success. As a result, she spent much of the early 1930s performing in Europe, where audiences took to her immediately. It was reported that at a meeting with Finland's composer Jean Sibelius, he initially offered her coffee, but once hearing her voice, he called for "champagne!" In Salzburg, conductor Arturo Toscanini told her, "A voice like yours is heard once in a hundred years."

In the face of such accolades, Anderson's own country could overlook her no longer. Returning to the United States in late 1935, she made her first concert stop at Carnegie Hall. With one foot in a cast as a result of a mishap on her homeward-bound ship, she had to support herself mostly on one leg and leaning against a piano. Nevertheless, she held her audience spellbound. One critic declared that "she returns to her native land one of the great singers of our age."

Anderson's concert repertoire included German lieder and African American spirituals. She also sang arias from operas, but racism kept her from performing in the productions of any major opera company. That changed in 1955, when at fifty-seven she appeared at the Metropolitan Opera in Verdi's *Un Ballo in Maschera*. Anderson's role was small, and her voice was past its peak. Still, the audience was enraptured. As the cry rose up for "Anderson! Anderson!" at the curtain call, many wept. The object of that emotionalism had always remained detached from civil rights agitation, saying she was not "designed for hand to hand combat." Nevertheless, by dint of talent and dignity, she had poked openings in this country's racial barriers that most hot-blooded activists only dreamed about.

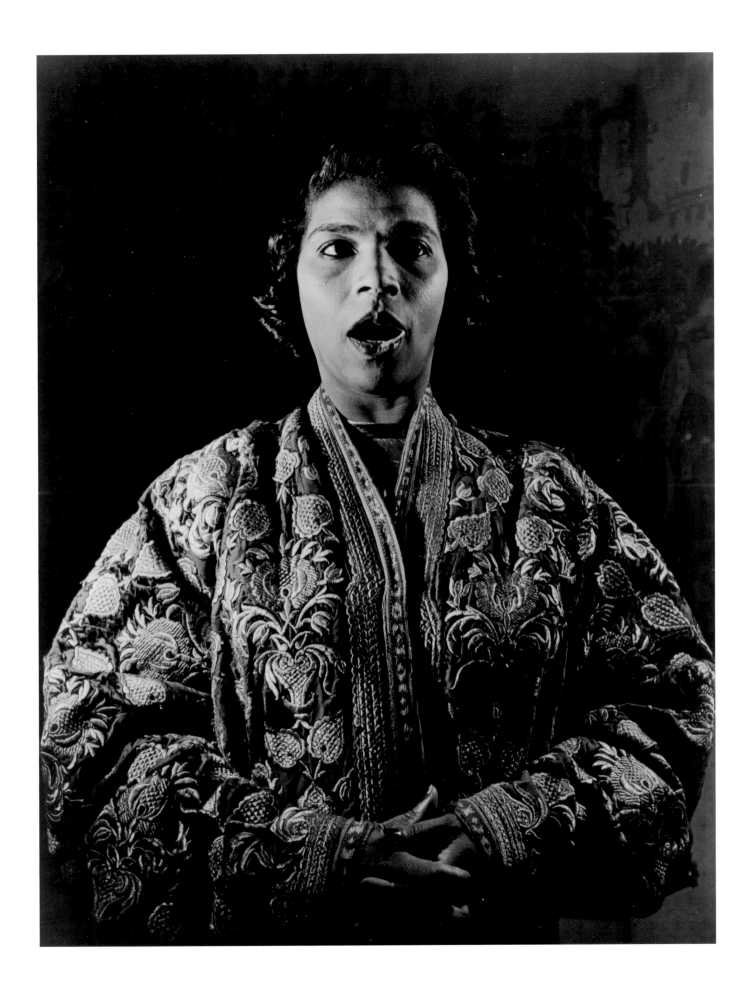

PEGGY GUGGENHEIM

1898–1979
ART DEALER, PATRON

ANDRÉ KERTÉSZ (1894–1985)
Gelatin silver print
34.8 × 27.8 cm (13 11/16 × 10 15/16 in.), 1945

She had been born into the Guggenheim family that had made millions in copper and ore refining, and she grew up in luxury. Thanks to her father's mishandling of investments, however, Peggy Guggenheim inherited only a modest fortune. Still, it provided enough income to live reasonably well, and after a few years of holding some nondescript jobs and a brief flirtation with left-wing radicalism, she took off for Europe. There, she settled into the life of an unfocused expatriate bohemian that brought her into contact with avant-garde literati and artists and ultimately included one failed marriage and a number of lovers. As one observer put it, Guggenheim was "a member not of the Lost, but of the Mislaid Generation."

But by age thirty-nine, she was bored with being a backdrop figure in Europe's artistic circles. She wanted an enterprise of her own. Vacillating between founding a publishing house and running an art gallery, she opted for the latter and decided that the gallery should specialize in modernism.

Opened in London in 1938, the Guggenheim Jeune Gallery was a losing proposition, but by the time that became apparent Guggenheim was in too deep to get out. As long as she was going to lose money, she decided that she might "just as well lose a lot more" by assembling a collection of modern art and creating a museum for it. Soon she was traveling through Europe snapping up works by such figures as René Magritte, Alberto Giacometti, and Georges Braque. The outbreak of World War II, however, forced a modification in her plan to establish the museum in London, and the venture's venue shifted to New York City.

In late 1942, Guggenheim opened Art of This Century, a combination museum and commercial art gallery on New York's West 57th Street. The city had never seen such a vast array of modernism, from Fernand Léger and Piet Mondrian to Wassily Kandinsky and Juan Gris. The conventionally minded did not know what to make of it all, but the more adventurous were warmly enthusiastic. While one critic congratulated Guggenheim on her "rare discrimination," another—bowled over by "a sense of wonders never ceasing" —declared Manhattan's newest gallery a "must."

Art of This Century only lasted until 1947, when Guggenheim moved to Venice and installed her collection in a renovated palazzo that is today a public museum. But in its brief existence, its proprietor exercised a considerable impact. Guggenheim numbered, for example, among the first to recognize the virtues of abstract expressionism, and it was her gallery that provided members of that school, such as Jackson Pollock and Mark Rothko, with some of their earliest support and patronage.

In this photograph, Guggenheim sits looking toward a concave mirror in her New York apartment. On the closet doors hang an assortment of the showy earrings that she favored and often used as wall decorations. The picture has a surreal feel to it, a trait that was frequently found in the work of its maker, André Kertész, and that echoes the surrealist painting behind Guggenheim, *The Break of Day* by Belgian artist Paul Delvaux.

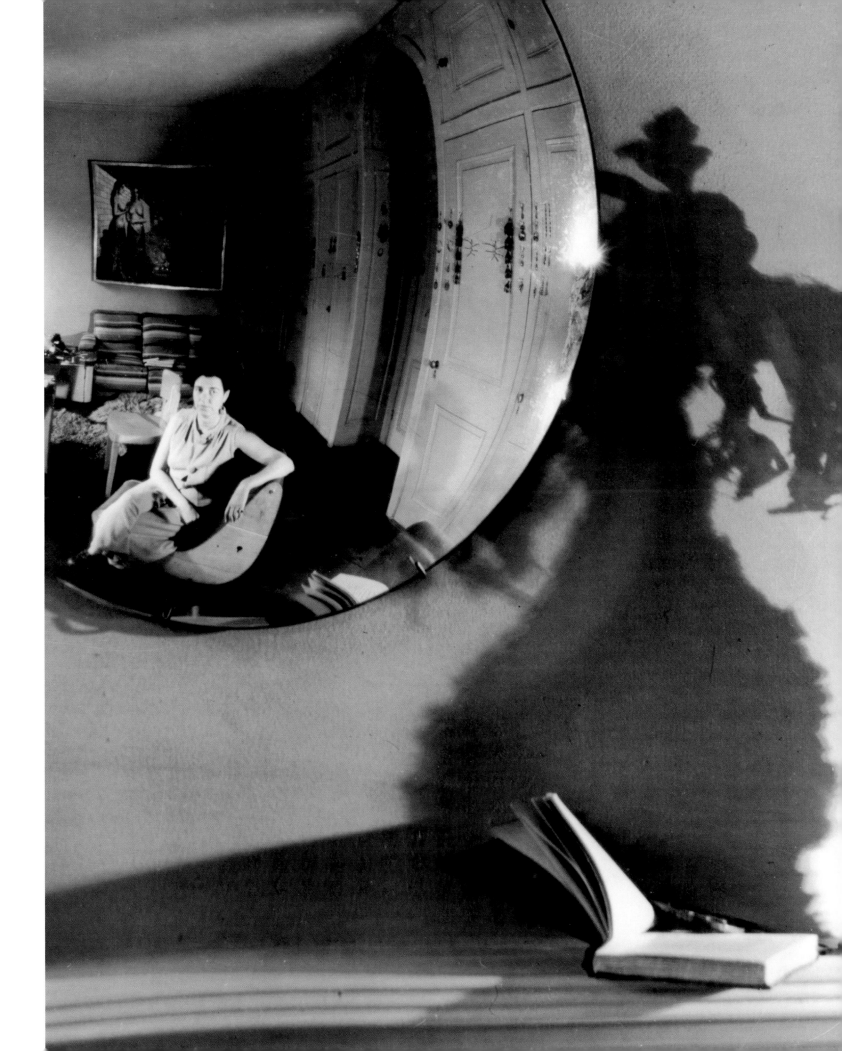

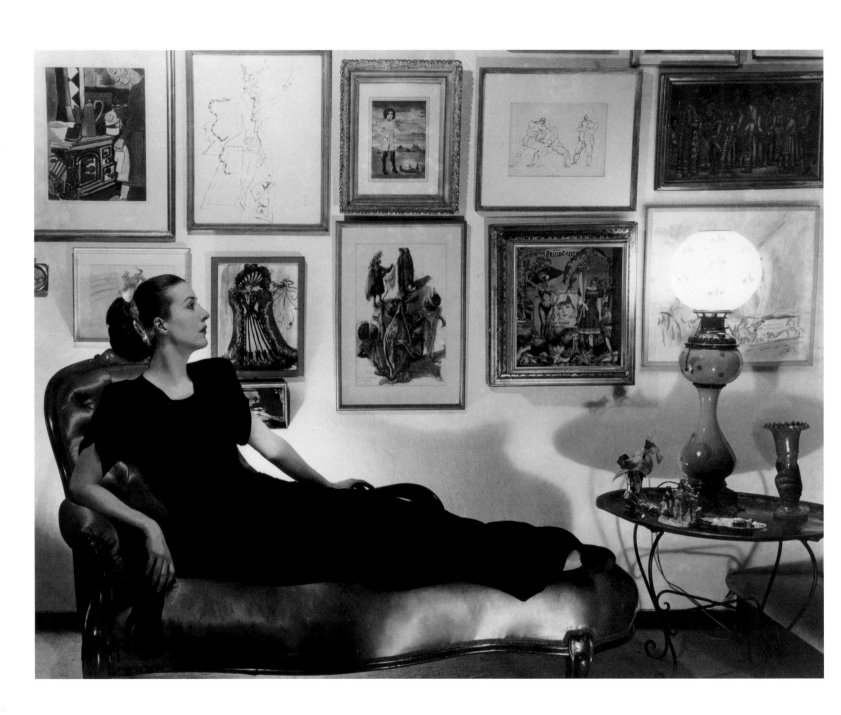

The future Gypsy Rose Lee began life as Rose Louise Hovick, the daughter of a ruthless stage mother who had Rose performing with her younger sister June on the vaudeville circuit by the time she was seven. Because Rose Louise was not deemed as cute, sister June got top billing, while Rose was relegated to a small support chorus of newsboys. The arrangement proved lucrative; at its height, the act earned fifteen hundred dollars a week. But then "Dainty June" eloped with one of the chorus, and it was left to Rose Louise to lead the act. Unfortunately, bookings in vaudeville were drying up. Finally, in 1929, Rose Louise and her act found themselves in Kansas City with no prospects for employment in the usual quarter, and they began accepting bookings at burlesque houses. Several months later, at a burlesque house in Toledo, Ohio, Rose Louise—then fifteen—agreed to fill in for one of the show's stripteasers who was in jail. So began Rose Louise's transformation into Gypsy Rose Lee, America's most famous practitioner in the art of disrobing.

The secret of Lee's success was a coy sophistication that often withheld from audiences some of what they expected without making them feel cheated. As Lee herself once explained, "You don't have to be naked to look naked. You just have to think naked." Armed with that outlook, she soon eclipsed her more blatantly suggestive competitors. According to Billy Minsky, proprietor of the leading New York burlesque house, she purged the striptease of its bump-and-grind crudities and turned it into "seven minutes of sheer art." And she made no apologies for what she did, either. "She peddles her act," wrote one observer, "shrugging off the moral issues figuring that she has a commodity for sale which people are going to buy anyhow."

Lee also had a good mind, and although her mother had ignored her educational needs, she had done rather well at educating herself. The evidence of intellect broadened her allure and enhanced her respectability. Pundit H. L. Mencken, feeling that the stripper's profession as practiced by her deserved more dignity, declared her an "ecdysiast," a term derived from two Greek words meaning to get out and to molt.

Ultimately, Lee's celebrity in burlesque became the springboard for other ventures. In the late 1930s she discovered that she had a way with words when she did a guest column for Walter Winchell. Soon she was at work on a mystery novel, ultimately titled *The G-String Murders*. Published in 1941, the book was not very good, but it became a best-seller anyway. Two years later, it was a similar story with the Broadway production of her play *The Naked Genius*: while critics panned it, the public bought tickets. Her greatest literary achievement was a lively autobiography of 1957, *Gypsy: A Memoir*, which eventually inspired the hit musical *Gypsy*.

One of America's leading portrait photographers for more than half a century, Arnold Newman is famous for likenesses where the setting is meant to evoke the sitter. In Lee's portrait, the background thus reflects her interest in collecting art and antiques. But also in the picture is a strong sense of her "queenly style" as an ecdysiast.

GYPSY ROSE LEE
1914–1970
ENTERTAINER

ARNOLD NEWMAN (born 1918)
Gelatin silver print
24.8 × 32.9 cm (9 3/4 × 12 15/16 in.), 1945
(printed later)

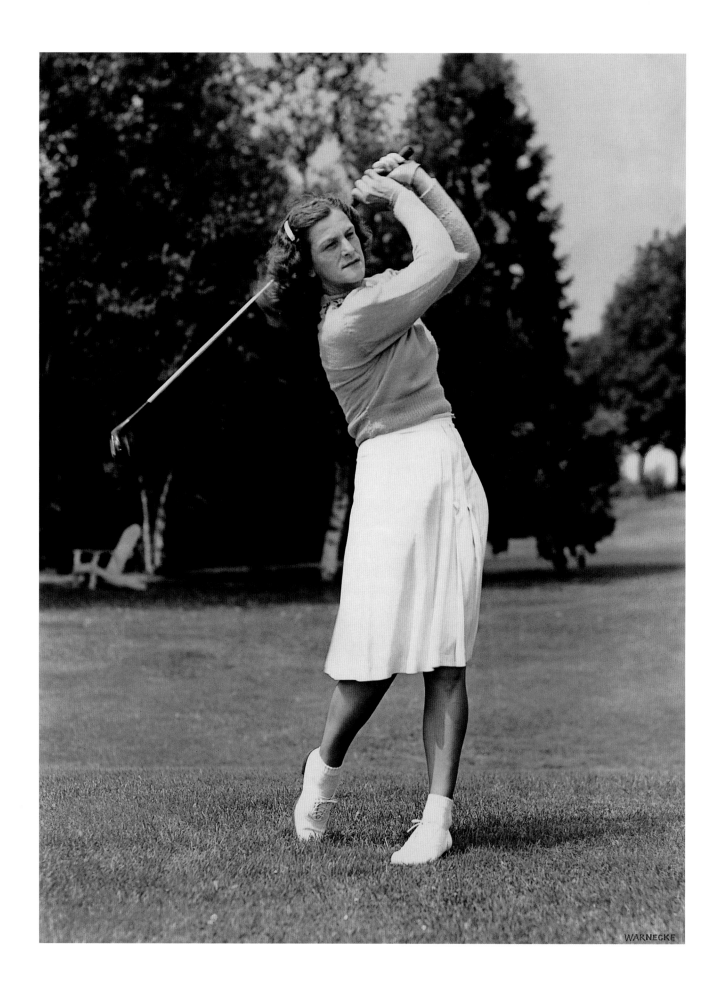

WARNECKE

The multitalented athlete Babe Didrikson Zaharias had her flaws, to be sure. She could be loud and irritatingly boastful. Given an unseemly penchant for comments to competitors like "*I'm* the star and all of you are the chorus," she would have run poorly indeed in any congeniality contest. But Didrikson had one undeniable virtue: She *was* the star she claimed to be.

Not only that, she managed to be a star at just about any sport she tried. In swimming, she missed setting a record in the hundred-yard freestyle by one second. She could throw a football pass forty-seven yards. In baseball, she once threw a ball 313 feet from center field to home plate. In 1932, at the Amateur Athletic Union women's track and field championships, she took firsts in five of eight events and claimed singlehandedly the entire thirty points that placed her team at the top in overall competition. Then, at the summer Olympics that same year, she made good her declaration that she had come "out to beat anybody in sight." Placing second in the high jump, she won gold medals in the eighty-meter hurdles and the javelin throw. In the former event, she set a world record; in the latter, an Olympic record.

If all her career accomplishments had stopped with that, they would have been quite enough to justify sports writer Grantland Rice's assertion that "there has never been another" in Didrikson's class. But the sport in which she made her biggest and most lasting mark was golf, which she did not begin to pursue seriously until she was in her early twenties. Late starter though she was, her athletic versatility clearly put her in good stead. Having taken her first golf lesson in 1933, she was qualifying for tournament competition within a year, and in 1935 she took the Texas Amateur Championship. Ultimately she would win forty amateur golf titles.

Sweetest among those triumphs was winning the British Women's Amateur Open in 1947. As Didrikson advanced in the tournament, an onlooker sniffed that she was "altogether lacking in refinement." But mostly there was just amazed admiration for the American "Babe." After she hit an especially good drive, a spectator whispered, "She must be Superman's sister." When asked to explain her winning ways after claiming the championship, she remarked, "I just loosen my girdle and let the ball have it."

The following year, Didrikson joined forces with five other women golfers to form the Ladies Professional Golf Association. Not surprisingly, she proved to be the LPGA's biggest draw and most frequent purse-winner. By the time she died of cancer in 1956, she had claimed thirty-one LPGA titles.

This photograph was part of a series of shots by Harry Warnecke that appeared in the Sunday Coloroto section of the *New York Daily News*, October 12, 1947. The object of the pictures was to show the form that had made Didrikson "Queen of the Links." Her golf form, in fact, had many faults. But on the long drives, she made up for that with strength. Besides, said one woman pro who played with her, "she was a great scrambler."

MILDRED "BABE" DIDRIKSON ZAHARIAS

1911–1956
ATHLETE

HARRY WARNECKE (1900–1984)
and Robert Cranston (lifedates unknown)
Color carbro print
41.4 × 31.4 cm (16 5/16 × 12 3/8 in.), 1947

LILLIAN HELLMAN

1905/07–1984
WRITER

IRVING PENN (born 1917)
Gelatin silver print
17.9 × 19.2 cm (7 1/16 × 7 9/16 in.), 1947

Lillian Hellman had no idea of what she wanted to do when she dropped out of Columbia in 1924, but a serendipitous connection at a party landed her on the perimeters of the literary world as a manuscript reader at publishers Boni and Liveright. She tended, however, to get the least-interesting manuscripts, and boredom quickly set in. After marrying writer Arthur Kober in 1925, she tried to make her way as a combination book reviewer, publicity agent, and play reader, and by the early 1930s she was in Hollywood, where her affair with mystery writer Dashiell Hammett soon contributed to the breakup of her marriage.

The relationship with Hammett had an impact on both their careers. For Hammett, it led to the creation of one of his most memorable characters, Nora Charles, the wife of detective Nick Charles in *The Thin Man*, who was patterned largely on Hellman. In the case of Hellman, who now harbored ambitions to write drama, however, the impact was substantially greater. For it was Hammett who advised that for her first plot, she ought to read the true story of two Scottish women who ran a school and whose lives were ruined by a false allegations of lesbian behavior. The suggestion was a godsend. In that dark tale, Hellman found the framework for *The Children's Hour*, which, when it opened on Broadway in 1934, established her as a playwright of great promise. Describing the play as "bravely written," one critic declared it "the season's dramatic high-water mark."

Success took Hellman back to Hollywood, where she became a highly paid screenwriter. But her ambitions to write for the stage remained, and when her play *The Little Foxes* opened in New York in 1939, her reputation as one of the country's most able playwrights became firmly fixed. Unlike many plays that become dated after a few years, this dark tale of intrafamily greed and ruthlessness garnered critical respect that has proved enduring. Writer John Malcolm Brinnin once noted that every time he went over it, his admiration only increased. "It was like a Chinese box," he said, "each piece fitting precisely with the next."

Hellman returned to her characters in *The Little Foxes* to create *Another Part of the Forest*. Staged in 1946, the play was a hit, and its success was probably what prompted *Vogue* to commission photographer Irving Penn to make this portrait of Hellman. Never published by the magazine, the likeness evokes the solid and unsentimental intelligence that went into the creation of her plays. But there was a softer side to Hellman, particularly when it came to the opposite sex. Despite "that brain and that talent," a longtime female friend once said, "put a good-looking man in front of her ... [and] she became ... Miss Lilly of New Orleans."

Hellman experienced her last stage success in 1960 with *Toys in the Attic,* which claimed the Drama Critics Circle Award. In later years, she turned to writing three volumes of memoirs, *An Unfinished Woman*, *Pentimento*, and *Scoundrel Time*. Though by no means scrupulously truthful, she proved as capable in the art of reminiscence as she had as a playwright, and the books inspired some of the best reviews she ever received.

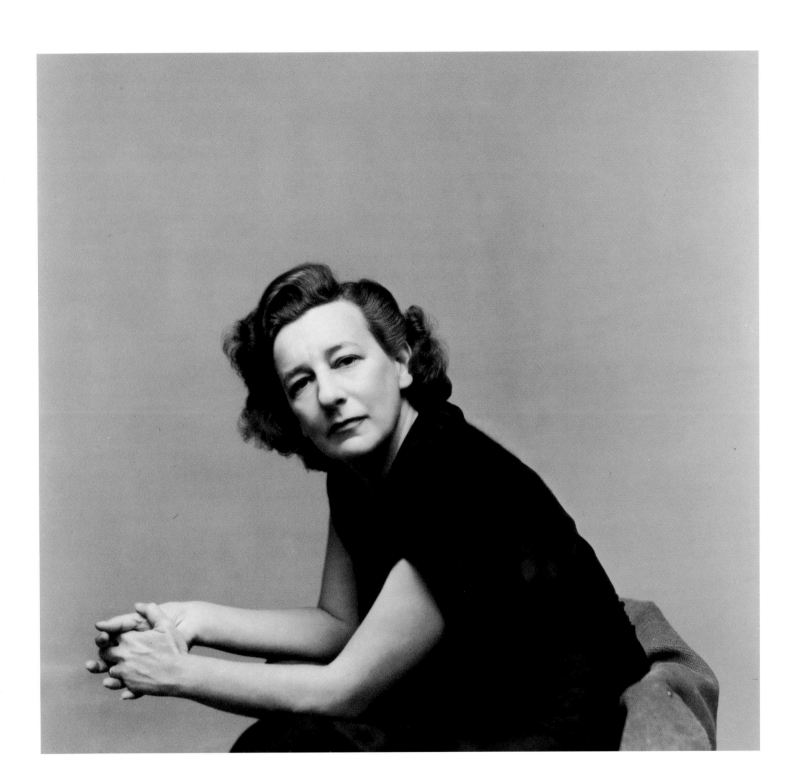

GEORGIA O'KEEFFE

1887–1986
ARTIST

Georgia O'Keeffe began her artistic training at the Art Institute of Chicago in 1905 and went on to study with William Merritt Chase at the Art Students League in New York City. But by her early twenties, she did not see much point in pursuing her ambitions to paint if it simply meant following in the conservative representational paths that the Art Institute and the Art Students League fostered. "I began to realize," she recalled years later, "that a lot of people had done this same kind of painting … and I didn't think I could do it any better." So ruminating, she decided to give up painting altogether. The resolution did not last, however. Inspired by the aesthetic values of Arthur Wesley Dow, she began charting her own path in painting.

Dow's mandate, as O'Keeffe understood it, was "to fill space in a beautiful way," and in the fall of 1915, while teaching art at Columbia College in South Carolina, she began a series of charcoal abstractions that sought to do just that. Sent on to a friend in New York, these works found their way to Alfred Stieglitz, photographer and proprietor of the 291 gallery, which was the hub of avant-garde modernism in American art. Stieglitz, who would marry O'Keeffe in 1924, was deeply impressed, and in March 1916 the drawings were featured in an exhibition at 291.

Although these pure abstractions gained her entrée into the modernist circles that gravitated to 291, O'Keeffe ultimately did not entirely reject realism. Instead, she gave it an abstractionist edge, and the works that began gaining her serious attention in the 1920s were her austerely painted, much-magnified renderings of flowers and other natural objects. In 1929 she discovered the arid landscape of New Mexico, which eventually provided her with much of her most important subject matter, and some of the images most readily associated with O'Keeffe are those compositions juxtaposing the sun-dried bones of an animal set against a blue New Mexico sky.

For observers who liked to fit their artists into categories, O'Keeffe often posed a problem. Viewed one way, she seemed to be a surrealist; others saw her as mostly an abstractionist; and yet others placed her with the precisionists. But wherever she belonged, there was little doubt of her stature. By the late 1930s, she was the best-known woman artist in America and numbered among its most respected painters—male or female.

O'Keeffe was not beautiful in the usual feminine sense. But she was serenely striking in a way that echoed the austere and enigmatic character of her pictures. With the passage of years, that strikingness did not diminish. Even in this photograph by Irving Penn, where there is clearly no attempt to flatter, O'Keeffe, now in her sixties, maintains her arresting dignity. Writing in 1926, a critic noted: "She is like the unflickering flame of a candle, steady, serene, softly brilliant…. It is no wonder that O'Keeffe disdains the ordinary trappings and lip rouge of her less-favored sisters and faces the world unconcernedly 'as is.'" That description could have applied as easily to O'Keeffe in 1948, when the picture was taken, as it had in 1926.

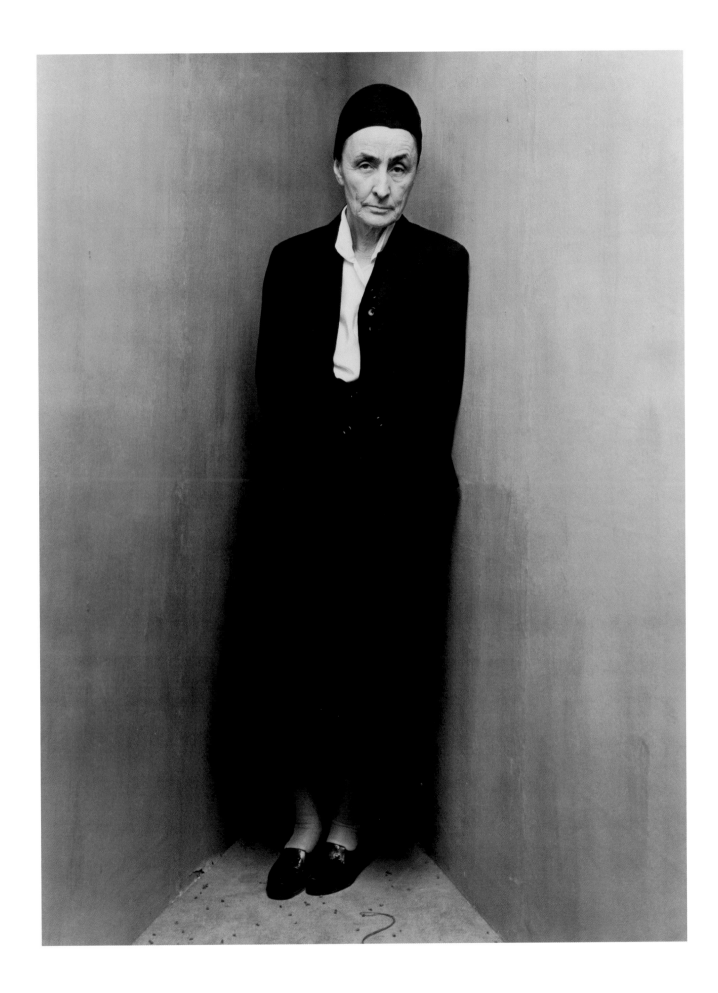

HELENA RUBINSTEIN

1870–1965
BUSINESSWOMAN

ARNOLD NEWMAN (born 1918)
Gelatin silver print
32.4 × 25.9 cm (12 3/4 × 10 3/16 in.), 1948
(printed later)
Gift of Arnold Newman

As a young woman in Kraków, Poland, Helena Rubinstein refused to marry the man that her parents had picked for her and instead set out for Australia to live on her uncle's sheep ranch. Tucked into her luggage on her arrival there were twelve pots of facial cream, concocted by an Hungarian doctor. That small trove of beauty aids was meant for Rubinstein's personal use. But in a country where sun took a dreadful toll on many female complexions, the effect of that cream on her skin drew many an envious compliment, which suggested an unusually splendid commercial opportunity. By 1902 Rubinstein was selling her Hungarian cream out of a shop in Melbourne. Barely able to keep up with demand for this revivifying elixir, she reaped a small fortune within only a few years. By 1915 she had beauty salons in London, Paris, and New York City, and over the next decade or so, her ever-expanding line of cosmetics and international chain of spas established her as one of the world's most successful businesswomen.

"It doesn't matter how shaky a woman's hand is. She can still apply makeup," Rubinstein once observed, and that enduring feminine impulse to improve on nature was certainly a significant factor in the creation of her fortune. But Rubinstein's own drive was doubtless more crucial yet. A relentless bargainer, she could be quite demanding of her employees and imperiously unpleasant when they displeased her. She was most demanding of herself, however, and her preoccupation with business remained unrelenting, quite literally to the day she died. Business took so much of Rubinstein's time, in fact, that she never once tried the full one-day beauty treatment offered at her salons. Nor could she be bothered with the nightly cleansing and skin-care rituals that she so aggressively urged on other women. "I tell you I am a worker," she once explained. "I have no time for it."

Still, Rubinstein managed to pursue a few nonbusiness pleasures. Among her fondest passions was jewelry—the showier the better. She was also an indefatigable collector of art and antiques, which created sumptuous backdrops for life in her seven residences. One of the most striking aspects of her collections was their catholicity, and while a room in one of her houses might feature Venetian baroque furniture, its walls were apt to be hung with the works of Marc Chagall, Salvador Dali, or Pablo Picasso.

This image is one of several that Arnold Newman made in 1948 for an article on Rubinstein in *Collier's* magazine that billed her as "a John D. Rockefeller in petticoated miniature." The portrait did not run with the piece, but whatever the reason for not using it, it had nothing to do with a weak sense of presence. Her beringed hand placed firmly on her hip, the four-foot, ten-inch Rubinstein exudes the commanding demeanor that leaves no doubt about who is in charge. That formidability still had the power to cow when at age ninety-four she encountered armed thieves in her Manhattan apartment. "Go ahead and kill me," she told them, "I am not going to let you rob me." Sensing they had met their match, the miscreants fled.

BILLIE HOLIDAY

1915–1959
SINGER

SID GROSSMAN (1913–1955)
Gelatin silver print
33.5 × 27.2 cm (13 3/16 × 10 11/16 in.),
circa 1948

She did not have a big voice, and her range did not extend beyond an octave. What was more, one of her musician friends once speculated that she herself "actually doesn't believe that she can sing." Voice limitations and want of confidence notwithstanding, there is no doubt of singer Billie Holiday's preeminent place in American jazz. She was, by almost universal agreement, "the greatest female jazz voice of all time." Coming from her, even the most unremarkable of pop songs turned into "iridescent gems," and her impact on other singers was incalculable. According to Frank Sinatra, almost "every major pop singer … [of] her generation" was "touched … by her genius," and for him personally, she had been "the greatest single musical influence" of his career.

Growing up in severe poverty, Holiday had her first taste of jazz while doing chores and running errands for a bordello in her native Baltimore. Among the benefits of that job was the opportunity to listen to the records of blues and jazz artists such as Bessie Smith and Louis Armstrong. Ultimately, both Smith and Armstrong would have a significant effect in shaping her own artistry, but initially her exposure to them planted no ambitious thoughts about becoming a singer. In fact, her first sojourn into the entertainment world was an effort to find a job in the early 1930s as a dancer in one of New York's speakeasies. At one tryout where the dancing went especially poorly, however, she was asked to sing, and her auditors were sufficiently impressed to give her a job singing the late shift at two dollars a night.

Holiday was no overnight sensation, but as she developed a soft, intimate style and perfected her gift for improvisation, she gradually built a following. When critic and jazz music producer John Hammond first saw her in a nightclub in 1933, he sat awestruck as she moved through the audience and "sang a completely different chorus to the same tune at each table." By the late 1930s she had reached the big leagues of her profession as a vocalist for the bands of Count Basie and Artie Shaw.

Unfortunately, even as Holiday hit her peak in the early 1940s, the seeds of her decline were being planted. Beginning about 1941, she became addicted to heroin, and her addiction soon began taking its toll on her performance. By the 1950s her voice had lost much of its wonderful elasticity. Still, she had her moments. Many claim, in fact, that some of her later recordings of certain songs were actually superior to earlier renditions.

This image is thought to date from 1948, not too long after Holiday had finished serving a jail sentence for possession of drugs. Free of her addiction for the moment, she seemed to her fans as good as ever. At her first post-incarceration concert, held at Carnegie Hall, the crowd greeted her performance with "hysterical applause." Alluding to her drug problems shortly thereafter, she said, "That's all over now; this is a new life." Unfortunately, that was not the case. Early the next year, she found herself once again arrested on charges of drug possession.

ELEANOR ROOSEVELT

1884–1962

FIRST LADY, HUMANITARIAN

CLARA E. SIPPRELL (1885–1975)
Gelatin silver print
22.6 × 17.6 cm (8 7/8 × 6 15/16 in.), 1949
Bequest of Phyllis Fenner

Not long before this picture was taken, *Time* magazine noted that its subject, Eleanor Roosevelt, wife of the deceased President Franklin Roosevelt, had "reversed the usual lot of presidents' widows." Instead of retreating into obscurity as other widowed first ladies had, she had in the more than three years since her husband's death "become, perhaps, the best known woman in the world." Voted the "most popular living American" in a recent magazine poll, she was, *Time* declared, "a unique combination of Citizeness Fix-it and great lady."

The ingredients that went into creating that stellar reputation were many. Not the least of them was the great residue of admiration that had accrued to Roosevelt during her twelve-year tenure as the nation's first lady. Just before embarking on her White House duties in 1933, she had told the press that she was "just going to be plain, ordinary Mrs. Roosevelt. And that's all." But the reality turned out to be quite different. She was soon a player in her husband's New Deal administration and, in such areas as race relations, acted as its moral conscience. During World War II, she became one of the country's most effective and tireless morale builders as she visited allied nations and offered motherly comfort to wounded soldiers in military hospitals. For a wartime goodwill ambassador, it was widely agreed that Franklin Roosevelt "could have made no better selection."

At some point, Roosevelt's stature ceased to be dependent on its identification with her husband's presidency, and following FDR's death in 1945 she went on to perhaps her most enduring achievement as a delegate to the newly formed United Nations. In 1946 she became chairman of the UN's Preliminary Commission on Human Rights (made permanent a year later) and presided over the drafting of the Universal Declaration of Human Rights. In doing so, she found herself traversing a hazardous terrain of clashing cultural ideals and national agendas. Armed with an endless supply of patient tact and a sunny candor that could be disarmingly childlike, she eluded its pitfalls successfully. On December 10, 1948, the UN's General Assembly endorsed the declaration, a document that has grown increasingly important with the years in the monitoring of international affairs. No one deserved more credit for that event than Roosevelt. Speaking of her role, one colleague claimed that he had never seen "naivete and cunning so gracefully blended." Even some of those who had never cared much for her style or liberal views were finding much to admire. After witnessing her performance at UN meetings, a one-time Eleanor naysayer, Michigan senator Arthur Vandenberg, said, "I take back everything I ever said about her, and believe me it's been plenty."

Not long after the passage of the Declaration of Human Rights, Roosevelt attended a luncheon hosted by Molly Dawson, head of the women's division of the Democratic Party. Also among the guests was the photographer Clara Sipprell, and after lunch Roosevelt posed for Sipprell. When Roosevelt reported this encounter in her newspaper column "My Day," Sipprell noted that even her chronically misspelled name was right. The photographer took Roosevelt's attention to that detail as just one more indication of the former first lady's unwavering thoughtfulness.

For most of Anna Robertson Moses's life, farmwork had been the central fact of her existence. By her late seventies, however, the everyday regimen of farming became too much for her, and as others in her family took over her part in running a family farm in Eagle Bridge, New York, she sought other ways to fill her time. At her daughter's urging, Moses began embroidering pictures. Unfortunately, arthritis soon made holding a needle too painful, but she found that wielding a paintbrush was fine. In 1938, using leftover paint and thresher cloth found in a barn, she created her first picture, and before long, she was producing scenes reminiscent of the rural past that she had known in her younger days. Despite their flat, primitive quality—or more accurately, in large part because of it—these pictures exuded a charm capable of winning over even sophisticated viewers. When an art collector from New York City spotted four of her paintings in 1939 in a drugstore in Hoosick Falls, New York, he snapped them up and then went out to Moses's nearby farm, where he purchased all the pictures she had on hand.

By late the next year, newspaper critics had dubbed her "Grandma" Moses, and her work was being featured in a one-person show at a Manhattan gallery. At age eighty, the self-taught Moses had indeed arrived. Over the next twenty years, she would become one of America's most popular artists, and her idyllic renderings of farm life became iconographic reflections of the way Americans saw their pastoral past. "Most of us would be bored to death," admitted one critic, "if we were suddenly marooned" in the world that her pictures recalled. But as presented in Moses's art, it all seemed utterly entrancing, and although her subject matter was strictly American, her work also had great appeal in Europe, where critics declared it to be "charming," "fresh," and "full of … childlike joy."

Part of the appeal of the rather frail-looking Moses was her amazing vitality in the face of advancing age. Her daughter-in-law once ventured that the source of her vigor was her continuing interest in painting, which endured almost until the day of her death at 101. Moses did not exactly disagree. Nevertheless, she felt the need to bring some down-to-earth perspective to the matter, "I don't know as it [painting]," she said, "done any more good than if I went down and cleaned the cellar."

For Arnold Newman, a photographer who likes to place his subjects in settings bespeaking their interests or personality, the proper milieu for photographing Grandma Moses was a nook in her own Eagle Bridge farmhouse, which had the same sense of serene pastoral simplicity found in her paintings. The picture was taken in 1949, the same year Moses went to Washington, D.C., where President Harry Truman presented her with an achievement award from the Women's National Press Club. Stopping in New York City on her way to the nation's capital, she told reporters, "It's nice to be here, but the city doesn't appeal to me." "As picture material?" someone asked. "As any material," she answered.

ANNA MARY
ROBERTSON
("GRANDMA")
MOSES

1860–1961
ARTIST

ARNOLD NEWMAN (born 1918)
Gelatin silver print
45.9 × 36.9 cm (18 1/16 × 14 1/2 in.), 1949
(printed later)

ETHEL WATERS

1896–1977

SINGER, ACTRESS

CARSON McCULLERS

1917–1967

WRITER

JULIE HARRIS

born 1925

ACTRESS

RUTH ORKIN (1921–1985)

Gelatin silver print

18.3 × 23.9 cm (7 3/16 × 7 7/16 in.), 1950

This photograph has a sense of cathartic letdown about it as one of its subjects somewhat awkwardly concentrates on taking a sip of coffee without spilling any of it on the sofa's satin damask arm and her two companions sit quietly clinging to each other. Taken by *Life* magazine's Ruth Orkin, the picture is indeed about letdown, albeit a letdown of the sweetest sort. The time of its taking was the wee morning hours of January 6, 1950, and the trio seated on the sofa were (left to right) singer-actress Ethel Waters, novelist and short-story writer Carson McCullers, and actress Julie Harris. Earlier that evening Waters and Harris had opened on Broadway in McCullers's own adaptation of her novel *The Member of the Wedding*, and the party thrown by the producer to mark the play's opening was drawing to a desultory close. But preceding the inertial quiet recorded in Orkin's picture, a goodly amount of jubilant celebration had prevailed, for the evening had been an unalloyed triumph for all three women.

Summing up McCullers's ability to transform her novel into a drama, *New York Times* critic Brooks Atkinson said that the formulation of two of the play's main characters represented "masterly pieces of writing" and that her depiction of the chief protagonist, an adolescent tomboy played by Harris, had been "wonderfully, almost painfully, perceptive." When he saw the play again some months later, his regard for McCullers's skill was undiminished. Her play, he said after his revisit, was the "chief literary treasure" of the year—a judgment widely shared in his profession that would soon earn for it the Drama Critics Circle Award.

As for Ethel Waters, who played the cook, Berenice, in *Member of the Wedding*, Atkinson had once declared that as a vocalist she knew "how to make a song stand on tiptoe." But her acting gifts were every bit as impressive. As the warm-hearted cook, Atkinson opined, she had given "one of those rich and eloquent performances that lay such a deep spell on any audience that sees her."

But perhaps the member of this sofa trio who experienced the greatest elation on the play's opening night was Julie Harris. Unlike McCullers and Waters, who had already known their fair share of plaudits for past accomplishments, the twenty-four-year-old Harris had been working in largely unappreciated anonymity until now. Obscurity, however, ceased to be her lot in the wake of her perfectly pitched depiction of the play's motherless twelve-year-old tomboy. Harris, however, did not really believe what was happening to her as her curtain calls drew roars of admiration, and scores of well-wishers toasted her with champagne in her dressing room. But as the reviews began coming in several hours later, one after another, congratulating her for her "extraordinary performance," she had no choice but to believe. By the time she joined McCullers and Waters on the sofa, it was abundantly clear even to her that there was "a new star in the theater" and that her name was Julie Harris.

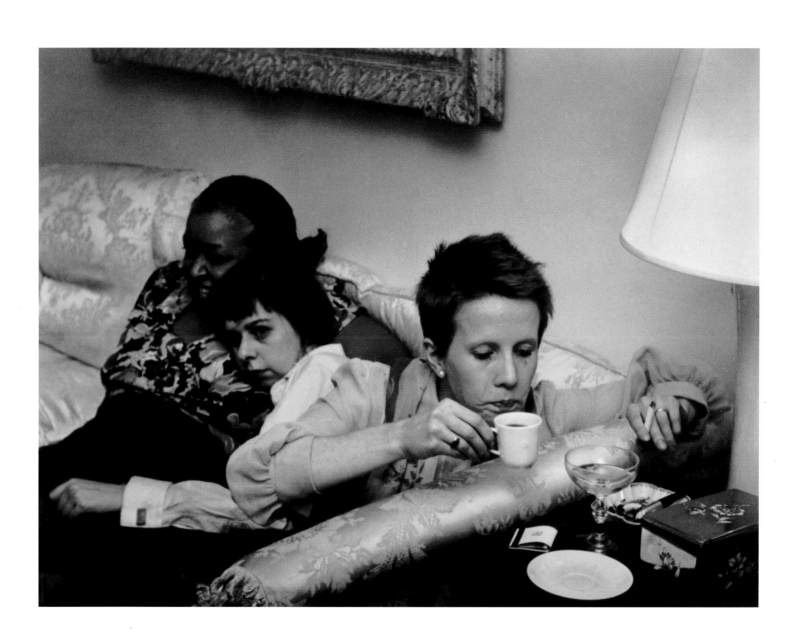

MARGARET MEAD

1901–1978

ANTHROPOLOGIST

LOTTE JACOBI (1896–1990)
Gelatin silver print
17.2 × 18.2 cm (6 3/4 × 7 3/16 in), 1949

Anthropologist Margaret Mead was the author of more than thirty books and scores of articles. She also found room in her life to teach, work as a curator of anthropology at New York City's American Museum of Natural History, and travel the lecture circuit. Over time her areas of expertise ranged ever more widely—from child-rearing practices in less developed societies to national character to ecology and culture-related problems of nutrition. Ultimately she took as her motto, "I expect to die but don't plan to retire." Recalling what it was like being married to this relentless doer, her third husband once said, "I couldn't keep up, and she couldn't stop…. She could sit down and write three thousand words by eleven o'clock in the morning and spend the rest of the day working at the museum."

Whether such tireless pursuit of her professional interests resulted more from genetic inheritance or early environment could have been the focus of a debate that Mead herself might have enjoyed. But whatever the outcome of any such discussion, there was no doubt that her two well-educated parents—one an economist, the other a sociologist—had one way or another imparted to their daughter some rather exceptional intellectual gifts and drive. By 1925, with the work for her doctorate in anthropology from Columbia University completed, she was on her way to American Samoa to study adolescence in the island's native culture. The guidelines for this kind of field probe into a living society were murky at best. But having to chart her own path proved no great deterrent. When her research reached book form as *Coming of Age in Samoa* in 1928, it enjoyed the best of all possible worlds. While the book drew praise from such noted members of her profession as Bronislaw Malinowski, it also appealed to the general book-buying public, and for an academic book, it enjoyed remarkably brisk sales. Despite the flaws that some critics have since found in the work, it is still considered a pathbreaking study.

In *Coming of Age*, Mead's findings supported the relatively new notion that behavior patterns, once thought to be mostly predetermined by biologically inherited predispositions, were in fact largely the result of cultural conditioning. She explored that hypothesis further in *Sex and Temperament in Three Primitive Societies*, a volume published in 1935 that was the culmination of field studies conducted over several years in New Guinea. In it she concluded that cultural influences shaped gender roles far more than many behavior experts had hitherto acknowledged.

At about the time that Mead sat for this photograph in the late 1940s, she was bringing out *Male and Female: A Study of the Sexes in a Changing World*, in which she sought to balance an examination of cultural influences on gender roles with a fuller acknowledgment of the impact of biological factors on those roles. In an interview that coincided with the book's publication in the fall of 1949, the interviewer described her as "a friendly but determined-looking woman." "Her speech," he said, "is not overweighted with technical terms, but it is careful and exact…. In short, this reporter found Miss Mead a substantial and highly informed presence."

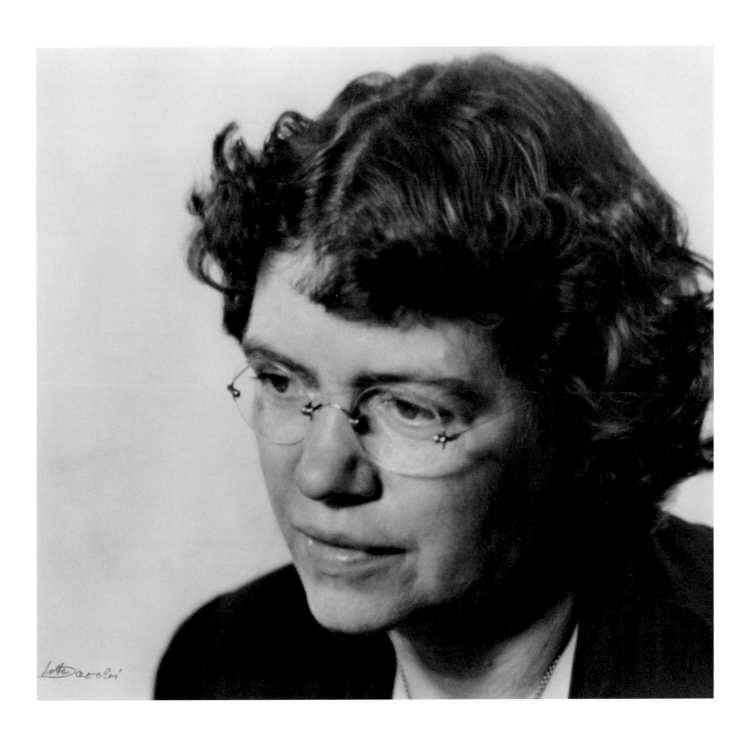

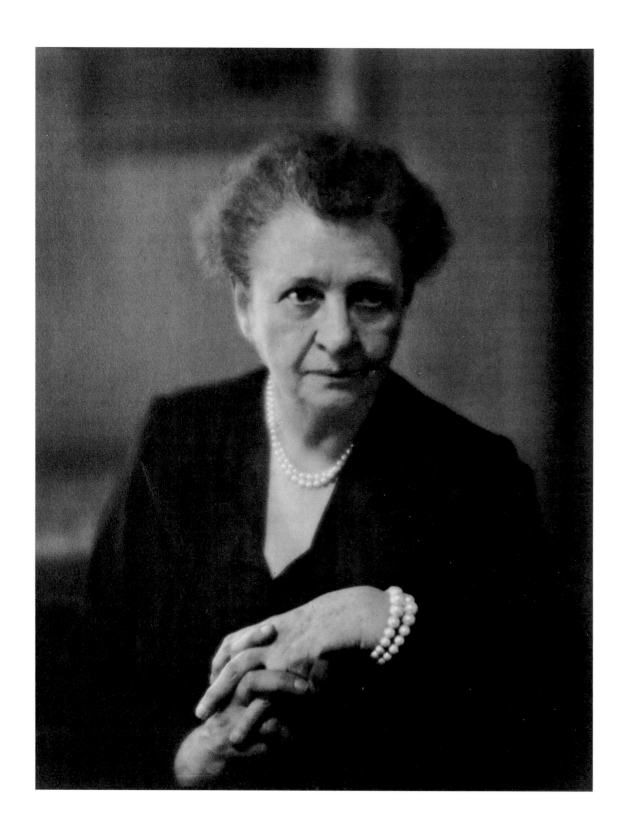

This photograph of 1952 should perhaps be titled "the last leaf on the tree." It was a phrase that its subject, Frances Perkins, applied to herself not long after the picture was taken, and with good justification. She had come to Washington, D.C., in March 1933 to serve as secretary of labor in Franklin Roosevelt's New Deal administration. The nation was in the throes of the worst economic depression in its history, and she was soon part of the New Deal's unprecedented efforts to restore prosperity and redefine the role of government in the lives of Americans. Now at age seventy-two, having headed the Department of Labor until 1945 and served some seven years as a member of the Civil Service Commission, Perkins was retiring to private life, and as the only one from the original cast of leading New Dealers still left in federal harness, "last leaf" seemed an apt metaphor indeed.

When Perkins took over at the Department of Labor, she had much to recommend her for the post. For more than two decades she had stood in the vanguard in promoting worker welfare in New York State, and during Roosevelt's governorship, she had served as the state's industrial commissioner. This first woman to hold a cabinet post, however, never won respectful acceptance in many quarters. United Mine Worker head John L. Lewis called her "woozy in the head," and one critic likened the attitude that both labor and management took toward her to the reaction of saloon habitués to a lady slumming in their midst—"grim, polite, and unimpressed." Nor did she kindle warm feelings among journalists, one of whom wrote her off as a "colorless woman who talked as if she swallowed a press release."

Behind many of the attacks on Perkins was the conviction that secretary of labor was not a proper job for a female. On that point, she once responded, "The accusation that I am a woman is incontrovertible." But ultimately there were even better ripostes to the charges of her ineffectiveness. Although she did not number among the most visibly influential of Roosevelt's advisers, her impact was far from negligible. Among the New Deal legislation that she had a primary role in shaping were the National Labor Relations Act, the Fair Labor Standards Act, and the Social Security Act, and when rumors circulated of her resigning from Labor in 1944, a columnist who generally had nothing good to say about any of FDR's New Dealers opined that "the argument can be made that Miss Perkins is the best" secretary of labor ever. "Unpleasant as it is to say," he noted, "apparently the basic reason for the long sustained campaign against her is that she is a woman."

Clara Sipprell's likeness of Perkins shows her subject wearing the pearl necklace that was routinely part of her daily garb. Not present, however, is the famous tricorn hat that was her trademark during her tenure at Labor, so much so that some wondered whether it had been mandated for her by the Bureau of Standards.

FRANCES PERKINS
1880–1965
CABINET OFFICIAL

CLARA E. SIPPRELL (1885–1975)
Gelatin silver print
25.2 × 20.3 cm (9 15/16 × 8 in.), 1952

MARIANNE MOORE

1887–1972
POET

ESTHER BUBLEY (1921–1998)
Gelatin silver print
24.9 × 34 cm (9 13/16 × 13 3/8 in.), 1953

While a student at Bryn Mawr in the early 1900s, Marianne Moore received a paper back from an English professor with the comment, "I presume you had an idea, if one could find out what it is." Some sixty years later, she was still having difficulty getting her thoughts out, at least in Moore's own estimation. "I never knew anyone," she said, "with a passion for words who had as much difficulty in saying things as I do. I seldom say them in a manner I like. Help is needed: you need a horse, a boat, to help you."

Moore's perception of the situation, however, was not exactly how the world saw it. To be sure, this poet was by no means prolific, and with the works in her *Complete Poems* (published in 1967) numbering 120, she was obviously stating the truth when she spoke of how difficult it was to set her thoughts down. But the end result was well worth the agony. In 1941 critic Malcolm Cowley ranked the title poem of her volume *What Are Years* "among the noblest lyrics of our time." Ten years later, she was hailed as "just about the most accomplished poetess alive," and according to T. S. Eliot, her poems belonged in "the small body of durable poetry of our time." Along with such praise came nearly every important award a poet could win, and in 1952 the bestowal of honors reached high tide when *Collected Poems* earned her a Pulitzer Prize, the Bollingen Prize in Poetry, and the National Book Award.

It was not always easy to penetrate the meaning of Moore's poems, despite their clean simplicity. Moore herself saw nothing wrong in that, claiming that "it ought to be work to read something that was work to write." It meant, however, that the audience for most of her verse remained relatively small. Still, she had at least one means of connecting to the public at large—her passion for baseball and in particular the Brooklyn Dodgers, whom she celebrated in "Hometown Piece for Messrs. Alston and Reese." The homage to her beloved Dodgers ran in part: "As for Gil Hodges, in custody of first— / 'He'll do it by himself.' Now a specialist—versed / in an extension reach far into the box seats— / he lengthens up, leans and gloves the ball. He defeats / expectation by a whisker." After reading lines like that and sharing in their joyous conviction, what sports-loving American could fail to feel a warm kinship with their author?

Although Moore's poems ultimately were about human values and virtues, they were filled with references to another of her passions, the members of the animal kingdom, and when *Life* decided to do a story on her in 1953, its editors enlisted freelance photographer Esther Bubley to take pictures of her as she communed at the Bronx Zoo with some of the animals that she wrote about. Accompanying the pictures in the final layout were lines from Moore's work alluding to the animals with whom she posed. In the case of the image here, the passage came from "Elephants" and ended with her observation that "these knowers 'arouse the feeling that they are / allied to man' and can change roles with their trustees."

CARMELITA MARACCI

1911–1987
DANCER

BOB WILLOUGHBY (born 1927)
Gelatin silver print
25.2 × 26.4 cm (9 15/16 × 10 3/8 in.), 1953
(printed 1991)
Gift of Mr. and Mrs. Bob Willoughby

"There is no doubt at all that in the hands of a capable manager, … the name of Carma Lita Maracci could be made to have not only genuine prestige among the connoisseurs but wide popular appeal at the box-office…. Here is a remarkable artist who, if there is any justice, will rank among the great dancers of her time." So wrote *New York Times* dance critic John Martin after viewing a performance of Carmelita Maracci in Los Angeles in June 1937. In her program showcasing her trademark blend of classical ballet and Spanish dance, Martin noted that she had performed one number "seated throughout on an old-fashioned circular piano stool." The idea of trying such a thing, he admitted, sounded "slightly ludicrous." But when she did it, he said that she became "an abstract of Spain in the dance, a projection of the spirit of the dance."

Martin was not alone in his awe of Maracci. Agnes de Mille recalled that she had "the perfect dancer's body: a small torso with narrow, trim shoulders, and a high chest, and long arms and legs for line." But what she did with that body was more remarkable yet. De Mille said that at their best Maracci's "dances were the most passionate and powerfully devised solos I have ever seen."

But despite her genius, Maracci never achieved the reputation that she deserved. At the heart of the problem was a high-strung temperament that made for unreliability. In 1946, at a concert in St. Paul, Minnesota, her outbreak of ugly temper over the behavior of a drunk in the audience forced the cancellation of the rest of her tour. Five years later, when her first in a series of appearances at the Ballet Theatre in New York did not go well, rather than try to fix the problems—as others urged her to—she canceled the rest of her performances. Sometimes it almost seemed as if she were afraid of success. Once, having accepted the starring role in a Ballet Theatre production of *Giselle*, she backed out after a few rehearsals because the part of this lovelorn girl, she later said, made her feel imbecilic.

Although her fame as a performer was never very substantial, Maracci did have considerable impact as teacher. Among her students were any number of distinguished dance figures, including dancer-choreographers Jerome Robbins and Donald Saddler and prima ballerina Cynthia Gregory, and many of these students numbered her among their most significant mentors.

Maracci is pictured here in her dance studio. We do not know the circumstances of the picture—whether, for example, she was demonstrating something for the unseen members of a class or whether she was simply practicing by herself. According to de Mille, Maracci had an unusually strong appetite for practice and, even after a grueling session with students, often returned to her studio to refine her skills yet further. The picture's maker, Bob Willoughby, was just the photographer to record such a moment. As a Hollywood freelance photographer, he specialized in capturing performers in the more private milieu of rehearsal and preparation.

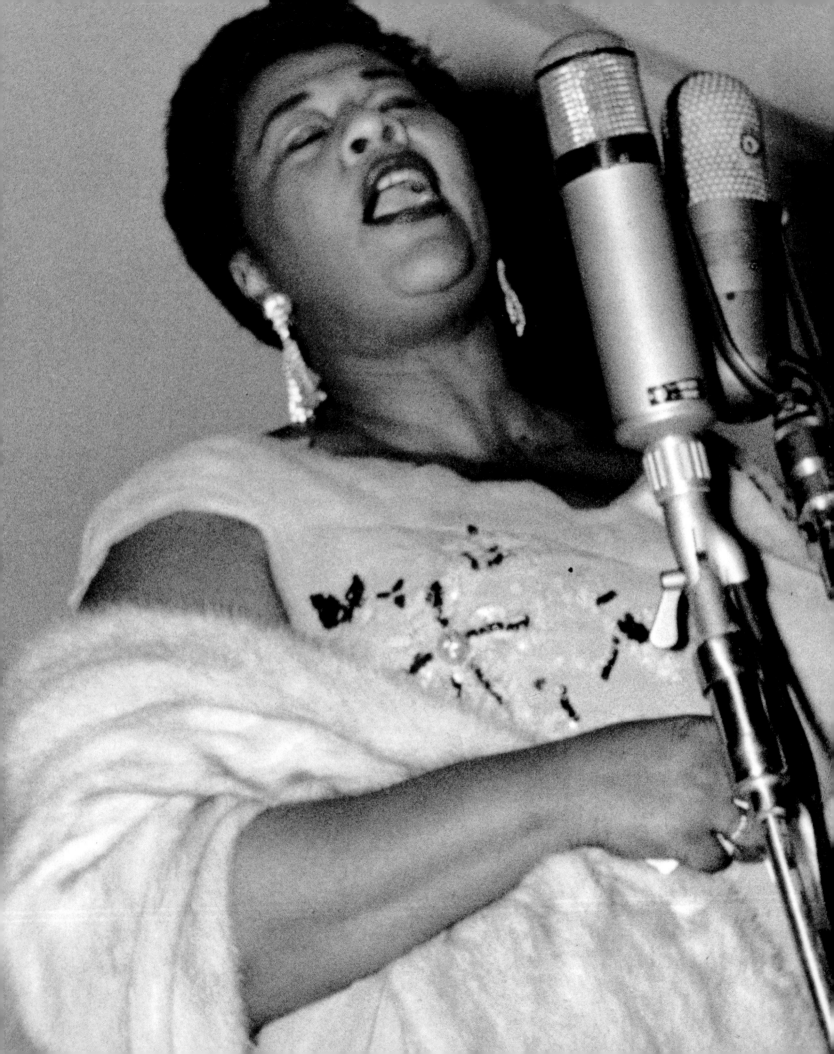

Although the details of the story varied from telling to telling, it is clear that Ella Fitzgerald's performing career began at an amateur talent show in the mid-1930s in Harlem. She had entered the show, she later recalled, on a dare from two girlfriends, and her intention was to offer a sampling of her dancing ability. But once on stage, she froze up, and the best she could do was to get out a rendition of the popular song "The Object of My Affection." Her fallback alternative, however, proved good enough to win the contest. After winning several more amateur competitions, she got a job singing with Chick Webb's band at Harlem's famous Savoy Ballroom, and with that, she began her rise as one of America's most admired popular vocalists. By the close of the 1930s, she would be "The First Lady of Swing," and in the years following she would claim the more all-encompassing sobriquet "The First Lady of Song."

Part of Fitzgerald's charms were her unprepossessing, almost shy ways, which made audiences warm to her immediately. But the main attraction, of course, was her miracle of a voice. Spanning three octaves, it had a silver-smooth clarity that was unrivaled. It was also incredibly supple, and she could take it from alto lows to soprano highs with seamless ease. Nowhere was this suppleness more apparent than in her flights of improvisational scat that she began perfecting in the 1940s as she adapted herself to the new bebop music and that would earn her yet a third sobriquet, "Queen of Scat."

Fitzgerald also brought to her music a respectful restraint, never imposing on a song personal preferences or flourishes. Instead, she seemed to understand intuitively what the composer wanted the work to be, and rather than "renovate" a song according to her taste, she "came to inhabit" it. So, it was not surprising that among her warmest fans were composers. "I never knew how good our songs were," lyricist Ira Gershwin once said, "until I heard Ella Fitzgerald sing them."

There were many single songs that came to be identified with Fitzgerald, among them "Oh, Lady Be Good," "How High the Moon," and her first hit, "A-Tisket, A-Tasket." But her most impressive legacy to popular music was a series of albums she began in the mid-1950s featuring the work of nine major single pop composers or composing teams, including George and Ira Gershwin, Richard Rodgers and Lorenz Hart, Jerome Kern, and Duke Ellington. A critic once declared these albums to be the "guidebooks to the great standards."

In the early 1950s, photographer Lisette Model began making photographs of jazz performances for a book in which she hoped to combine her images with writings by the African American poet and fellow jazz enthusiast Langston Hughes. The book never materialized, but by the time she gave up on the project, she had collated more than eight hundred possible pictures for it.

Model's image of Fitzgerald is thought to have been taken in 1954, the year she performed at the first annual Newport Jazz Festival. According to someone who saw her there, she was nervous about how other musicians would regard her performance. She need not have worried. She soon had "the crowd in a frenzy," and when she was done, "the roar was deafening."

ELLA FITZGERALD
1917–1996
SINGER

LISETTE MODEL (1906–1983)
Gelatin silver print
34.9 × 27.5 cm (13 3/4 × 10 13/16 in.),
circa 1954

JUDY GARLAND

1922–1969

SINGER, ACTRESS

BOB WILLOUGHBY (born 1927)
Gelatin silver print
35.2 × 21.4 cm (13 13/16 × 8 3/8 in.), 1954
(printed 1977)
Gift of Mr. and Mrs. Bob Willoughby

Hollywood photographer Bob Willoughby's photograph of Judy Garland taken during the filming of *A Star Is Born* captures the singer-actress at both her epic worst and her epic best. One of the great adolescent stars of the second half of the 1930s, she had won the adoration of young and old alike with her portrayal of Dorothy in *The Wizard of Oz* in 1939, and her teaming with Mickey Rooney in the Andy Hardy films about teenage romance and backyard musicals had been box office favorites. Now, however, she was thirty-two and widely considered a Hollywood has-been, thanks to a difficult temperament and drug addiction problems. As one admirer later put it, she had become "the star of her own adult melodrama."

In large degree, the making of *A Star Is Born* encompassed both those extremes. On the one hand, Garland's outbursts of ugly temper and failures to show up on the set pushed back the movie's shooting schedule by months. Her behavior also contributed heavily to an escalation in production costs that eventually exceeded five million dollars, making *Star* the second most expensive movie made up to that time in Hollywood. At one point, the film's exasperated director, George Cukor, confided to Katharine Hepburn that Garland was definitely "unhinged," but there was, he added, "a ruthless selfishness" mixed in with her behavior "that eventually alienates one's sympathy."

The one thing that was not coming unhinged amid all the tantrums, however, was Garland's showmanship. In that department, she managed to turn in a performance that was not just good. She was spectacular, and *A Star Is Born*, thanks mostly to her, ranks today as one of Hollywood's classic greats. At the film's release in late 1954, one critic declared *Star* "a mighty long gulp of champagne." The main ingredient of this irresistible libation was Garland, who had given "just about the greatest one-woman show in modern movie history." "Everybody's little sister," that same reviewer opined, had "grown out of her braids and into a tiara."

Unfortunately, this success was not exactly a harbinger of better things to come, and the remaining fifteen years of Garland's life were fraught with marital unhappiness, financial difficulties, and a host of health problems that were both emotional and physical. Nevertheless, there were some very good moments. A true child of the vaudeville circuit, where she had made her performing debut before she was three, Garland once likened the applause of live audiences to having "a great big warm heating pad all over me," and in her later years, her appetite for that applause led to a number of concert appearances where she mesmerized fans with renditions of popular classics, many of which she had first sung in her own movies. One of the most memorable of those appearances occurred in the spring of 1961 at New York City's Carnegie Hall. The recording of this performance eventually sold more than two million copies and won five Grammy Awards, and although one reviewer found some of Garland's more dedicated admirers at the concert itself a little mawkishly sentimental in their enthusiasm, he had to admit that even a "non-believer" such as himself left the hall "knowing that he had heard the best belter in the business."

MARILYN MONROE

1926–1962
ACTRESS

DAVID D. GEARY (1930–1999)
Silver dye bleach print
23.5 × 34.8 cm (9 1/4 × 13 11/16 in.), 1954
(printed 1998)
Gift of David D. Geary

Anyone considering the celebrity status of Marilyn Monroe in early 1954 would never have thought of disputing the assertion that she was a Hollywood star of the first magnitude. In the previous year, one movie magazine had proclaimed her its most popular actress; her films *Gentlemen Prefer Blondes* and *How to Marry a Millionaire* had been box office smashes. But beyond all that, there was yet one thing more: With a figure that evoked the unreal perfection of a George Petty pinup and a face to match, she possessed a sensuous allure that made her the most celebrated sex symbol ever to come out of Hollywood.

There was, nevertheless, one person who remained somewhat skeptical of Monroe's star status. The doubter was Monroe herself, whose deep-seated insecurities made it hard for her to believe fully in her popularity. But in mid-February of 1954, she too became a believer. Married the previous month to baseball great Joe DiMaggio, she had gone to Japan with her new husband for the opening of the Japanese baseball season. From there, she flew off to Korea to entertain American troops stationed there. Poured into a low-cut purple-sequined sheath, she was a sensation as she shimmied, cooed, and sang before thousands of women-starved G.I.'s. The soldiers could not get enough of it, but neither could Monroe, who, despite the cold, seemed thoroughly warmed by the whole experience. As one of her biographers put it, judging only from Monroe, it might as well "have been the hottest day of the year." Afterward she called it "the best thing that ever happened to me." "I never felt like a star before in my heart," she told a friend. "It was so wonderful to look down and see a fellow smiling at me."

More precisely, it was fellows—acres of them, gaping, ogling, and cheering. Between cheers and gapes, a good many of them were also snapping pictures. Among the photographers was Navy Hospitalman Second Class David Geary. Before the show started, Geary was hunting for a place to sit, never thinking that he could claim a spot in the front area reserved for higher ranking officers. Then somebody in that section spotted his Red Cross armband and, assuming him to be a doctor and a commissioned officer, called out, "Hey doc, c'mere." So it was that Geary found himself in the second row "with a beautiful angle onto the stage." Among the pictures he took from that choice position was the one here.

Unfortunately, the euphoria that Monroe felt as Geary shot his pictures was by no means permanent. Although she would grow substantially as an actress, her successes were never enough to ease her often paralyzing insecurities, and her instability made it excruciatingly difficult to work with her. Even so, no one would deny her impact on film. At Monroe's death from a drug overdose in 1962, Billy Wilder, who had directed one of her finest films, *Some Like It Hot*, admitted to having trouble with her. Nevertheless, he added, it was "worth a week's torment" to capture "three luminous minutes" of Monroe on screen.

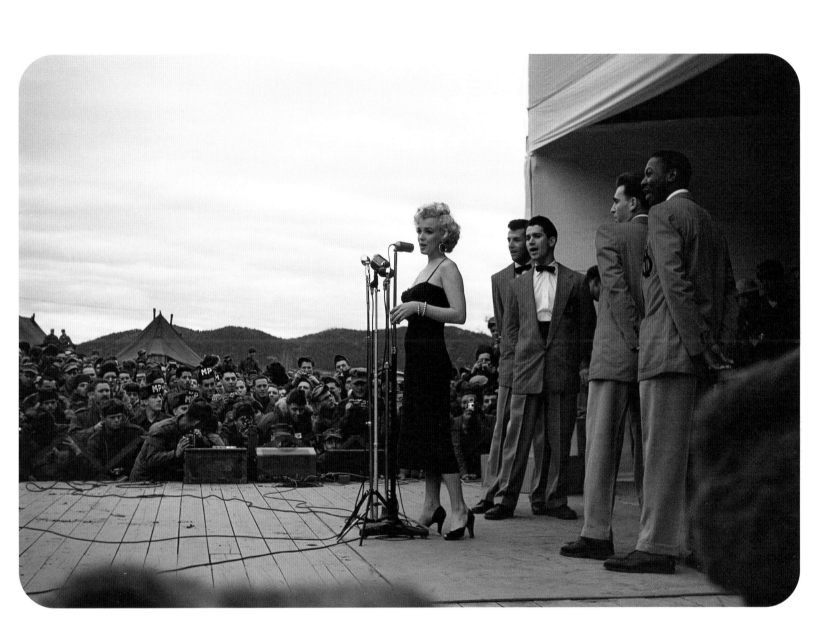

In late 1932, with the country approaching the depths of the greatest depression in its history, Dorothy Day was in Washington, D.C., to write an article for *Commonweal* on a Communist-organized hunger march on Congress. Had she still been the radical idealist of her younger days, she might well have been inclined to drop her reporter's notepad and join the Communist leadership in generating enthusiasm for the march. Now, however, she no longer felt much affinity for that brand of political extremism. Instead, having converted to Catholicism five years earlier, she was searching for a way to vent her reformer's impulse that was more in keeping with her keenly felt religious beliefs. So, after witnessing the march and completing her account of it, she went to the Shrine of the Immaculate Conception to pray for something to show her how she could best use her talents for the betterment of humankind.

The answer to her prayer was not long in coming. The next day, a Catholic friend sent a French-born former Christian brother named Peter Maurin to visit her at her New York apartment. Day would later credit this apostle of religious-based communitarianism with completing her religious education, and within a few months, the two had founded the *Catholic Worker*, a newspaper dedicated to redressing social and economic injustices and promoting the communal values of the Christian tradition. Selling for a penny a copy, the newspaper's circulation soared to more than 150,000 in three years. In the meantime, its headquarters on New York's Lower East Side became a model for the cooperative activism preached in its columns. By the mid-1930s, its tenement premises were as much soup kitchen, shelter, and used-clothing shop for the poor and homeless as they were editorial offices, and soon similar Catholic Worker "Houses of Hospitality" were springing up in cities across the country.

Day's unswerving pacifism seriously eroded support for her Catholic Worker movement's existence during World War II. But somehow it survived, and ultimately the pacifist underpinnings that she had brought to the movement placed it in the vanguard of protest against the Vietnam War in the 1960s.

Day's dedication to improving the human condition inspired great admiration among many, from cardinals to labor organizers. At her funeral in 1980, Abbie Hoffman, the antiwar activist of the 1960s, said, "She is the nearest this Jewish boy is ever going to get to a saint." It was just as well Day was not there to hear that. "When they say you are a saint," she once mused, "what they mean is that you are not to be taken seriously." And seriously was most definitely how she wished to be taken.

In 1955 photographer Vivian Cherry visited the House of Hospitality in New York City and the rural communes among which Day divided her time to do a picture essay on the Catholic Worker movement for another Catholic publication, *Jubilee* magazine. Among the shots taken was the one seen here, showing Day in her newspaper's offices. The writer who did the story with Cherry noted that Day was "quiet, even shy," but when it came to defending the weak and destitute, she added, she was "strong and tirelessly outspoken."

DOROTHY DAY
1897–1980
SOCIAL ACTIVIST, JOURNALIST

VIVIAN CHERRY (born 1920)
Gelatin silver print
16 × 23.7 cm (6 5/16 × 9 5/16 in.), 1955

ALTHEA GIBSON
born 1927
ATHLETE

GENEVIEVE NAYLOR (1915–1989)
Gelatin silver print
18.8 × 18.9 cm (7 3/8 × 7 7/16 in.), 1955
(printed circa 1970)

About the time tennis great Althea Gibson posed for this picture in 1955 in New York City's Harlem, where she had grown up, she was feeling that the time had come for her to get out of competitive tennis. The sport had brought her a long way from her adolescent days as a streetwise tough and habitual school truant. In 1947 she had claimed her first of ten women's singles championships in competitions sponsored by the all-black American Tennis Association. But ultimately the all-white world of mainstream tournament tennis could not overlook her talent, and three years later, she broke through the color barrier to become the first African American to compete for a title in the National Championship Tournament at Forest Hills. By 1953 she had achieved a ranking of seventh in American women's tennis. The next year, however, she dropped down to thirteen, and by late summer of 1955, with no major titles outside of black tennis to call her own, she had decided to put down her racket in favor of a military career.

Before she could carry out that plan, however, the State Department asked her to join a goodwill tennis tour in Southeast Asia, and after some cajoling, she finally said yes. Although she did not know it at the time, this was precisely the tonic that her tennis game needed. As the tour progressed, she encountered a genuine acceptance that she had seldom felt in the overwhelmingly white world of American tennis, and suddenly her play was soaring to a new level. By the late spring of 1956, she was claiming the prestigious French Singles Championship. But that was only the beginning. The next year, she won the women's singles at Wimbledon in July, and then, just after her thirtieth birthday, she took the American National singles title at Forest Hills. In that second victory, she had dominated the championship match without seeming to draw so much as a "hurried breath." As if that were not enough, "this lanky jumping jack of a girl" repeated that same pair of triumphs in 1958.

During some of Gibson's matches, there were moments when she did not always look like the great winner that she had become. "Althea Gibson is not," *Time* reported just before her first Forest Hills win, "the most graceful figure on the courts, and her game is not the most stylish. She is apt to flail with more than the usual frenzy." Still, there was a "power and drive" to her game that was unequaled. As for strategy, another player told the magazine, "she plays smarter all the time."

The children from her old neighborhood milling around Gibson in this picture do not appear very attentive to the improvised tennis demonstration that she seems to want to offer them. Some of them may have come to regret that, for, as Gibson advanced from victory to victory over the next few years, enthusiasm for tennis in African American communities increased substantially. As one of her black fans recalled years later, tennis was now viewed as yet another way out of the ghetto, and "everyone went out and bought a new racquet."

ROSA PARKS

born 1913
CIVIL RIGHTS ACTIVIST

IDA BERMAN (born 1911)
Gelatin silver print
24.4 × 19.5 cm (9 7/8 × 7 11/16 in.), 1955

In the summer of 1955, the labor-union photographer Ida Berman visited Highlander Folk School in Tennessee, a center that offered workshops in community activism. Shortly after her arrival, Highlander's director asked her to take some pictures for the school. Her choices of subject were made on the basis of whom she found interesting, and one of the individuals fitting that category was an African American seamstress from Montgomery, Alabama, named Rosa Parks. "I liked her," Berman recalled years later, and among the remembrances of that liking was this exquisitely simple image of Parks.

When the picture was taken, no one would have suspected that Parks would soon spark a significant chapter in black civil rights activism, and if anyone had raised that possibility at Highlander, Parks would have dismissed it as lunacy. It was not that she had no faith in activist means for redressing the grievances of African Americans. After all, since 1943 she had been secretary of the Montgomery branch of the National Association for the Advancement of Colored People, an organization premised on community activism. But in her part of the Deep South, where the protest of blacks all too often met with brutal white reprisal, she feared that more aggressive forms of activism did her cause more harm than good. In fact, she did not think that she would apply much of what she was learning at Highlander when she returned to Montgomery.

She could not have been more wrong. On December 1, Parks was riding home from her job at a Montgomery department store on a city bus. When she boarded, she took a seat in the section reserved for blacks, but local regulations required that if a white person boarded a bus after its "whites only" section was filled, a black rider would be asked to surrender his or her seat to the white. And that is what happened to Parks. She was, however, in no mood to surrender her seat. When her refusal to stand led to a threat from the bus driver to call the police in, Parks told him to call, and she soon found herself arrested and fined fourteen dollars.

Parks's cause became the cause of Montgomery's entire black community. Before long, the city's African American leadership was launching a boycott of the bus system to force modification in its policies regarding passenger seating and its unwillingness to hire black drivers. With most of the system's riders coming from the black community, chances for the boycott's success looked good, provided it lasted long enough. And last it did—for more than a year. At the same time, a case seeking to outlaw some of the bus system's segregationist practices moved through the federal courts. Finally, in December 1956 the boycott and the Supreme Court's decision banning Montgomery's bus segregation brought the struggle to its successful close. The battle had taken its toll, however. Among those hurt was Parks herself, whose defiance cost her her job. But eventually she would find solace in the knowledge that the boycott had been one of the great energizing events of the black civil rights movement of the mid-twentieth century.

Writer Sylvia Plath was living in Boston when this picture was taken in 1959, and photographer Rollie McKenna shot it in the Beacon Hill apartment that Plath shared with her English poet husband, Ted Hughes. Eventually, the image appeared, along with two of Plath's poems, in *The Modern Poet: An American British Anthology*, published in 1963, the year of her death.

Not too long before McKenna made the picture, yet another image of Plath in her Boston apartment—this time looking over the shoulder of husband Ted—had run in *Mademoiselle*. In the article that it accompanied, Plath came off as quite content with her literary progress thus far and with a marriage in which the shared poetic pursuits seemed to offer the perfect stimulus for fostering her ambitions. There was some substance to that impression. In many respects this was probably one of happiest periods in Plath's adult life. Living in Boston, she not only had her husband with whom she could share her art. There was also the older poet Robert Lowell, whose seminar she attended, and Anne Sexton, another young poet in the seminar, who became a good friend. Most important to Plath, however, her powers as a writer were advancing steadily, she believed, and in May 1959, she wrote in her journal, "I have done … what I said I would: overcome my fear of facing a blank page day after day, acknowledging myself, in my deepest emotions, a writer, come what may: rejections or curtailed budgets."

That optimistic assessment received reinforcement several months later when an English editor expressed interest in publishing the first collection of her poetry. Not long after moving to England at year's end, Plath was preparing the final manuscript of that collection, which appeared as *The Colossus and Other Poems* in 1960. The volume, predicted one critic, "will be enjoyed most by intelligent people capable of having fun with poetry and not just being holy with it."

Unfortunately, even in the best of times, Plath was a fundamentally tormented person who suffered from severe depression. Her turbulent despair found constant expression in her work. But as far as her personal equilibrium was concerned, capturing her feelings in verse had little therapeutic effect, and in early 1963 Plath committed suicide.

Within her own lifetime, Plath was never very widely known. Her later, posthumously published poems, however, indicate that whatever the anguish of her final years, her poetic gifts kept growing to the very end, and she has long since come to be seen as one of the more important poetic voices of mid-twentieth-century America. Adding further to her reputation is her autobiographical novel, *The Bell Jar*, inspired by her student years at Smith College, which had been marked, on the one hand, by stellar achievement and, on the other, by emotional breakdown and attempted suicide. Originally published in England in 1963, this book did not draw much American attention until 1971. When it did, however, its chronicle of a young woman trying to find herself in a world intent on stifling her individuality struck a meaningful chord, especially among feminists, who soon embraced Plath as a prophet of their cause.

SYLVIA PLATH
1932–1963
POET, NOVELIST

ROLLIE McKENNA (born 1918)
Gelatin silver print
18.4 × 14 cm (7 1/4 × 5 1/2 in.), 1959
(printed 1995)
Gift of Rollie McKenna

LORRAINE HANSBERRY

1930–1965
PLAYWRIGHT

DAVID MOSES ATTIE (1920–1983)
Gelatin silver print
34.6 × 27.3 cm (13 5/8 × 10 3/4 in.), circa 1960

When Lorraine Hansberry was eight years old, she moved with her prosperous African American family into an all-white neighborhood of Chicago. They were not at all welcome there. Like many urban residential enclaves of the late 1930s, the neighborhood's covenant agreement prohibiting black residents was soon being invoked to drive the Hansberrys out of their new home. The family, however, stood its ground, and while his wife and children vigilantly confronted threats from white neighbors, Carl Hansberry was preoccupied with challenging the covenant's legality in court. Finally in 1940, in the case of *Hansberry v. Lee*, the Supreme Court declared the covenant invalid. Unfortunately, the decision proved unenforceable in the face of white Chicago's hostility to it, and Hansberry's father became convinced that fair treatment was something that blacks simply could never expect to receive in the United States.

To say that those events left a lasting impression on Hansberry would be an understatement, and in 1956, when she began crafting a play ultimately titled *A Raisin in the Sun*, she was to a large extent mining her own past by centering her plot on a black family's ambition to trade a cramped apartment in a black ghetto for a neat, sunny house in a white neighborhood. Having worked a good deal in journalism, Hansberry had tried writing plays several times before but never finished them. This time, however, she carried her effort to completion. Better still, despite cynics who thought there was no market for a play of this sort with a nearly all-black cast, there were those who wanted to stage it, and in March 1959, with a cast that included Sidney Poitier and Ruby Dee, *Raisin* opened on Broadway to a loud choruses of praise. Congratulated on her "intelligence, honesty and humor" and the "vigor" and "veracity" of her story, Hansberry soon became the first black playwright to win the New York Drama Critics Award.

Raisin in the Sun ended with the play's black family finally getting their house in a white neighborhood that did not want them. Many playgoers interpreted that as a happy ending, and some faulted Hansberry for what they deemed a falsely sunny reflection of African Americans' struggle against the intransigent racism that denied them so many fundamental rights. Hansberry, however, was not the Pollyanna that some thought her to be. She knew full well that when *Raisin*'s black family moved into its house, its main struggle against white hostility had only just begun.

Certainly that awareness was evident in Hansberry's involvements in the civil rights movement and her strong support for the movement's growing militance. At a meeting in May 1963 between black leaders and Attorney General Robert F. Kennedy regarding the country's current state of racial unrest, she was among the most outspoken. At one point in the discussion, she went so far as to suggest that if the federal government could not do more to redress the grievances of American blacks, then perhaps there was "no alternative except our going in the streets … and chaos."

ANNE SEXTON

1928–1974
POET

ROLLIE McKENNA (born 1918)
Gelatin silver print
34.3 × 26.5 cm (13 1/2 × 10 7/16 in.), 1961
(printed 1995)
Gift of Rollie McKenna

In the mid-1950s, Anne Sexton experienced repeated psychological breakdowns that sent her into extended therapy. In the course of treatment, her doctor suggested that she try writing to gain an understanding of her difficulties. Shortly thereafter, while listening to a televised lecture on sonnets, she said to herself, "I can do that," and in what she later described as "a kind of rebirth at twenty-nine," she was soon trying her hand at various forms of poetry. At first, these exercises were regarded as mostly therapeutic, but it was not long before they were invested with a strong sense of vocation as well. Over the next several years, she attended poetry workshops where, using her verse to probe the dark emotional recesses of her life, she aligned herself with the so-called "confessional" poets. In 1960 the first collection of her work, *To Bedlam and Part Way Back*, reached publication and quickly established her as an important new voice in American poetry.

Taken the following year, this photograph showing Sexton at her desk in a dining room corner of her house in Weston, Massachusetts, seems to depict a woman entirely at ease with herself and her newfound fame. She appears, in fact, to be one of those lucky individuals who has the proverbial "all" or at least a good portion of it—beauty and talent topped off by a serene self-assurance. At moments in 1961, that was indeed a fair reflection of how she struck people. Meeting Sexton for the first time in April at the Cornell University Arts Festival, where she had gone to give a reading, fellow poet Peter Davison said that he suspected that her pre-performance confessions of jitters and anxiety was a mere act. Not only did she "read splendidly," she also turned out to be a live wire afterward. "She ... carried herself like a model," Davison remembered. "Once the parties started, she was going half the night."

That was Sexton viewed from the outside. From the inside, it was a different story altogether. Several months before going to Cornell, she had noted, "I hate to go to the market.... Somebody sees me, *and I see myself through them....* The whole world falls apart." And at Cornell, her interior state was no better, regardless of how others might have perceived it. "I was scared the whole time," she told her therapist afterward.

Yet however intractable her emotional difficulties remained, Sexton's artistry thrived. By year's end, she was preparing to bring out another volume of verse, *All My Pretty Ones*, which only increased her stature in the world of poetry. Some of her most appreciative audiences were in England, and in 1965, following the publication of her *Selected Poems*—assembled specifically to meet the English demand for her work—she became an overseas fellow of the Royal Society of Literature. Two years later, her collection *Live or Die* earned her a Pulitzer Prize.

Unfortunately, neither the accolades nor continual therapy could fully heal Sexton's deeply troubled personality or curb her vulnerability to deep depression. In 1974, suffering both a mental and physical decline brought on in part by alcoholism and dependency on prescription drugs, she committed suicide.

There were many reasons that seemed to mark folk singer Joan Baez as singularly ill-cast for the role of a popular vocal artist. She suffered from a severe case of shyness, which she made little effort to overcome when she performed, and she had little use for efforts to enhance her audience attraction through makeup or appealing dress. When she came on stage, it was thus apt to be a rather stark affair—no witty patter, no eye-catching garb, just a plainly clad, soft-spoken girl with her guitar. Nor was there a burning ambition driving Baez down her road to fame. After performing in coffeehouses around Boston for a few years, she went to the Newport Folk Festival in 1959 to perform and was a great hit there. But when that success spawned some impressive recording offers and chances for concert tours, she turned them all down and went back to performing in Boston.

There was one factor, however, that balanced out all these career-hampering minuses, and then some: Baez's soprano voice was an incredible instrument. Though totally untrained, it was, in the words of one critic, "as lustrous and rich as old gold." Thanks to that voice, the lack of showmanship and personal drive for fame did not matter much. When Baez finally did accept a recording offer in 1960 and consented to a concert tour the following year, her reputation soared. With two of her albums "perched high on the pop charts," *Time* reported in mid-1962, she had sold more records than any other female folk singer in history. Noting that her recent concert at Carnegie Hall sold out months in advance despite little advertising, the magazine commented that, had she chosen to perform with greater frequency, she stood to reap a good deal more than the already substantial income she was earning.

But Baez rejected that possibility, claiming that the greater the focus on money the more she jeopardized the integrity of her identification with folk singing, which at its most authentic was not about profit. At the same time, she was deeply committed to promoting causes that she believed in. As a result, by the mid-1960s, she was giving increasing time to benefit concerts in support of such movements as the struggle for African American civil rights and the protests inspired by the war in Vietnam.

The work of photojournalist Ivan Massar, this photograph was taken in the late summer of 1963, during the great March on Washington that civil rights groups had organized to demand federal action guaranteeing full equality for black Americans. The demonstration drew more than 250,000 people, and many well-known singers had been invited to perform at the march's gathering at the Lincoln Memorial on August 28, including Odetta, Bob Dylan, and Mahalia Jackson. But the honor fell to Baez to lead the crowd in singing what had become the civil rights movement's anthem, "We Shall Overcome." Recalling the scene years later, Baez noted "that one of the medals which hangs over my heart I awarded to myself for having been asked to sing that day."

JOAN BAEZ
born 1941
FOLK SINGER

IVAN MASSAR (born 1924)
Gelatin silver print
24.2 × 16.5 cm. (9 1/2 × 6 1/2 in.), 1963

DIANA ROSS

born 1944
with fellow Supremes
FLORENCE BALLARD
and MARY WILSON
SINGERS

BRUCE DAVIDSON (born 1933)
Gelatin silver print
20.4 × 30.5 cm (8 × 12 in.), 1965

As photographer Bruce Davidson snapped this picture in the Motown recording studios in Detroit, Michigan, in 1965, the three young women caught in his lens—(left to right) Florence Ballard, Diana Ross, and Mary Wilson—were rapidly scaling the heights of the pop music world. Within a few more years, this trio would have nowhere further to climb. They had originally called themselves the Primettes when they began performing—a name that was certainly an apt prediction of their ascendance. But they changed their name to the Supremes, and that sobriquet had an even more appropriate ring to it. By 1965, after several years serving as backup for other singers recording at Motown, they were indeed beginning to reign supreme. In the previous year, their single "Where Did Our Love Go" had reached number one on the hit charts and sold more than two million records. But that was only the beginning. Over the next twelve months, five more of their songs climbed to the number one spot, and some of them, such as "Stop in the Name of Love," would ultimately be regarded as emblematic pop classics. By 1967 they had earned seven gold records and could claim more than a dozen best-selling albums. The Supremes had, in short, become the most successful female group in pop music history.

In analyzing the Supremes' success, there was no doubt about its main component. It was called Diana Ross, and as the group's lead singer, she was without question the main attraction. Her chief asset was a voice that one pop critic described as a "torchy come-hither purr" and that another said could put "swerves into the most unsupple lyrics." But Ross also had a intuitive sense of style that was often as riveting as her voice. With her lithe body "slung like six feet of limp wrist," one observer noted, "she stood under the velvet spotlight, a perfect summa-cum-laude Supreme."

But while Ross's stellar allure was the making of the Supremes, it also turned out to be its undoing when Ross struck out on her own in 1970. The move proved good for her. Not only did she continue to enjoy immense popularity as a vocalist; she also distinguished herself as an actress, and her portrayal of Billie Holiday in the movie *Lady Sings the Blues* in 1972 won her a best actress Oscar nomination. For a reconstituted Supremes, however, the results were not nearly as good. Though some of their recordings made the hit charts in the next several years, the group never again occupied the heights that it had with Ross.

Davidson's photograph of the Supremes was one of many that he shot of the group over several days in Detroit and New York City. What struck him most about this extended encounter was the spontaneity of his subjects and their indifference to his presence. As he worked around them, he said years later, it was as if "I didn't exist. They just let me be wherever I wanted to be. I don't think we ever spoke." Even so, he noted, "I enjoyed them as people, and they were gorgeous."

FANNIE LOU HAMER

1917–1977
CIVIL RIGHTS ACTIVIST

CHARMIAN READING (born 1930)
Gelatin silver print
25.7 × 34 cm (10 1/8 × 13 3/8 in.), 1966
(printed later)

In August 1962, Fannie Lou Hamer walked into a civil rights meeting in Mississippi where the speakers were urging their black audience to join the fight for the full equality that had been so long denied them. The poorly educated Hamer lived on a white-owned plantation, where she and her husband eked out a marginal living. Given the hardness of her existence, it perhaps seemed unlikely that she would have any energy left over for civil rights activism. But when the meeting's organizers asked the audience to join a challenge to Mississippi's systematic disenfranchisement of blacks, she quickly signed on, and several days later, she was with a group of blacks trying to register to vote at a courthouse in Indianola. The effort failed and so irritated local white authorities that Hamer and the other would-be registrants were fined for using a farm-worker bus that was supposedly painted an illegal color. Then, upon arriving home, Hamer was informed that her continued defiance of Mississippi's white political mores would mean the loss of her job. By now, however, she was in too far to give up. The following January, she finally succeeded in registering to vote, and on the way to that personal victory, she found a new vocation as a civil rights field worker.

Several months later, Hamer was arrested and brutally beaten in the Winona, Mississippi, jail for venturing into a "whites only" lunchroom. But she came out of the experience more determined than ever. By the summer of 1964, she was spearheading a protest at the Democratic National Convention challenging the legitimacy of Mississippi's all-white delegation, which had been chosen under a system that excluded black participation. Hamer and her allies won only a token compromise, which granted them two seats in their state's delegation and which she regarded as a defeat. As she put it, "We didn't come all this way for no two seats when all of us is tired." But while the immediate battle may have been lost, the war had been won. Hamer's compelling testimony at the convention about the horrific methods sometimes employed in Mississippi to deny blacks their rights had jolted the national conscience. In so jolting, she had assured that the days of exclusionary politics in Mississippi and other parts of the South were numbered.

Hamer was fond of punctuating her public utterances with "I'm sick and tired of being sick and tired," but she never lost her zest for working toward improving the lot of Mississippi blacks. In the late 1960s she founded the Freedom Farm Cooperative that ultimately provided food for some five thousand people, and she became involved in an organization to provide decent housing for the poor.

In the picture here, Hamer is seen participating in the March Against Fear from Memphis, Tennessee, to Jackson, Mississippi, that James Meredith launched in June 1966 to dramatize the determination of blacks to gain their full rights in the South. It was during this event that the term "black power" first began to gain currency as an evocation of a new and more militant brand of civil rights agitation.

JANIS JOPLIN

1943–1970
SINGER

LINDA McCARTNEY (1942–1998)
Chromogenic print
50.7 × 40.5 cm (19 15/16 × 15 15/16 in.), 1967
(printed 1996)
Gift of the photographer, Linda McCartney

Growing up in Port Arthur, Texas, Janis Joplin was the proverbial square peg in a universe of round holes. Not especially good-looking and somewhat overweight, she fell well short of the image that might have won her a place among the cheerleading set, and her interests in reading, painting, and folk music made yet more remote any chance of popular acceptance by her peers. As she summed it up years later, she was "just 'silly crazy Janis,'" the resident beatnik. In the years after high school, Joplin's odd-man-out syndrome continued as she dropped in and out of college and moved back and forth between the West Coast and Texas. In the midst of that drift, however, she began singing in coffeehouses and clubs. Increasingly, Joplin regarded singing as her career of choice, and in mid-1966, she accepted an invitation to be the lead vocalist for Big Brother and the Holding Company, a San Francisco rock band that had been organized by a Texas friend.

Joplin reveled in San Francisco's vibrant hippie pop culture, and in the process her singing took on a new and uninhibited exuberance, characterized by a sound that was shrill, rasping, and, above all, aggressive. San Francisco, in turn, readily appreciated that aggressiveness, and it was not long before Big Brother's new female vocalist had become one of the city's hottest rock music attractions. Joplin ceased to be a mostly local phenomenon, however, in June 1967, when she appeared with Big Brother at the Monterey International Pop Festival. Describing her rendition on that occasion of "Love Is Like a Ball and Chain," *Newsweek* reported that she "sang like a demonic angel." Yet another observer said that the song had been "wrenched out of some deep dark nether region of her Texas soul." Whatever its origin, "Ball and Chain" had clearly connected with the audience and gained a nationwide attention that signaled Joplin's emergence as one of pop music's major stars. When it became known not long afterward that Joplin and her group were coming out with their first album, *Cheap Thrills*, the album climbed to the coveted one million mark in sales even before it actually went on the market.

The feverish energy that Joplin put into her singing was physically taxing in the extreme. She also routinely consumed large quantities of whiskey during performances. So it was not surprising when pop music observers began to think that she would soon burn herself out. When asked about this, she once said, "I don't want to do anything half-assed…. When I can't sing, I'll worry about it then." That was an eventuality, however, that she never had to confront. In October of 1970, Joplin was found dead at the age of twenty-seven from an overdose of heroin.

Linda McCartney, who made a specialty of photographing pop musicians and singers in the 1960s, took this photograph several months after Joplin and her group had given their momentous performance in Monterey. Shot at New York City's Fillmore East, the picture depicts Joplin singing "Ball and Chain," the song that had propelled her to stardom.

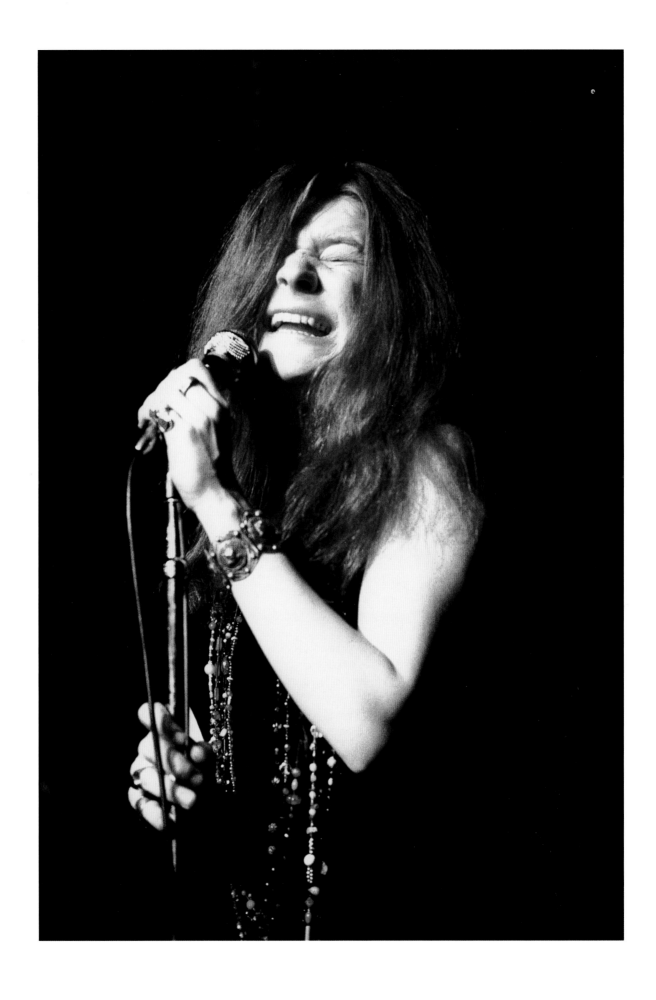

From early on, Pauline Trigère was destined for a career in the clothing business. Born and raised in Paris, she was the daughter of a tailor and a seamstress, and at an early age, her father was already teaching her cutting strategies for getting the most out of a bolt of cloth. By ten, she could operate a Singer sewing machine, and by the time she was in her early twenties, she was married to a tailor. But although these factors may have portended a future in clothing manufacture, they could not anticipate that one day Trigère would be regarded as one of the leading designers in American high fashion.

Oddly enough, the ascent toward that eminence began with a French national election in June 1936. Out of that contest, socialist Léon Blum emerged as the country's new premier, and Trigère's husband, fearing that Blum's anticapitalist outlook spelled the end of free enterprise, convinced his wife and her family to immigrate with him to Chile. Instead, they settled in New York City, where they soon had a tailoring and dressmaking business that unfortunately failed in 1941. In the process, Trigère's marriage failed as well, and she was soon pawning her few bits of valuable jewelry to finance a try at dressmaking on her own. In terms of quantity, her first collection of eleven dresses was not very impressive. But their clean elegance and attention to detail were. Before long, her jewelry had been redeemed, and fashion buyers from the nation's most prestigious stores were clamoring for her clothes. By 1949 she was claiming the Coty American Fashion Critics' Award, and ten years later she was admitted to the Coty Fashion Hall of Fame.

At a chance meeting in a restaurant, a man once informed Trigère that his recently deceased mother, a longtime customer of hers, had been buried in her newest Trigère creation. Walking away to her own table, the designer remarked to a companion, "You see? With a Trigère you can go anywhere!" Within that jest was a significant grain of seriousness that reflected one of the shaping concerns of Trigère's career, for she was never interested in creating novelty or sensation. Instead, she wanted to make versatile clothes of timeless elegance that could make women feel good about wearing them for years.

Trigère did not do her designing at a drawing board. Instead, often acting on only a vague notion of what she wanted, she would unwind cloth from a bolt and drape it on a live model, cutting and shaping it as she went. Described once as a "virtuoso with the shears," she was unerring in her judgments of where to cut and made few irrevocable mistakes. "I can't draw, I can't paint," she once boasted, "but put a piece of fabric in my hands and magic happens." Many of her staff agreed. However often they witnessed this creative process, one of them said, it "never fails to electrify."

In the photograph here, Trigère seems to be making some finishing adjustments to one of her dresses. On this occasion, she was working in front of a group of students from a New York City vocational high school pursuing careers in the clothing industry, and some of her audience are visible in the mirror's reflection.

PAULINE TRIGÈRE
1911–2002
FASHION DESIGNER

ARTHUR LEIPZIG (born 1918)
Gelatin silver print
22.8 × 34.2 cm (9 × 13 7/16 in.), 1968
(printed 1997)

DIANE ARBUS

1923–1971
PHOTOGRAPHER

GARRY WINOGRAND (1928–1984)
Gelatin silver print
31.2 × 47.1 cm (12 5/16 × 18 9/16 in.), 1969

When Diane Arbus's husband, Allan, went into the Army Signal Corps following the outbreak of World War II, she followed him to his New Jersey training camp, where he was learning to be a photographer, and at night he would teach her what he had learned in classes during the day. Soon she was taking pictures on her own, and not long after Allan returned to civilian life in 1945, the two formed a partnership to do fashion photography for her family's women's clothing store in New York City. The collaboration worked well, and their business gradually expanded to include commissions from fashion magazines such as *Harper's Bazaar* and *Glamour*.

As the years passed, however, Arbus came to hate this work, and between raising two daughters and keeping up her end of the partnership, she became deeply frustrated over the lack of opportunity to explore other avenues in photography. Finally her unhappiness reached a breaking point at a dinner party in 1957. When asked by another guest to describe her fashion work, she broke into uncontrollable sobs, and shortly thereafter, she and her husband agreed that she should withdraw from their business to concentrate on other branches of photography that better satisfied her creative restlessness.

In this new phase of her career, human portraiture became Arbus's main subject matter, but it was not a studio brand of portraiture. Rather, her likenesses were taken in venues that were part of her subjects' lives—their living rooms, their bedrooms, the streets where they walked daily. Still, there was a definite sense of posing in these likenesses, and ultimately Arbus's images evolved into a distinctive meld of in situ spontaneity and photographer control.

The individuals that peopled Arbus's photographs ranged from the celebrated to the anonymous, and a large portion of them were eccentrics and freaks living on urban society's margins. But whether they documented the high or the low, the freakish or the more normal, her pictures tended to have one trait in common—an adversarial abrasiveness that sometimes seemed calculated to expose subjects at their most vulnerable point.

This sort of candor did not find praise in every quarter. One of her subjects, writer Norman Mailer, once remarked that "giving a camera to Diane Arbus is like putting a hand grenade in the hands of a child," and a critic, who conceded that her work had its virtues, nevertheless admitted that some of her frankness bordered "close to poor taste." On the other hand, Arbus had a substantial following of ardent champions. Not the least among them was the Museum of Modern Art's photography curator John Szarkowski, who in an introduction to a 1967 exhibition declared that "the honesty of her vision" was the reflection of a "truly generous spirit." Moreover, by the time Arbus took her own life in 1971, a consensus was emerging that, likable or not, her pictures were the work of one of the most original practitioners of mid-twentieth-century photography.

It is thought that this picture was taken in Central Park after an antiwar protest. The droll impact of Arbus's grim expression as she clenches a daffodil in her mouth, however, reveals a basic tool of her trade—namely, her remarkable stock of tricks for making subjects drop their defenses before her camera.

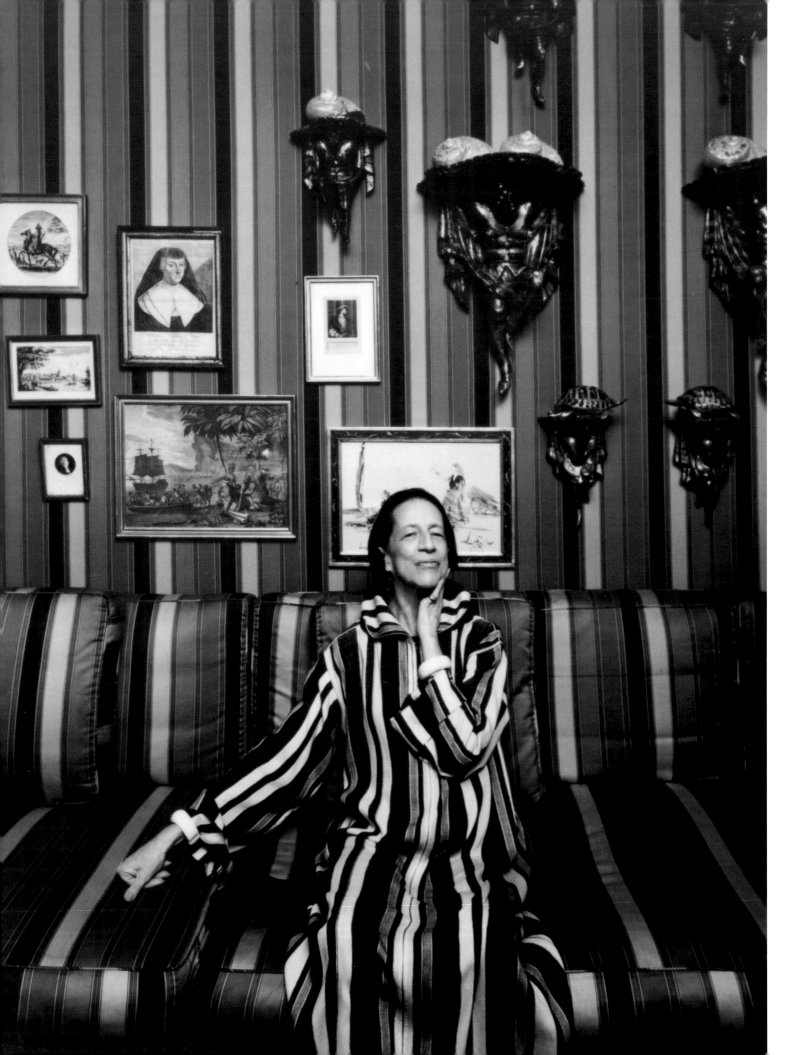

Diana Vreeland grew up in Europe and the United States, a daughter of privilege who was never expected to pursue a career. And that is probably why her parents, whose own focus was the pursuit of pleasure, never showed much concern about her formal schooling, which amounted to sporadic attendance at various exclusive schools. Nevertheless, as Vreeland grew into young womanhood and settled into a happy marriage to a handsome banker, she was unknowingly enrolled in a vocational education of sorts that was destined to make her peculiarly well suited for at least one career opportunity. Everywhere she turned in her upper-crust world there were lessons to be learned in what was chic and elegant and what the subtle differences were that distinguished stylish originality from breach of taste. Apparently Vreeland absorbed those lessons exceptionally well, and when an economic pinch prompted her to take a job to supplement her husband's income in the mid-1930s, she found a perfect match for her expertise: working in the fashion-minded editorial rooms of *Harper's Bazaar*. As she herself later put it, "Suddenly I found that my *whole* background *was my future*."

Her first work for the magazine was an eminently frivolous column called "Why Don't You … " which offered readers such brittlely sophisticated counsels as "Why don't you … sweep into the drawing room … with an enormous red-fox muff of many skins?" But Vreeland was soon on to bigger things. Within a few years she had become *Harper's Bazaar*'s fashion editor, a post she would hold for more than twenty years, and during that tenure she carved out her place as perhaps the most influential arbiter in American women's fashion. By the time she left *Harper's Bazaar* in the early 1960s to become editor-in-chief at *Vogue*, the qualifying "perhaps" in that description was no longer necessary. It was said that designers "tremble[d] at her nod" and justifiably so, since a good many customers at their showings were inclined "to pick purely" on the basis of what she seemed to approve.

When Vreeland left *Vogue* in 1971, she was in her late sixties, but she was not ready for retirement. Instead, she worked for more than a decade as a consultant for the Costume Institute at New York's Metropolitan Museum of Art and curated a series of exhibitions on clothing design that were celebrated as much for their innovative installation as they were for their engaging content.

Taken not long after the opening of her second show for the Metropolitan, on clothing and costumes of the Hollywood stars, this photograph by Arnold Newman shows Vreeland seated in her Park Avenue apartment. The image underscores the irony that in a business where good looks were highly valued, she had herself been no great beauty. Her walk was once likened to "a camel's gait," and her face was described as having been stolen off a "cigar-store Indian." But the photograph also evokes a presence that seems substantially greater than the sum of its parts, and looking at this vibrant woman planted on her sofa, it is easy to understand why so many found Vreeland such a magnetic and appealing individual. As one admirer put it, she was "a bird of paradise who took her plumage for granted," and when she walked into a room, even the more dazzling figures around her "melted into the background."

DIANA VREELAND
1903–1989
FASHION EDITOR

ARNOLD NEWMAN (born 1918)
Gelatin silver print
33.1 × 25.1 cm (13 1/16 × 9 7/8 in.), 1974

155

KATHARINE GRAHAM

1917–2001
NEWSPAPER PUBLISHER,
WRITER

RICHARD AVEDON (born 1923)
Gelatin silver print
25.5 × 20.2 cm (10 1/16 × 7 15/16 in.), 1976
This acquisition was made possible by
generous contributions from Jeane W. Austin
and the James Smithson Society

In the summer of 1963, Katharine Graham's husband, Philip, committed suicide, and in the midst of her grief, she had to decide whether she should try to succeed him at the helm of the family-owned company that was the umbrella organization for a number of media enterprises, including its flagship newspaper, the *Washington Post*, and *Newsweek* magazine. Content for many years with her roles as wife, mother, and Washington, D.C., hostess, she had long been a sometime adviser in the company. But she certainly knew nothing about managing it and was terrified at the prospect of having to learn. Nevertheless, driven by a sense of familial obligation, she concluded that she had to try.

Recalling that decision many years later, Graham said: "What I essentially did was to put one foot in front of the other, shut my eyes and step off the ledge. The surprise was that I landed on my feet." Actually, she did quite a bit more than just land on her feet. Under her guidance, the *Washington Post* grew into one of the most highly regarded and influential newspapers in the world, and the profitability of its parent company increased dramatically. As for the impact of that success on Graham's public reputation, it was not uncommon by the mid-1970s to find her characterized in such superlative terms as the "most powerful woman in journalism" or "one of the most important women in America."

Among Graham's greatest strengths was her ability to spot journalistic talents and then allow them free rein to do their job as they saw fit. More memorable, however, was her commitment to the tradition of a free press. Even in the face of possible legal reprisals and economic intimidation, that commitment proved unswerving and placed the *Post* in the vanguard in reporting the two most controversial news stories of the early 1970s—the airing of the top-secret Pentagon Papers relating to the Vietnam War and the Watergate scandals that climaxed in Richard Nixon's presidential resignation.

In about 1990, Graham began writing her memoirs, and just as she had once thought she would never make much of a news publisher, she was not altogether confident that what she wrote would amount to much. The resulting book, however, was remarkable for its candor and engaging style. One observer said that it rescued "the art of autobiography from years of celebrity abuse," and after many weeks as a best-seller, it earned its author a Pulitzer Prize.

Graham's likeness was part of a portrait series of noted public figures that photographer Richard Avedon took to mark the American bicentennial year of 1976 and that appeared in *Rolling Stone*. While this starkly unadorned image may not be especially flattering, the picture evokes a sense of stolidness that makes quite clear what prompted *Post* executive editor Ben Bradlee to describe Graham as someone with "the guts of a burglar." In 1969 Graham had opined, "I think a man would be better at this job I'm in than a woman." Much had happened by the time she posed for Avedon, however, and it is hard to imagine the woman pictured here ever entertaining that thought.

BARBARA JORDAN

1936–1996

CONGRESSWOMAN, LAWYER

RICHARD AVEDON (born 1923)
Gelatin silver print
25.3 × 20.3 cm (9 15/16 × 8 in.), 1976
This acquisition was made possible by
generous contributions from Jeane W. Austin
and the James Smithson Society

Photographer Richard Avedon's habit of setting his portrait subjects against stark backgrounds and catching them in emotionless confrontations with his camera have often produced images that seem to erode their stature. But when he took that tack in 1976 with Texas Congresswoman Barbara Jordan for his bicentennial series of American notables published in *Rolling Stone* magazine, that was not the case. Instead, Jordan filled the picture frame with a presence that seemed to challenge the photographer to expose a hole in her armor if he dared. And dare he did not. Looking at this likeness a quarter century later, it is not hard to understand why one journalist said that doing an interview with Jordan was "a bit like grilling God."

It is also not hard to imagine that the individual in this picture was the same person who once said, "I never wanted to be run of the mill." Indeed, that was the guiding principle of Jordan's life from early on. As a young girl, she had put aside her ambition to be a pharmacist when she realized that it was unlikely to win her a place in the ranks of the outstanding. Instead, she focused on becoming a lawyer, and after practicing law for a while in her native Houston, she set her sights on obtaining public office. In 1962, armed with a deep, rich voice that added immeasurably to her credibility on the stump, she launched a campaign for a seat in the Texas House of Representatives. She lost, but not by enough to discourage more tries for office, and four years later she became the first woman ever elected to the Texas senate and the first African American to sit in that body since the early 1880s.

Jordan dazzled her fellow lawmakers with her intelligence and depth of knowledge on the issues, but in ways that neither intimidated nor put them off. As one observer put it, it was amazing how she could "be standing there schooling you about something and still make you feel that you knew all that right along."

In 1972 Jordan won election to the U.S. House of Representatives, and on the advice of former President Lyndon Johnson, she sought and obtained a seat on its Judiciary Committee. In doing so, she situated herself at the heart of the political storm that was about to overtake the country, for it was this committee that was soon charged with determining whether President Richard Nixon's alleged involvements in the Watergate scandals were grounds for impeachment. One commentator claimed that Jordan was "the best mind on the committee." But equally noteworthy was her gift for expressing what was on that mind, and her statement on July 24, 1974, recommending acceptance of the articles of impeachment against Nixon was among the most memorable moments in Watergate rhetoric. "Today I am an inquisitor," she said in her preamble. "I believe hyperbole … would not overstate the solemnness that I feel right now. My faith in the Constitution is whole. It is complete. It is total." Spoken by someone else, such declarations might have been dismissed as cynically calculated or overwrought. But the carefully paced cadence of Jordan's delivery and the magisterial tone of her voice invested her words with a weight and sincerity that seemed to strike exactly the right chord for this deeply troubling political occasion.

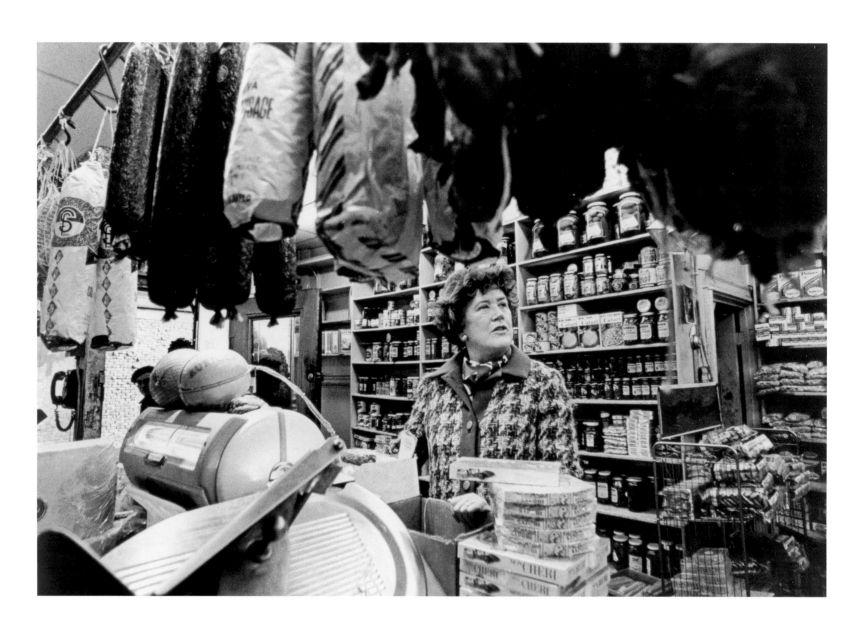

Until well into her thirties, Julia Child had never given much thought to food. But in 1946 she married a man who took quite a keen interest in what he ate, and over the next several years that single fact became an increasingly significant determinant in guiding her own preoccupations. Not long after her husband's job with the United States Information Agency took them to Paris in 1948, she began taking classes at France's world-famous Cordon Bleu cooking school, and within weeks her onetime indifference to culinary matters had been displaced by a nearly insatiable passion. In a letter home, describing himself as a "Cordon Bleu widower," her husband reported that it was now all but impossible to pry Child "loose from the kitchen day or night—not even with an oyster knife."

What was more, it was clear that this was no flash-in-the-pan enthusiasm that would soon burn itself out. With two French friends, Simone Beck and Louisette Bertholle, Child was soon operating a cooking school in her Paris apartment, which in turn led to a three-way collaboration on a French cookbook for the American market. The work on that volume took more than six years, and its original intended publisher, Houghton Mifflin, ultimately rejected it, thinking that it offered a complicated style of cooking that would not appeal to America's made-with-a-mix mentality. Houghton, however, lived to regret that judgment. When Alfred Knopf finally brought the book out in 1961 under the title *Mastering the Art of French Cooking*, it quickly became a best-seller. The *New York Times* food critic, Craig Claiborne, called it the "most comprehensive, laudable and monumental work" available on French cuisine and predicted that for nonprofessional cooks, it would remain the "definitive work" on the subject for many years to come.

Such hyperbole notwithstanding, Child's career as America's explicator of French cooking had not, however, reached full bloom. That event occurred several years later, following her debut in 1963 as *The French Chef* on Boston's public television station, WGBH. Speaking in a high, chirpy voice, the tall, somewhat gawky Child may have struck some viewers as hopelessly miscast for this program. She made mistakes and dropped food, and even as she grew more experienced, the fumbling did not entirely go away. *Time* characterized her on-screen style as a "kind of muddleheaded nonchalance." But audiences loved that muddleheadedness, and more than one hundred stations were soon carrying the show. By the late 1960s Child had become a force in shaping America's dietary mores. If she opted on a program, for example, to beat egg whites with a hand whisk, kitchenware departments across the country would suddenly find themselves sold out of the normally slow-selling implement. If one of her dishes called for fresh broccoli, demand for that vegetable was certain to soar.

Child did her last segment of *The French Chef* in 1972, but when Hans Namuth photographed her shopping in an Italian market in Boston's North End in 1977, she was about to begin work on a new television series, titled *Julia Child & Company*. In the past several years, she noted, she had burst "out of the French straitjacket" to become interested in other types of cuisine, and among the featured dishes in the new series would be variations on traditional American recipes.

JULIA CHILD
born 1912
CHEF, AUTHOR

HANS NAMUTH (1915–1990)
Gelatin silver print
24 × 34.8 cm (9 7/16 × 13 11/16 in.), 1977
Gift of the estate of Hans Namuth

JESSYE NORMAN
born 1945
SINGER

IRVING PENN (born 1917)
Platinum-palladium print
49 × 47.9 cm (19 5/16 × 18 7/8 in.), 1983
(printed 1985)
Gift of Irving Penn

In December 1968, a recent Howard University music-major graduate named Jessye Norman appeared at Constitution Hall in Washington, D.C., singing the soprano solos in a presentation of Handel's *Messiah*. Among those bowled over by her performance was *Washington Post* music critic Paul Hume, who could not say enough about her "prodigious voice." Given Norman's age and lack of experience, Hume could only think that her performance was but a "prelude to something quite extraordinary." It was not long before that prediction began playing itself out. Twelve months later, she was making her opera debut as Elisabeth in Richard Wagner's *Tannhäuser* at Berlin's venerable Deutsche Oper, where her rich, sumptuously smooth voice created a sensation, and shortly thereafter the Deutsche Oper signed her to a three-year contract.

Over the next several years, Norman was offered many choice roles, but not wanting to overstrain her voice or fall into the repertoire of the typical soprano diva, she accepted them on only a selective basis. Of all the choice Verdi roles that she could have sung, the only one that she was interested in taking on was that of Aida, and one of her most oft-cited statements reflecting the circumspect character of her pursuit of stardom was her perversely proud declaration, "I've turned down all … [Verdi's] Leonoras." But choosiness in roles hampered the growth of neither her talent nor her reputation. Of her interpretation of the Liebestod from *Tristan und Isolde* at a Toronto concert in 1974, a reviewer said that she had given "as nearly flawless a performance as one could rightly expect from the human voice."

Between 1975 and 1980, Norman turned away all offers for opera engagements and instead focused on lieder recitals and orchestra concerts. When she finally returned to the opera stage, she seemed better than ever, and her long-delayed American opera debut in 1982 with the Opera Company of Philadelphia was an unalloyed triumph. One critic hailed it as "A Modern Norman Conquest," claiming that it was "not simply the lustrousness of her voice" that made her performance so impressive. It was also her striking presence and her voice's supple ability to shift from the "dark and dramatic," to the "light and lilting," to the "fiercely intense."

This image of Norman by Irving Penn was taken in 1983 and appeared in *Vanity Fair*. The occasion was the hundredth-anniversary season of the Metropolitan Opera, which was to begin with a production of Hector Berlioz's *Les Troyens*, where Norman was to have the role of Cassandra. This was Norman's first appearance at the prestigious Met, and the magazine interpreted this pride of place in the company's bicentenary celebration as an atonement for its failure to invite her to perform sooner. By now Norman had sung all over the world and in most of the greatest opera houses. She was also familiar with the Cassandra role, which she had once sung at London's Covent Garden. Even so, appearing with her own country's most revered company proved a bit more unnerving than she had expected. She had thought that the long rehearsals had given her plenty of time to work out all her nervousness, but it did not work quite that way. At her opening night entrance, she said, "I still turned to jelly."

As an undergraduate at Hunter College, Rosalyn Yalow took a physics course that, because it met soon after lunch, suffered a bit from post-prandial lethargy. To raise the energy level one day, the professor began class with an announcement challenging his audience to detect the two errors that were to be found in his presentation. Recalling the incident years later, the professor said that Yalow met the challenge admirably—indeed, finding not two mistakes, but three.

Clearly here was a student with substantial promise. But when Yalow graduated from Hunter in 1941, physics was still very much a male domain, and as a graduate student in physics at the University of Illinois, her sex was sometimes a deterrent to full collegial acceptance. When, for example, she received an A- in an optics lab, the department chairman claimed that the "minus" only proved that "women could not do laboratory work." Still, she persevered, and in 1945 she became the second woman at Illinois to complete a doctorate in physics.

After leaving Illinois, Yalow returned to her native New York City to work briefly as an electrical engineer at Federal Telecommunications Laboratory and then went on to a teaching position at Hunter. Blessed with an inexhaustible energy, she found, however, that teaching did not keep her fully occupied, and in 1947 she joined the staff of the Bronx Veterans Administration Hospital as a medical physicist charged with exploring the potential of radioisotopes in diagnosing and treating illnesses. Her first lab at the hospital was a large janitor's closet, and thanks to a lack of commercially made equipment for the type of work she was about to begin, she found herself having to design some of her own apparatus.

In 1950 Yalow formed a working partnership with Dr. Solomon Berson—a pairing that proved unusually fortunate. As one colleague put it, "he provided the biological brilliance, and she the mathematical muscle," and together they were soon conducting pathbreaking explorations into the use of radioisotopes for a variety of purposes, from diagnosing thyroid disease to measuring blood volume to determining the distribution of serum proteins in body tissues. In time they became interested in diabetes and began using radioactive iodine to measure insulin levels. Out of those investigations came the development of radioimmunoassay—commonly referred to as RIA—a procedure that has proven to be of immense value in diagnosing and determining treatment for a wide range of diseases. Unfortunately, Berson died in 1972, before the plaudits for that accomplishment had run their full course. The ultimate recognitions of the remarkably fruitful Yalow-Berson collaboration came in 1976, when Yalow was the first woman to win the prestigious Albert Lasker Prize for Basic Medical Research, and in 1977, when she was the second woman to receive the Nobel Prize in medicine.

Yalow had recently been appointed Solomon A. Berson Distinguished Professor at Large at Mt. Sinai School of Medicine when she posed for this likeness by Arthur Leipzig in 1987. Her image has the direct and unforced quality that typifies so much of Leipzig's work. The picture was part of a series of images depicting Jewish women from around the world that formed the basis for his book *Sarah's Daughters*.

ROSALYN YALOW
born 1921
MEDICAL PHYSICIST

ARTHUR LEIPZIG (born 1918)
Gelatin silver print
22.1 × 33 cm (8 11/16 × 13 in.), 1987

165

MAYA LIN

born 1959
DESIGNER, ARCHITECT

MICHAEL KATAKIS (born 1952)
Gelatin silver print
22.2 × 33.3 cm (8 3/4 × 13 1/8 in.), 1988
Gift of Michael Katakis in memory of his
father, George E. Katakis

When Maya Lin handed in her proposal for a Vietnam War memorial in fulfillment of an assignment in one of her undergraduate architecture courses at Yale, her professor thought it rated no more than a B. That was a respectable grade to be sure, but it was hardly a ringing endorsement of her design. Lin, however, thought well of her conception, consisting of a V-shaped stretch of black marble inscribed with the names of the more than 57,000 who had died in Vietnam. So well, in fact, that she sent her proposal off to vie with some 1,420 other applications in a nationwide competition to determine a design for the Vietnam Memorial in Washington, D.C. As it turned out, the judges in the contest were considerably more impressed with Lin's work than her Yale professor. Captivated with its clean simplicity and lack of histrionics, they awarded Lin the commission for the nation's Vietnam tribute, declaring her design "a memorial of our own times" that "could not have been achieved in another time or place."

Not everyone agreed with the commissioners' judgment, however. Indeed, when the competition's outcome became public, a good many individuals indicated that they did not think that Lin's proposal was even worth her Yale professor's lukewarm B. One Vietnam veteran denounced it as "a black gash of shame." The *National Review* labeled it an "Orwellian glop," and many shared its view that Lin's memorial was a scheme, somehow perpetrated by critics of the Vietnam War, to demean those who had died in the conflict. Despite such outcries, the plans to carry out Lin's conception continued apace, and in the end her own faith in her conception was totally vindicated.

Seeing it drawn on paper, no one could have anticipated just how effective this understated monument of dark polished stone was going to be. But as people streamed past it upon its completion in 1982 and stopped to touch the incised names of soldiers they had known, it became abundantly clear that Lin had struck a deeply emotional chord that in no way dishonored the dead of the Vietnam War. Of all the war memorials across America, it was hard to think of any that, in the last decades of the twentieth century or for many years thereafter, could carry deeper meaning for its citizenry.

Not long after the Vietnam Memorial was done, Lin returned to Yale to complete a master's degree in architecture, and by the time she posed for this photograph in 1988, she had established herself as a designer, architect, and sculptor in New York City. At the moment, she was focused on completing her most significant commission since leaving graduate school, a civil rights memorial for Montgomery, Alabama, which would prove to be yet another critical triumph for her.

The maker of this likeness, Michael Katakis, recalled three years after his visit to Lin's studio that Lin did not especially like posing for him. "For two hours we talked," he said, "and still she remained tense and uncomfortable." Then her cat jumped on the windowsill and reached out a paw to demand her attention. With that, Lin was transformed. "Her face and hands took on a gentle and vulnerable posture," and Katakis lost no time in snapping the kind of picture that he had been hoping to get.

SUSAN FALUDI
born 1959 and

GLORIA STEINEM
born 1934
FEMINISTS, WRITERS

GREGORY HEISLER (born 1954)
Chromogenic print
31.7 × 25.2 cm (12 1/2 × 9 15/16 in.), 1992
Gift of *Time* magazine

In March 1992, *Time* magazine featured on its cover this image of Susan Faludi standing behind a seated Gloria Steinem. It was, at that moment, a natural and eminently newsworthy pairing. To begin with, both were feminists. While Steinem, founder of the staunchly feminist *Ms.* magazine, belonged to the older generation of women's movement activists who had emerged in the late 1960s and early 1970s, Faludi, a Pulitzer Prize–winning reporter for the *Wall Street Journal*, represented feminism's younger contingent of articulate spokespersons. They had both also recently published books that offered two sides of the most recently minted feminist coin and now occupied the higher reaches of the nonfiction best-seller lists.

Faludi's book, *Backlash: The Undeclared War against American Women*, took for its premise the assertion that the progress of women resulting from feminist agitation of the sixties and seventies had eroded in the eighties and that the source of that erosion was a sort of haphazard coalition of societal forces and institutions that was out to discourage the feminist impulse. Among the chief factors contributing to the erosion, she said, was the perpetration of the myths that feminism was unnecessary because women had essentially achieved their goals already and that many women were, in fact, feeling painfully at odds with themselves as a result of the conflicting pressures of career and child rearing. Faludi proved remarkably deft at finding the flaws in the studies and anecdotes that were supporting such myths, and her book—likened in feminist circles to Betty Friedan's groundbreaking book of 1963, *The Feminine Mystique*—was coming to be regarded as "feminism's new manifesto." After reading her "hair-raising … [but] documented analysis" of how the current American zeitgeist was circumscribing female potential, wrote a critic, "you may never read a magazine or see a movie or walk through a department store the same way again."

Steinem's book, *Revolution from Within: A Book of Self-Esteem*, was more individually oriented, and its central thrust was a contention that the potential for enlarging life's possibilities hinged largely on building self-esteem and self-understanding. Some feminists took Steinem to task for writing this book, *Time* reported, and accused her of "'abandoning the cause' by subsuming feminism in a model for self-recovery and creating a harmful diversion from the feminist agenda." But Steinem had at least one ready rejoinder to such charges. "When one member of a group changes," she had observed in *Revolution*, "the balance shifts for everyone, and when one group changes, it shifts the balance of society."

In photographing Faludi and Steinem for *Time*, Gregory Heisler created a composition with something of a built-in contradiction. While the close proximity of the two women suggests a blending into one single entity, the different direction of their gazes puts them at a distance from each other and reinforces the separateness of their identities. In light of the sharply different emphases of their books, that was perhaps an apt way to depict this feminist pair.

NOTES ON SOURCES

GERTRUDE SIMMONS BONNIN (ZITKALA-ŠA)
"I made no friends," in Zitkala-Ša, *American Indian Stories,* with a foreword by Dexter Fisher (Lincoln: University of Nebraska Press, 1985), 97. "I fear no man," in David Johnson and Raymond Wilson, "Gertrude Simmons Bonnin, 1876–1938: 'Americanize the First American,'" *American Indian Quarterly* 12 (winter 1988): 38.

HELEN KELLER
"Our worst foes," in Helen Keller, *The Story of My Life* (New York: Doubleday, Page & Company, 1904), 434. "Paradise," in Helen Keller, "A Chat about the Hand," *Century* 69 (January 1905): 455.

FRANCES BENJAMIN JOHNSTON
"In portraiture, especially," in Pete Daniel and Raymond Smock, *A Talent for Detail: The Photographs of Miss Frances Benjamin Johnston, 1889–1910* (New York: Harmony Books, 1974), 7.

ISADORA DUNCAN
"More like a spirit," in *Philadelphia Telegraph,* December 22, 1908. "The applause became more and more hearty," in *New York Sun,* August 29, 1908. "The flame of genius" and "Her body was not beautiful," in Arnold Genthe, *As I Remember* (New York: Reynal & Hitchcock, 1936), 196, 198.

MARGARET SANGER
"I am the protagonist," in *Time,* September 16, 1966, 98. "Bruised and exhausted," in *New York Times,* March 7, 1917, 20.

JEANNETTE RANKIN
"The Girl of the Golden West," in Hope Chamberlin, *A Minority of Members* (New York: Praeger, 1973), 7–8. "Now that we have a pull in Congress" and "I want to stand by my country," in Kevin S. Giles, *Flight of the Dove: The Story of Jeannette Rankin* (Beaverton, Oreg.: Touchstone Press, 1980), 83, 94.

LOUISE BRYANT
"I think she's the first person," in Virginia Gardner, *"Friend and Lover": The Life of Louise Bryant* (New York: Horizon Press, 1982), 13. "A kingdom more bright," in Barbara Gelb, *So Short a Time: A Biography of John Reed and Louise Bryant* (New York: W. W. Norton, 1973), 167. "From the eyes of the people themselves," in Gardner, *"Friend and Lover,"* 112.

KATHERINE STINSON
"Flying Schoolgirl" and "dippy twist loop," in Lisa Yount, *Women Aviators* (New York: Facts on File, 1995), 4, 6. "The women were wild with excitement," in Valerie Moolman, *Women Aloft* (Alexandria, Va.: Time-Life Books, 1981), 35. "It's all right," in Yount, *Women Aviators,* 3.

MARY PICKFORD
"You're too little and too fat," in Scott Eyman, *Mary Pickford: America's Sweetheart* (New York: Donald I. Fine, 1990), 37. "Any picture in which [Mary Pickford] appears," in Raymond Lee, *The Films of Mary Pickford* (New York: Castle Books, 1970), 20. "Though she looks almost helplessly feminine," in *Vogue,* February 1920, 60.

AIMEE SEMPLE McPHERSON
"[Sarah] Bernhardt of the sawdust trail," in Joseph Henry Steele, "Sister Aimée: Bernhardt of the Sawdust Trail," in *Vanity Fair: Selections from America's Most Memorable Magazine,* ed. Cleveland Amory and Frederic Bradlee (New York: Viking Press, 1977), 237. "The titian-haired whoopee" and "[P. T.] Barnum of religion," in Edward T. James, ed., *Notable American Women, 1607–1950* (Cambridge, Mass.: Belknap Press of Harvard University Press, 1971), vol. 2, 479. "She shouts and chants and sings," in Steele, "Sister Aimée," 237. "MAN BARKS," in Daniel Mark Epstein, *Sister Aimee: The Life of Aimee Semple McPherson* (New York: Harcourt Brace Jovanovich, 1993), 212.

LILLIAN GISH
"Played so many frail, downtrodden little virgins," in Louise M. Collins and Lorna M. Mabunda, eds., *The Annual Obituary 1993* (London: St. James Press, 1994), 146. "Finest example of emotional hysteria" and "She is not Hawthorne's," in Anna Rothe, ed., *Current Biography, 1944* (New York: H. W. Wilson, 1945), 240–41.

GERTRUDE STEIN WITH JO DAVIDSON
"The Chinese water torture," in *New York Times,* July 28, 1946. "Soporific rigamaroles" and "of her presence," in *Time,* September 11, 1933, 59. "American Revolutionary" and "Wives of great man," in *Vanity Fair,* February 1923, 48.

DORIS HUMPHREY
"Moving from the inside out" and "Never ceases to be curious," in John Garraty and Mark C. Carnes, eds., *American National Biography* (New York: Oxford University Press, 1999), vol. 11, 468, 467. "An enduring part of the dance," in *New York Times,* January 11, 1959, 12.

JOSEPHINE BAKER
"There was something about her rhythm," in Charles Moritz, ed., *Current Biography, 1964,* 20. "A scream of salutation," in *New York Times,* April 13, 1975. "Nefertiti of now" and "a most beautiful panther," in Lynn Haney, *Naked at the Feast: A Biography of Josephine Baker* (New York: Dodd, Mead, 1981), 67–68.

WILLA CATHER
"An erasure of personality," in *Dictionary of American Biography* (New York: Charles Scribner's Sons, 1974), supp. 4, 153. "For fear of dying in a cornfield" and "concerned entirely with heavy farming people," in Deborah Carlin, "Willa Cather," in *Modern American Women Writers* (New York: Charles Scribner's Sons, 1991), 50, 55. "Touched with genius," "most vital, subtle, and artistic piece," and "literary artistry," in James Woodress, *Willa Cather: A Literary Life* (Lincoln: University of Nebraska Press, 1987), 240, 409–10. "A stylist of precision and beauty," in *Vanity Fair,* April 1927, 65. "The heir apparent," in *Vanity Fair,* July 1927, 30.

MALVINA HOFFMAN
"Wondered if it might not be a defect" and "as if she had wings," in *New York Times,* July 11, 1966, 29.

BERENICE ABBOTT
"How about me," "I had no idea," and "most of them were good," in Hank O'Neal, *Berenice Abbott: American Photographer* (New York: McGraw Hill, 1982), 9–10. "The degree to which they retain," in *New York Times*, January 10, 1976.

PEARL S. BUCK
"The most distinguished work," in Marjorie Dent Candee, ed., *Current Biography, 1956*, 83. "So searching and frankly realistic," in Paul A. Doyle, "Pearl S. Buck," *American Novelists, 1910–1945*, vol. 9 of *Dictionary of Literary Biography* (Detroit: Gale Research, 1981), 100–2.

ELEANOR HOLM and HELENE MADISON
"Looks, grace, and carriage" and "a human torpedo boat," in Robert S. McFee, "Ladies from Olympus," *Vanity Fair*, September 1932, 31. "Uncanny ability to manipulate reality," in Mary Panzer, "Steichen," *American Photo* 12 (January/February 2001): 76.

HELEN WILLS MOODY
"She plays her game," in Marc Pachter et al., *Champions of American Sport* (New York: Harry N. Abrams, 1981), 155. "More than anything else," in Phyllis Hollander, *100 Greatest Women in Sports* (New York: Grosset & Dunlap, 1976), 106.

KATHARINE HEPBURN
"Startlingly clear," in Gary Carey, *Katharine Hepburn: A Hollywood Yankee* (New York: St. Martin's Press, 1983), 44. "Strangely distinguished," in *Time*, August 28, 1933, 18. "One of the most memorable heroines," in *Time*, November 27, 1933, 30. "Ran the whole gamut," in Leslie Frewin, *The Late Mrs. Dorothy Parker* (New York: MacMillan, 1986), 137. "Miss Hepburn has many of the qualities" and "like a woman who has at last found the joy," in Carey, *Katharine Hepburn*, 66, 110.

EMMA GOLDMAN
"Red Emma," in *New York Times*, February 2, 1934, 9. "Worked itself into a nervous lather," in *Toledo Blade*, October 7, 1990. "No. I was always considered bad," in *New York Times*, February 3, 1934, 15. "Who the hell wants to be reasonable?" in *Newsweek*, January 20, 1934, 20.

MAE WEST
"Sin-promising strut" and "her wriggles," in *New York Times,* November 23, 1980. "Come up and see me some time," in *Time*, October 16, 1933, 14. "Between two evils" and "Goodness, what beautiful diamonds," in *New York Times*, November 23, 1980. "What once looked like hearty bawdiness," in Emily Leider, *Becoming Mae West* (New York: Farrar, Straus & Giroux, 1997), 314.

AMELIA EARHART
"Favorite pony," "A Lady's Plane as Well as a Man's," "Hooray for the last grand adventure!" and "You betja!" in Susan Butler, *East to the Dawn: The Life of Amelia Earhart* (Reading, Mass.: Addison-Wesley, 1997), 100, 109, 170, 395.

HELEN HAYES
"It would be idle to say," in Donn B. Murphy and Stephen Moore, *Helen Hayes: A Bio-Bibliography* (Westport, Conn.: Greenwood Press, 1993), 109. "My posture became military" and "seen anything like the ovation," in *New York Times*, March 18, 1993, B9. "She acts with passion," in Murphy and Moore, *Helen Hayes*, 94. "By some alchemy," in *Time*, December 30, 1935, 22.

MARTHA GRAHAM
"Ugly girl makes ugly movements," in Susan Ware, *Letter to the World: Seven Women Who Shaped the American Century* (New York: W. W. Norton, 1998), 213. "Macabre" and "unhealthy," in Garraty and Carnes, *American National Biography*, vol. 9, 385. "From downright ugliness," "perilous work," and "letters comparing him,"in Don McDonagh, *Martha Graham: A Biography* (New York: Praeger, 1973), 115. "A miracle of intuition," in Agnes De Mille, *Martha: The Life and Work of Martha Graham* (New York: Random House, 1991), 244. "No artist is ahead of his time," in Merle Armitage, ed., *Martha Graham: The Early Years* (New York: Da Capo Press, 1978), 107.

ANNA MAY WONG
"Rose blushing through ivory," in *New York Times*, February 4, 1961.

SHIRLEY TEMPLE
"Boom in Child Stars," in *Time*, July 25, 1938, 25. "The most celebrated child alive," in *Time*, April 27, 1936, 40. "Shame on them!" in *New York Times*, July 18, 1938, 12.

ELIZABETH HAWES
"ALL REDDISH BROWN OR BLACK PRINTS" and "absolutely out of fashion," in Bettina Berch, *Radical by Design: The Life and Style of Elizabeth Hawes* (New York: E. P. Dutton, 1988), 30, 29. "A complete anachronism," in *Newsweek*, March 28, 1938, 29.

CARMEL SNOW
"Voice of American fashion," in *New York Times*, May 9, 1961, 39. "You can't keep an exciting fashion down," in Jane Trahey, *Harper's Bazaar* (New York: Random House, 1967), 90.

KATHARINE CORNELL
"Got worse as the years went on," "I don't think," and "She was born to be an actress," in *New York Times*, June 10, 1974. "Had something in it," in *New York Times*, December 13, 1924, 12. "An actress of the first order," in William C. Young, ed., *Famous Actors and Actresses of the American Stage* (New York: R. R. Bowker Company, 1975), vol. 1, 220–21.

MARY LOU WILLIAMS
"One of the very few capable female jazz musicians," in *Life*, October 11, 1943, 120. "If you shut your eyes," in *Time*, July 26, 1943, 76. "The Lady Who Swings the Band," in Linda Dahl, *Stormy Weather: The Music and Lives of a Century of Jazzwomen* (New York: Pantheon Books, 1984), 62. "Every great in jazzdom" and "a revelation," in Gjon Mili, *Photographs and Recollections of Gjon Mili* (Boston: New York Graphic Society, 1980), 168.

DOROTHY PARKER

"Odd ... blend," in *New York Times*, June 8, 1967, 38. "That's queer," "You can lead a whore," and "Excuse my dust," in Robert E. Drennan, *The Algonquin Wits* (New York: Citadel Press, 1985), 116, 121, 125. "What's a couple of sandspits," in Marion Meade, *Dorothy Parker: What Fresh Hell Is This?* (New York: Villard Books, 1988), 319.

PEARL PRIMUS

"If ever a young dancer," in Lynne Fauley Emery, *Black Dance from 1619 to Today* (Princeton, N.J.: Princeton Book Co., 1988), 262. "Pearl Primus is no filmy ballerina," in *Time*, August 25, 1947, 42. "Dance is my medicine," in Barbara Carlisle Bigelow, ed., *Contemporary Black Biography* (Detroit: Gale Research, 1994), vol. 6, 214.

MARGARET BOURKE-WHITE

"Life's Margaret Bourke-White Goes Bombing," in *Life*, March 1, 1943, 17. "Almost beyond praise," in Theodore M. Brown, "A Legend That Was Largely True," in *The Photographs of Margaret Bourke-White* (New York: Bonanza Books, 1972), 15–16. "The most famous on-the-spot," in *Washington Post*, June 29, 1989. "I was wild," in Margaret Bourke-White, *Portrait of Myself* (New York: Simon and Schuster, 1963), 250.

HANNAH ARENDT

"The combination of tremendous," in *New York Times*, December 6, 1975, 32. "One of the most brilliant," in Irving Kristol, "A Treasure of the Future," *New Republic*, July 10, 1961, 19. "Isn't that marvelous!" in *New York Times*, December 6, 1975, 32.

MARIAN ANDERSON

"I have never been so proud," in *Washington Post*, April 9, 1993. "Champagne!" and "a voice like yours," in *Time*, December 30, 1946, 59. "She returns to her native land," in Arthur Bronson, "Marian Anderson," *American Mercury* 61 (September 1945): 285. "Designed for hand to hand combat," *New York Times*, April 9, 1993.

PEGGY GUGGENHEIM

"A member not of the Lost" and "just as well lose," in Aline B. Saarinen, *The Proud Possessors* (New York: Random House, 1958), 327, 331. "Rare discrimination" and "a sense of wonders" in *Art Digest* 17 (November 1942): 8.

GYPSY ROSE LEE

"You don't have to be naked," in *Life*, May 27, 1957, 104. "Seven minutes of sheer art" and "She peddles her act," in *Life*, December 14, 1942, 99. "Queenly style," in *Life*, May 27, 1957, 104.

MILDRED "BABE" DIDRIKSON ZAHARIAS

"*I'm* the star," "Out to beat anybody in sight," and "there has never been another," in Ware, *Letter to the World*, 199, 175, 171. "Altogether lacking in refinement," "She must be Superman's sister," and "I just loosen my girdle," in *Time*, June 23, 1947, 66. "Queen of the Links," in *New York Daily News*, October 12, 1947. "She was a great scrambler," in Ware, *Letter to the World*, 196.

LILLIAN HELLMAN

"Bravely written," "It was like a Chinese box," and "that brain," in William Wright, *Lillian Hellman: The Image, the Woman* (New York: Simon and Schuster, 1986), 96, 149, 36.

GEORGIA O'KEEFFE

"I began to realize" and "to fill space in a beautiful way," in Katharine Kuh, *The Artist's Voice* (New York: Harper & Row, 1962), 189, 190. "She is like the unflickering flame of a candle," Laurie Lisle, *Portrait of an Artist: A Biography of Georgia O'Keeffe* (New York: Seaview Books, 1980), 123.

HELENA RUBINSTEIN

"It doesn't matter how shaky," in *Time*, April 9, 1965, 98. "I tell you I am a worker," and "John D. Rockefeller in petticoated miniature," in Hambla Bauer, "Beauty Tycoon," *Collier's*, December 4, 1948, 16. "Go ahead and kill me," in *Newsweek*, April 12, 1965, 87.

BILLIE HOLIDAY

"Actually doesn't believe that she can sing," in Robert O'Meally, *Lady Day: The Many Faces of Billie Holiday* (New York: Arcade Publishing, 1991), 167. "The greatest female jazz voice" and "iridescent gems," in Jessie Carney Smith, ed., *Notable Black American Women* (Detroit: Gale Research, 1992), 500–501. "Every major pop singer" and "the greatest single musical influence," in Deborah G. Felder, *The 100 Most Influential Women of All Time: A Ranking Past and Present* (Secaucus, N.J.: Carol Publishing Group, 1996), 318. "Sang a completely different chorus," in Smith, *Notable Black American Women*, 499. "Hysterical applause" and "That's all over now," *Time*, April 12, 1948, 68–69.

ELEANOR ROOSEVELT

"Reversed the usual lot, " "become, perhaps, the best known woman," "the most popular living American," and a "unique combination," in *Time*, October 25, 1948, 25. "Just going to be plain," in Joseph Lash, *Eleanor and Franklin* (New York: W. W. Norton, 1971), 355. "Could have made no better selection," in *Time*, September 13, 1943, 20. "Naivete and cunning," in Lash, *Eleanor: The Years Alone* (New York: W. W. Norton, 1972), 69. "I take back everything," in Arthur A. Vandenberg, *The Private Papers of Senator Vandenberg*, ed. Arthur A. Vandenberg Jr. (Boston: Houghton Mifflin Company, 1952), 240.

ANNA MARY ROBERTSON ("GRANDMA") MOSES

"Most of us would be bored," in *Washington Star*, July 24, 1945. "Charming," "fresh," and "full of ... childlike joy," in *New York Times*, December 14, 1961, 46. "I don't know as it done any more good," in *Time*, September 6, 1948, 44. "It's nice to be here," in *New York Times*, May 15, 1949, 58.

ETHEL WATERS, CARSON McCULLERS, and JULIE HARRIS

"Masterly pieces of writing" and "wonderfully, almost painfully perceptive," in *New York Times*, January 6, 1950, 26. "Chief literary treasure," in *New York Times*, September 17, 1950, pt. 2, 1. "How to make a song stand on tiptoe," in *New York Times*, September 2, 1977. "One of those rich and eloquent performances" and "extraordinary performance," in *New York Times*, January 6, 1950, 26. "A new star in the theater," in *Life*, January 23, 1950, 63.

MARGARET MEAD

"I expect to die" and "I couldn't keep up," in Ware, *Letter to the World*, 122, 109.
"A friendly but determined-looking woman," and "Her speech is not overweighted,"
in Harvey Briet, "Talk with Margaret Mead," *New York Times*, October 30, 1949,
pt. 7, 41.

FRANCES PERKINS

"The last leaf on the tree," in Lillian Holmen Mohr, *Frances Perkins: That Woman in
FDR's Cabinet!* (Croton-on-Hudson, N.Y.: North River Press, 1979), 288. "Woozy in
the head" and "grim, polite, and unimpressed," in *Time*, May 21, 1965, 31. "Colorless
woman," in *New York Times*, May 15, 1945, 31. "The accusation that I am a
woman," in *Time*, May 21, 1965, 31. "The argument can be made" and
"Unpleasant as it is to say," in *Time*, December 25, 1944, 14.

MARIANNE MOORE

"I presume you had an idea," in Moritz, *Current Biography, 1968*, 266. "I never knew
anyone," in Jane Howard, "Leading Lady of U.S. Verse," *Life*, January 13, 1967, 40.
"Among the noblest lyrics," in *New York Times*, February 6, 1972, 40. "Just about the
most accomplished poetess alive," in *Time*, December 10, 1951, 112. "The small body
of durable poetry" and "It ought to be work to read," in *New York Times*, February 6,
1972, 40. "As for Gil Hodges," in Marianne Moore, *The Complete Poems of
Marianne Moore* (New York: Macmillan, 1967), 183. "These knowers," in *Life*,
September 21, 1953, 205.

CARMELITA MARACCI

"There is no doubt at all," "seated throughout," and "an abstract of Spain in the
dance," in *New York Times*, June 27, 1937, 8. "The perfect dancer's body" and
"dances were the most passionate," in Agnes De Mille, *Portrait Gallery*
(Boston: Houghton Mifflin, 1990), 51–52, 58.

ELLA FITZGERALD

"Renovate," "came to inhabit," and "I never knew how good," in *Washington Post*,
June 17, 1996, pt. C, 2. "Guidebooks to the great standards," *New York Times*, June
23, 1996. "The crowd in a frenzy" and "the roar was deafening," in Stuart Nicholson,
Ella Fitzgerald: A Biography of the First Lady of Jazz (New York: Charles Scribner's
Sons, 1993), 148.

JUDY GARLAND

"The star of her own adult melodrama," *New York Times*, June 29, 1969.
"Unhinged," in Gerald Clarke, *Get Happy: The Life of Judy Garland* (New York:
Random House, 2000), 318. "A mighty long gulp," "just about the greatest," and
"Everybody's little sister," in *Time*, October 25, 1954, 86. "A great big warm heating
pad," in *New York Times*, June 23, 1969. "Non-believer," in *Time*, May 5, 1961, 52.

MARILYN MONROE

"Have been the hottest day of the year," in Barbara Leaming, *Marilyn Monroe*
(New York: Crown Publishers, 1998), 109. "The best thing that ever happened to me"
and "I never felt like a star," in *Marilyn Monroe and the Camera* (Boston: Little,
Brown and Company, 1989), 116, 239. "Hey doc" and "with a beautiful angle into the
stage," record of conversation with David Geary, curatorial files, National Portrait
Gallery, Smithsonian Institution. "Worth a week's torment," in *New York Times*,
August 6, 1962, 13.

DOROTHY DAY

"She is the nearest," in *Time*, December 15, 1980, 74. "When they say you are a saint,"
Moritz, *Current Biography, 1962*, 96. "Quiet, even shy," in Vivian Cherry and Sarah S.
Appleton, "The Catholic Worker," *Jubilee* 3 (July 1955): 32.

ALTHEA GIBSON

"Hurried breath," in *Time*, September 16, 1957, 61. "Lanky jumping jack of a girl,"
"Althea Gibson is not the most graceful," "power and drive," and "she plays smarter
all the time," in *Time*, August 26, 1957, 44, 47. "Everyone went out," in *New York
Times*, August 29, 1998, sec. B, 17.

ROSA PARKS

"I liked her," record of conversation with Ida Berman, curatorial files,
National Portrait Gallery.

SYLVIA PLATH

"I have done … what I said I would," in Sylvia Plath, *The Journals of Sylvia Plath*
(New York: Dial Press, 1982), 307. "Will be enjoyed most by intelligent people,"
in Thomas McClanahan, "Sylvia Plath," in *American Poets Since World War II*, vol. 5
of *Dictionary of Literary Biography*, ed. Donald Greiner (Detroit, Mich.: Gale
Research Company, 1980), 164.

LORRAINE HANSBERRY

"Intelligence, honesty and humor," in *Time*, March 23, 1959, 58. "Vigor"
and "veracity," in Moritz, *Current Biography, 1959*, 166. "No alternative," in
Arthur M. Schlesinger, *Robert F. Kennedy and His Times* (Boston: Houghton Mifflin
Company, 1978), 332.

ANNE SEXTON

"I can do that," in *New York Times*, October 6, 1974, 65. "A kind of rebirth at
twenty-nine," in *Dictionary of American Biography*, supp. 9, 711. "Read splendidly,"
"She … carried herself," "I hate to go to the market," and "I was scared the whole
time," in Diane Wood Middlebrook, *Anne Sexton: A Biography* (New York: Vintage
Books, Random House, 1992), 140, 138.

JOAN BAEZ

"As lustrous and rich," in *New York Times*, November 13, 1961, 42. "Perched high
on the charts," in *Time*, June 1, 1962, 39. "That one of the medals which hangs over
my heart," in Joan Baez, *And a Voice to Sing With: A Memoir* (New York: Summit
Books, 1987), 103.

DIANA ROSS, with fellow Supremes FLORENCE BALLARD and
MARY WILSON

"Torchy come-hither purr," in *Time*, May 21, 1965, 86. "Swerves into the most
unsupple lyrics" and "slung like six feet of limp wrist," in *New York Times*, July 23,
1967, pt. 2, 11. "I didn't exist" and "I enjoyed them as people," in Bruce Davidson,
Portraits (New York: Aperture, 1999), 5.

FANNIE LOU HAMER

"We didn't come all this way" and "I'm sick and tired of being sick and tired,"
in Smith, *Notable Black American Women*, 443–44.

JANIS JOPLIN

"Just 'silly crazy Janis,'" in Michael Lydon, "The Janis Joplin Philosophy: Every Moment She Is What She Feels," *The New York Times Biographical Edition, 1969* (New York: New York Times, 1969), 1384. "Sang like a demonic angel" in *Newsweek*, July 3, 1967, 80. "Wrenched out of some deep dark nether region," *New York Times*, October 5, 1970, 43. "I don't want to do any thing half-assed," in *Newsweek*, February 24, 1969, 84.

PAULINE TRIGÈRE

"You see?" in Amy Fine Collins, "Every Inch an Original," *Vanity Fair*, December 1999, 347. "Virtuoso with the shears," in Jack Alexander, "New York's Queen of Fashion," *Saturday Evening Post*, April 18, 1961, 90. "I can't draw, I can't paint," in Moritz, *Current Biography, 1960*, 435. "Never fails to electrify," in Alexander, "New York's Queen of Fashion," 90.

DIANE ARBUS

"Giving a camera to Diane Arbus," "close to poor taste," "the honesty of her vision," and "truly generous spirit" in Doon Arbus and Marvin Israel, eds., *Diane Arbus: Magazine Work* (New York: Aperture, 1984), 166–65.

DIANA VREELAND

"Suddenly I found," in Moritz, *Current Biography, 1978*, 446. "Why don't you … sweep," in Ted Burke, "Mrs. Vreeland," *Town & Country* 129 (June 1975): 82. "Tremble[d] at her nod," "to pick purely," "a camel's gait," and "cigar-store Indian," in *Time*, May 10, 1963, 53. "A bird of paradise" and "melted into the background," in Burke, "Mrs. Vreeland," 79.

KATHARINE GRAHAM

"What I essentially did," in *Washington Post*, July 18, 2001. "Most powerful woman in journalism," in *Time*, February 7, 1977, 70. "One of the most important women in America," in *Detroit News*, April 9, 1974. "The art of autobiography," in *Time*, February 17, 1997, 24. "The guts of a burglar" and "I think a man would be better at this job" in *Washington Post*, July 18, 2001.

BARBARA JORDAN

"A bit like grilling God" and "I never wanted to be run of the mill," in *New York Times*, January 18, 1996. "Be standing there schooling you," in Smith, *Notable Black American Women*, 611. "The best mind on the committee," in Moritz, *Current Biography, 1974*, 190. "Today I am an inquisitor," in Mary Beth Rogers, *Barbara Jordan: American Hero* (New York: Bantam Books, 1998), 214.

JULIA CHILD

"Cordon Bleu widower," "most comprehensive," and "definitive work," in Noël Riley Fitch, *Appetite for Life: The Biography of Julia Child* (New York: Doubleday, 1997), 175, 271. "Kind of muddleheaded nonchalance," in *Time*, March 20, 1964, 56. "Out of the French straitjacket," in Fitch, *Appetite for Life*, 398.

JESSYE NORMAN

"Prodigious voice" and "prelude to something quite extraordinary," in *Washington Post*, December 30, 1968. "I've turned down all," in C. Steven Larue, ed., *International Dictionary of Opera* (London: St. James Press, 1993), vol. 2, 943. "As nearly flawless a performance," in Moritz, *Current Biography, 1976*, 295. "A Modern Norman Conquest," in *Newsweek*, December 6, 1982, 128. "I still turned to jelly," in *New York Times*, September 27, 1983.

ROSALYN YALOW

"Women could not do laboratory work" and "he provided the biological brilliance," in Elizabeth Stone, "Madame Curie from the Bronx," *New York Times Magazine*, April 9, 1970, 30, 95.

MAYA LIN

"A memorial of our own times" and "could not have been achieved," in *New York Times*, June 29, 1981. "A black gash of shame" and "Orwellian glop," in *Time*, November 9, 1981, 103. "For two hours we talked" and "Her face and hands," in Michael Katakis to Ann Shumard, November 23, 1991, curatorial files, National Portrait Gallery.

SUSAN FALUDI AND GLORIA STEINEM

"Feminism's new manifesto," in Judith Graham, ed., *Current Biography, 1993*, 187. "Hair-raising," in Laura Shapiro, "Why Women Are Angry," *Newsweek*, October 21, 1991, 41. "'Abandoning the cause'" and "When one member of a group changes," in *Time*, March 9, 1992, 41.

PHOTOGRAPHY CREDITS

© *Berenice Abbott / Commerce Graphics Ltd., Inc.*: **pp. 50, 54**

© *1976 Richard Avedon*: **pp. 157, 159**

© *Ida Berman*: **p. 135**

© *Estate of Esther Bubley*: **p. 121**

© *1989 Center for Creative Photography, Arizona Board of Regents*: **p. 82**

© *Vivian Cherry*: **pp. 18–19, 130**

© *Miriam Grossman Cohen; courtesy of the Howard Greenberg Gallery, New York City*:
p. 109

© *1983 Condé Nast Publications Inc.*: **p. 163**

© *Bruce Davidson*: **p. 145**

Courtesy of the Howard Greenberg Gallery, New York City: **p. 33**

© *Robert Gurbo*: **p. 97**

© *Halsman Estate*: **pp. 90, 95**

© *1992 Gregory Heisler*: **p. 169**

© *Lotte Jacobi Archive Instructional Services, University of New Hampshire*: **p. 14, 117**

© *Michael Katakis*: **p. 167**

© *Arthur Leipzig*: **pp. 150, 164**

© *Estate of George Platt Lynes*: **p. 86**

© *Estate of Linda McCartney*: **p. 149**

© *1959 Rollie McKenna*: **p. 136**

© *1961 Rollie McKenna*: **pp. 2, 142**

© *2000 Man Ray Trust/Artists Rights Society, NY/ADAGP, Paris*: **p. 43**

© *Ivan Massar/from BLACKSTAR*: **p. 142**

© *The Lisette Model Foundation, Inc. (1983). Used by permission*: **pp. 89, 124**

© *Courtesy Nickolas Muray Photo Archives*: **pp. 44, 74**

© *Hans Namuth Ltd.*: **p. 160**

© *Estate of Genevieve Naylor; courtesy Staley-Wise Gallery, New York City*: **p. 133**

© *Arnold Newman/Getty Images*: **pp. 17, 98, 107, 112, 154**

© *New York Daily News, LP*: **pp. 77, 100**

© *Sonya Noskowiak; Center for Creative Photography*: **p. 72**

© *1984 Irving Penn; courtesy of Vogue*: **pp. 103, 105**

© *1966 Charmian Reading*: **p. 147**

© *Joanna T. Steichen; reproduced with permission*: **pp. 16, 49, 57, 58, 63**

© *Estate of Fred Stein*: **p. 92**

© *Ralph Steiner; courtesy Estate*: **p. 79**

Courtesy TimePix: **pp. 85, 115**

© *The Valente Collection*: **p. 71**

© *Reproduced by permission of the Van Vechten Trust*: **p. 64**

© *Vogue, Condé Nast Publications Inc.*: **p. 37**

© *Todd Webb*: **p. 15**

© *Bob Willoughby 1960*: **pp. 123, 127**

© *Garry Winogrand; courtesy of Fraenkel Gallery*: **p. 153**

INDEX

Page numbers in *italics* refer to illustrations.
Page numbers in **bold** refer to main entries.